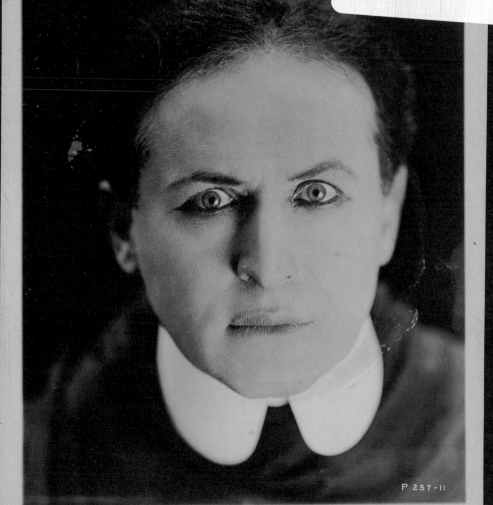

P 257-11

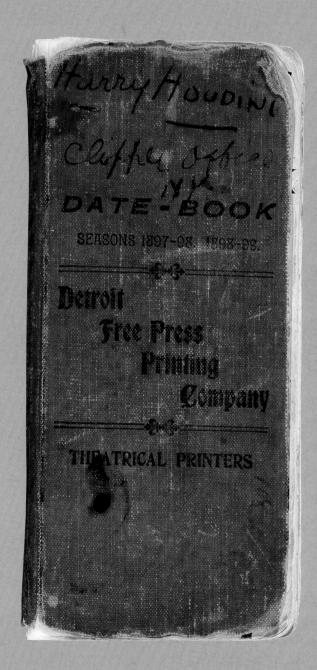

Harry Houdini

Clipper office
N.Y.

DATE-BOOK

SEASONS 1897-98. 1898-99.

Detroit Free Press Printing Company

THEATRICAL PRINTERS

MARCH, 1898.	MEMORANDA.	
M 14	Middleton's	Had new Litho's made
T 15	Museum	paid 50.º deposit to
W 16	Chicago Ill	Barton.
T 17		
F 18		
S 19		
S 20	Smiths Opera House	1st week
M 21		magic act
T 22	Gd. Rapids	and
W 23		Handcuff + Box
T 24		gave exhibition Friday
F 25		to packed house
S 26		Police bought 14 style cuffs
S 27	Smiths Opera House	2nd weeks act
M 28	Gd Rapids	Bess' singing act
T 29	Mich	+
W 30		second Sight consisting of
T 31		Envelopes, B Board +
APRIL.		Spirt cabinet
F 1		
S 2		
S 3		
M 4	Buffalo N.Y.	Had argument regarding
T 5		books. wanted to quit
W 6	Salary	but could not get our stuff
T 7	Eual to	out. Settled satisfactory.
F 8	Big Pay!	wired for books to chicago
S 9		got books writ.
S 10	$100.ºº	cha

The illustrations on these pages and the two that follow are from Harry Houdini's diaries. In the entries for March 1898 and August 1898, Houdini records the triumphs and tribulations of barnstorming across the United States with his wife, Bess. The pages from the later diary include a February 1916 clipping from a Memphis newspaper and Houdini's May 1916 account of visiting his teenage home in New York, where he "stood . . . in silent meditation" thinking about the death of his father: "It grieves me more now than it did then. I can still hear our blessed mother weep in supplication."

AUGUST, 1898.

M	1	gust 1st, Binghamton, N.Y.
T	2	August 2d, Binghamton, N.Y.
W	3	lay, August 3d, Binghamton, N.Y.
T	4	ay, August 4th, Corning, N.Y.
F	5	y, August 5th, Corning, N.Y.
S	6	urday, August 6th, Addison, N.Y.
		16th week
S	**7**	
M	8	ugust 8th, Hornellsville, N.Y.
T	9	August 9th, Hornellsville, N.Y.
		esday, August 10th, Wellsville, N.Y.
W	10	day, August 11th, Olean, N.Y.
T	11	day, August 12th, Olean, N.Y.
		aturday, August 13th, Salamanca, N.
F	12	
		17th week
S	13	
S	**14**	
M	15	Monday, August 15th, Bradford, Pa.
T	16	Tuesday, August 16th, Bradford, Pa.
W	17	MT. JEWETT Pa
T	18	RIDGWAY "
F	19	DUBOIS- " —
S	20	PUNXSUTANEY "
S	**21**	
M	22	MAHAFFEY "
T	23	coal Port "
W	24	altoona "
T	25	"
F	26	
S	27	TYRONE Pa
S	**28**	

(left margin vertical notes: "18th week", "18th week")

MEMORANDA.

saw Hose team practice on track
Practiced every day
Ran 1/2 mile prize money
My back Somerset:

2 Band practing doubles from
far I lived mechanic
met Stanly Gervis the court
S.R.O. Had to stop selling ticket

S.R.O. Papule Herald revoled show
Nettle done long somerset school
very rainy - Small house met horse gypsy Boss
" " Firemens convention
could not Show Lot flooded moved
here + showd 2 night
Had Haircut
Bum town Good for num SHOW.
missed matinee

still at somerset

Memphis Feb 17/1916

916

Mor

Goldsmith & Sons Co.

jenfeedt

THE COMMERCIAL APPEAL,

Houdini Demonstrates His Skill Before Thousands of People

N

Ro

Ga

VI

BLUFF CITY ENG. CO.

Saturday, May 20, 1916

Went to Store house. early. 9. a.m. Paid boys took all metal to be nickle plated.

Up to dentist W. G. Schuff W. 125 th St.

I then having time went to 305 E 69th St. The house from which we buried dear old Father.

I had not been there for many years, stood there in silent meditation half an hour, In my minds eye, I saw Father leave the house the last time — he was brot back Oct 6 – 1892 in Peace & Silence.

I was 18 years of age — and now being 42 I could re-live through the whole scene.

It grieves me more now — than it did then. I can still hear our blessed mother weep in supplication saying "Weiss, Weiss, du hast mich verlassen mit deiner Kinder!.." was hast du gethan.

T'was them Ma said to me when I asked her not to weep " Wenn Du hast ein kind 28 jehr, wirdst du auch weinen. Mother is also Asleep. and God Grant them the Restful Sleep after both their Fitful fever Life.

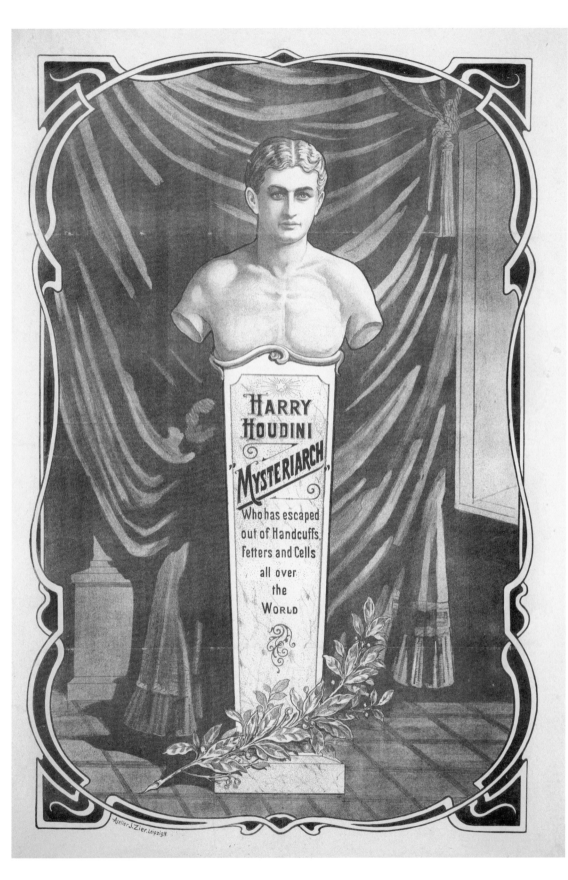

HARRY HOUDINI

"MYSTERIARCH"

Who has escaped
out of Handcuffs,
Fetters and Cells
all over
the
WORLD

Atelier J. Zier, Leipzig N.

Houdini
Art and Magic

Brooke Kamin Rapaport

WITH CONTRIBUTIONS BY
Alan Brinkley
Gabriel de Guzman
Hasia R. Diner
Kenneth Silverman

THE JEWISH MUSEUM, NEW YORK
UNDER THE AUSPICES OF THE JEWISH THEOLOGICAL SEMINARY OF AMERICA

YALE UNIVERSITY PRESS
NEW HAVEN AND LONDON

This book has been published in conjunction with the exhibition *Houdini: Art and Magic,* organized by The Jewish Museum.

Houdini: Art and Magic was generously funded by Jane and James Stern, Kathryn and Alan C. Greenberg, and the Blanche and Irving Laurie Foundation, with additional support from Rita and Burton Goldberg, the National Endowment for the Arts, the Susan and Elihu Rose Foundation, and other donors.

Corporate support was provided by

Bloomberg

The Skirball Fund for American Jewish Life Exhibitions, the Dorot Foundation publications endowment, the Neubauer Family Foundation Exhibition Fund, and the Horace W. Goldsmith Foundation Exhibition Fund also provided important funding.

NATIONAL
ENDOWMENT
FOR THE ARTS

The Jewish Museum, New York
October 29, 2010–March 27, 2011

Skirball Cultural Center, Los Angeles
April 28–September 4, 2011

Contemporary Jewish Museum, San Francisco
September 26, 2011–January 15, 2012

Madison Museum of Contemporary Art, Wisconsin
February 11–May 13, 2012

The Jewish Museum
Director of Publications: Michael Sittenfeld
Text edited by Anna Jardine and Michael Sittenfeld

Yale University Press
Publisher, Art and Architecture: Patricia Fidler
Senior Editor, Art and Architecture:
 Michelle Komie
Manuscript Editor: Heidi Downey
Production Manager: Mary Mayer

Designed by Miko McGinty
Set in Garamond and Zinco type
Printed in Singapore by CS Graphics

The Jewish Museum
1109 Fifth Avenue
New York, New York 10128
thejewishmuseum.org

Yale University Press
P.O. Box 209040
New Haven, Connecticut 06520-9040
yalebooks.com

Library of Congress Cataloging-in-Publication Data

Rapaport, Brooke Kamin.
 Houdini : art and magic / Brooke Kamin Rapaport ; with contributions by Alan Brinkley . . . [et al.].
 p. cm.
 "Published in conjunction with an exhibition held at the Jewish Museum in New York and three other institutions between Oct. 31, 2010, and May 13, 2012."
 Includes bibliographical references and index.
 ISBN 978-0-300-14684-4 (cloth : alk. paper)
 1. Houdini, Harry, 1874–1926—Exhibitions. 2. Houdini, Harry, 1874–1926—Influence—Exhibitions. 3. Identity (Psychology) in art—Exhibitions. 4. Art and popular culture—United States—History—20th century—Exhibitions. 5. Art and popular culture—United States—History—21st century—Exhibitions. I. Houdini, Harry, 1874–1926. II. Brinkley, Alan. III. Jewish Museum (New York, N.Y.) IV. Title.
 GV1545.H8R37 2010
 793.8092—dc22
 [B] 2010008394

A catalogue record for this book is available from the British Library.

The paper in this book meets the guidelines for permanence and durability of the Committee on Production Guidelines for Book Longevity of the Council on Library Resources.

10 9 8 7 6 5 4 3 2 1

Pages i–iii: Houdini's travel diary, 1897–99. Book, 5½ x 2⅝ x ⅜ in. (14 x 6.7 x 1 cm). Collection of Dr. Bruce J. Averbook, Cleveland

Pages iv–v: Houdini's travel diary, 1916. Book, 12½ x 7⅞ x 1 in. (31.8 x 20 x 2.5 cm). Collection of Dr. Bruce J. Averbook, Cleveland

Frontispiece: Atelier J. Zier, Leipzig, *Mysteriarch,* c. 1915. Lithograph, 39¼ x 27⅝ in. (99.7 x 70.2 cm). Harry Ransom Humanities Research Center, The University of Texas at Austin, Performing Arts Collection, Harry Houdini Collection

Page 262: White Studio, *Photographs of Houdini Escapes,* c. 1915 (detail of illustration on page 41)

Cover illustration: *Harry Houdini,* c. 1920 (detail of illustration on page xiii)

Contents

Foreword

Houdini is widely regarded as synonymous with the word *magician*. His genius and astounding ingenuity have an indelible place in American history and lore. But few people have a full understanding of Houdini's extraordinary persona. In *Houdini: Art and Magic,* the personal and professional aspects of the magician are synthesized for the first time in a major exhibition and catalogue, created by The Jewish Museum and presented in three additional museums in Los Angeles, San Francisco, and Madison, Wisconsin. Houdini, the great celebrity conjurer, is in effect being conjured by curators, writers, and artists. One hundred thirty-six years after his birth in Hungary, they offer new insights into his Jewish identity, inventiveness as an illusionist, business acuity, and enduring influence on artists, writers, and filmmakers.

The exhibition combines a variety of media—texts, artifacts, film, memorabilia—to illuminate the challenges and transformations that underlay the trajectory of Houdini's career. We learn of his rise from poverty to American superhero and the feats that ensured his evolution from marginal circus performer to world-famous illusionist, from someone with virtually no possessions to a wealthy man who honored the memory of his learned father by amassing a huge library. This

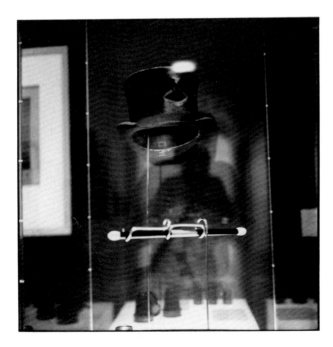

Bruce Cratsley
(AMERICAN, 1944–1998)

Hat and Wand of Houdini, the Louvre Museum, 1995. Gelatin silver print, 9⅝ x 9⅝ in. (24.5 x 24.5 cm). Brooklyn Museum, Gift of Jonathan L. Fagin

book goes beyond the exhibition to enhance our understanding of Houdini in all his complexity as a performer prodigiously gifted at keeping himself in the public eye.

An impressive array of curatorial and academic talent has been brought to bear in both the exhibition and book, and it is appealing to imagine that Houdini would have admired this visually captivating and erudite approach to celebrating his life. Indeed, he might have been pleased to know that his brilliance, drive, and thrilling effrontery inspired all who have been involved in *Houdini: Art and Magic* to create this interweaving of research, loans, scholarship, and design.

The lasting presence of Houdini in the public imagination has been such that many people are surprised to learn that he was born in the nineteenth century, especially as his life continues to be the subject of films, books, and theater productions. Less well known is the potent influence of his character on the world of contemporary visual artists, and one of the important features of *Houdini: Art and Magic* is curator Brooke Kamin Rapaport's discovery of a large and diverse group of artists for whom Houdini functions as a cultural touchstone because of his mastery of illusion, his ability to escape from peril and impossible constraints, and his tremendous renown.

At their core, exhibitions at The Jewish Museum provide the public with new ways to view art, history, and Jewish culture. This was central to two recent shows—*Chagall and the Artists of the Russian Jewish Theater* and *Action/Abstraction: Pollock, de Kooning, and American Art, 1940–1976*—as well as the 2005 exhibition *Sarah Bernhardt: The Art of High Drama*. The latter explored the multiple talents of a person who was not only a great artist but rose from hardship in an atmosphere of anti-Semitism to achieve an unparalleled celebrity status with the new vehicles of photomechanical reproduction and mass culture at her disposal.

The ability of The Jewish Museum to realize projects of such scope and depth depends upon the collaboration of every department and many months of work. The impetus is always an inspired curatorial vision, and in this instance it came from the guest curator, Brooke Kamin Rapaport. She not only conceived the project but also oversaw its realization with a combination of intellectual rigor, patience, and administrative skill. Her enthusiasm for her subject inspired all of the participants, including the generous donors and lenders noted on pages viii and 255, whose engagement was critical and to whom we are most grateful. From those staff members who wrote grant proposals to our trustees and advisors who have encouraged the staff to continuously rise to new heights, all have participated in creating a viewing and reading experience that we hope is worthy of Ehrich Weiss, the great Houdini.

Joan Rosenbaum
Helen Goldsmith Menschel Director
The Jewish Museum

Introduction

Who knew that the arc of Harry Houdini (1874–1926) would span three centuries, exhilarating popular and vanguard culture? In the late nineteenth and early twentieth centuries, Houdini's theater performances sold out, his outdoor presentations attracted thousands of spectators, and his work made front-page news internationally. He spawned a host of magicians who pirated his effects and even capitalized on his name, such as Torrini and Miss Undina. (Houdini called these and other performers the "horde of imitators who have sprung into existence with mushroom rapidity of growth, and equal flimsiness of vital fibre.")[1] He was lauded by the Jewish community, which was thrilled that one of its own—an immigrant from Budapest and a rabbi's son, no less—had penetrated the mainstream despite anti-Semitism and anti-immigrant sentiment. Today, he is revered for different reasons by contemporary magicians, a mainstream public, and artists, writers, and filmmakers. The visual record—posters, broadsides, photographs, films, and now contemporary art—documents the evolution of Houdini's fame: a youthful entertainer who originally teamed with his wife (in the Metamorphosis illusion), a formally dressed official magician (presenting the Needle Threading Trick), a muscled and handcuffed grappler (draped in chains and cuffs), a crusading authority (exposing the Spiritualists), a Hollywood hunk (played by Tony Curtis in 1953), a man full of self-doubt and disillusion (in the novel *Ragtime* from 1975), and a radical performer (to artists working today). There is no question that Houdini is the most famous magician who ever lived.

But Houdini's celebrated role as the classic magician is debated. Today's magicians and magic scholars point out that Houdini was not revered for typical stage magic; his performance apparatus were not standard fare. The magic wand, flittering doves, white rabbit pulled from a top hat, and showgirl assistant were not mainstays of his act. Rather, Houdini catapulted to fame as an audacious escape artist who accepted all challenges: he freed himself from handcuffs and legcuffs, underwater straits, a U.S. government mail bag, a basket, an outsize paper bag, a beer cask, boxes, crates, jail cells, straitjackets, and milk cans. If his star rose with his Needle Threading Trick, it was the jaw-clenching escapes that dazzled and terrified audiences and secured Houdini's prominence.

The escapes have been extensively documented in bestsellers, scholarly literature, and Houdini's own writing; exaggerated on certain Web sites; and consid-

ered in various displays at the Houdini Museum in Scranton, Pennsylvania; The History Museum at the Castle in Appleton, Wisconsin (Houdini's adopted American birthplace); and formerly at the Houdini Magical Hall of Fame in Niagara Falls (destroyed by fire in 1995). But liberation from political, racial, or religious oppression was a genuine nineteenth-century aspiration as immigrants traveled via steerage to American harbors and enslaved African Americans made their way to freedom via the Underground Railroad from the early nineteenth century through the 1860s. If those conveyances were actual and perilous means to freedom, then mundane objects such as trunks, crates, and boxes also had real-life

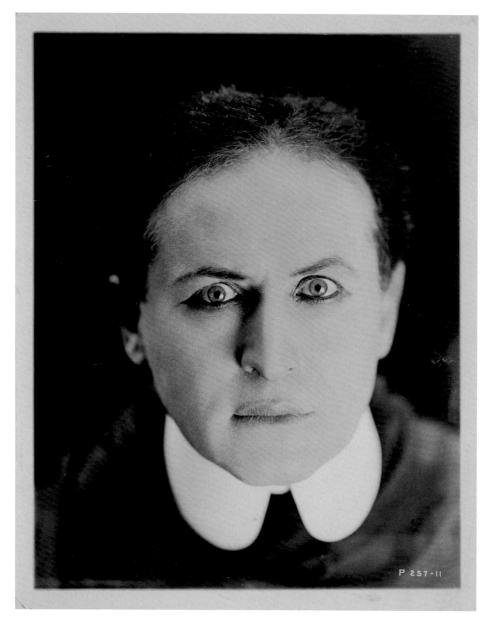

Harry Houdini, c. 1920. Gelatin silver print, 10 x 8¹⁄₁₆ in. (25.4 x 20.5 cm). National Portrait Gallery, Smithsonian Institution, Washington, D.C.

significance to the people in Houdini's era, more so than to anyone who reflects on the metaphor of escape in hindsight.

For Houdini, escape was literally and conceptually the aftermath of his impoverished boyhood. His liberation from an immigrant past into celebrity culture resulted in his choice of everyday objects as magic apparatus. The confining vessels that Houdini chose for performance purposes were associated with escape by other immigrants as well as African American slaves. Henry Brown's dramatic flight from slavery in 1849 is one example of how an individual used a common container for deliverance. Decades before Houdini's arrival in America in 1878, Brown paid a storekeeper to ship him from a Richmond, Virginia, plantation to freedom in Philadelphia via the postal system in a crate "three feet long, two feet wide and two feet deep."[2] Of course, Brown's ascent to free black was an almost unimaginably arduous journey, while Houdini's theater and outdoor escapes were performances. Brown would soon become a public speaker in the North and reenact his passage through performance pieces. He became known as Henry Box Brown.

Certain names given to Houdini were similarly related to his status as an agent of escape: Handcuff King, World's Handcuff King and Prison Breaker, "death defy-er," World-Famous Self-Liberator. In documenting and displaying examples of the objects for which Houdini became best known, we can see how the metaphor of escape arose from the authentic, treacherous breakaway experiences of the countless individuals in the nineteenth century who moved from oppression to freedom. For the opportunity to present the remarkable objects and ephemera from Houdini's era, to connect those artifacts to Houdini's importance today, and to study Judaism's bearing on his life's work, I wish to thank my colleagues at The Jewish Museum who have welcomed me as a guest curator.

We are grateful to the generosity of donors to the exhibition and I join Joan Rosenbaum, Helen Goldsmith Menschel Director of The Jewish Museum, in thanking those listed on page viii for their contributions supporting all aspects of *Houdini: Art and Magic.*

This volume provides a new interpretation of Houdini's significance from the 1890s to the present and documents how a celebrated individual's identity evolves across generations. My essay considers how Houdini's image has been transformed in visual culture from the late nineteenth century to the present. Alan Brinkley appraises Houdini through his status as a newcomer to America by examining the implications of nineteenth-century immigration patterns. Kenneth Silverman explores Houdini's Jewishness as it relates to questions of assimilation. Hasia Diner surveys the life and contributions of Bess Rahner Houdini as a magician's wife and a female performer who surrendered her career to join her husband on the stage. I wish to thank Professors Brinkley, Silverman, and Diner for their outstanding contributions.

In the section titled "Considering Houdini," contemporary artists Matthew Barney, Whitney Bedford, Joe Coleman, Petah Coyne, Jane Hammond, Tim Lee,

Vik Muniz, Ikuo Nakamura, Deborah Oropallo, Raymond Pettibon, Sara Greenberger Rafferty, Allen Ruppersberg, and Christopher Wool have each discussed the importance of Houdini to their work. I am deeply grateful to the artists for their revealing comments here and for the fine work included in the exhibition. Raymond Pettibon and Ikuo Nakamura created new work for the exhibition and their contributions add enormously to our understanding of Houdini's sustained influence. Two longer interviews with the novelist E. L. Doctorow and the magician Teller are remarkable for their reflections on how Houdini saw his way into their creative work.

Joan Rosenbaum suggested from the outset that the power of Houdiniana today is in juxtaposing the historic material with the contemporary art it inspired. Her support and intellectual engagement on this project have been inspiring. Ruth Beesch, deputy director for program, has been a truly generous colleague whose intelligence and commitment to the exhibition and catalogue were beneficent. Before proposing this exhibition, I sat with Norman L. Kleeblatt, Susan and Elihu Rose Chief Curator, whose magnanimous insights were helpful at the project's inception. Associate curator Karen Levitov was a fine colleague whose judgment about the exhibition tour was welcomed. Jane Rubin, director of collections and exhibitions, provided sound, helpful opinions throughout. Julie Maguire, associate registrar, fielded complex queries from lenders and venues with great knowledge, proficiency, and grace. Dolores Pukki, former coordinator of exhibitions, expertly pulled together the many logistics of putting this show on the road. Al Lazarte, director of operations, was wonderfully open to putting magic into the exhibition installation.

Michael Sittenfeld, director of publications, applied his scholarly acumen to all aspects of this publication. He worked with essayists, public institutions, and private lenders to obtain the finest possible contributions and images for this volume. Thanks to Anna Jardine for her careful review of the manuscript and her countless improvements to the text. Miko McGinty, catalogue and exhibition graphic designer, realized her work with great sensitivity to the historical material and provided a cogent, contemporary interpretation. Emily Casden, curatorial intern, handled many logistics in the early planning period. At Yale University Press, many staff members shared an ardor for the subject and contributed to the volume's realization, especially Patricia Fidler, Michelle Komie, and Mary Mayer.

Gabriel de Guzman, Neubauer Family Foundation Curatorial Assistant, was an outstanding colleague from the outset. He worked skillfully on the myriad details of the exhibition and publication with rigor and focus. His chronology of Harry and Bess Houdini's lives will serve as an authoritative resource for how this couple maneuvered together through the entertainment world.

Other staff members at The Jewish Museum were key to *Houdini: Art and Magic.* Sarah Himmelfarb, Susan Wyatt, and Elyse Buxbaum in the development office worked tirelessly and creatively to secure exhibition funding. In the education department, Nelly Benedek and Jennifer Mock proposed creative and enlightening

public programs. Aviva Weintraub, Andrew Ingall, and Niger Miles provided guidance for the film components of the exhibition. Grace Rapkin, director of marketing, Anne Scher, director of communications, and Alex Wittenberg, communications coordinator, brought the museum's enthusiasm for Houdini to public attention. The creative team at Acoustiguide worked tirelessly to produce a wonderful audio tour.

We are thrilled that *Houdini: Art and Magic* is traveling to the Skirball Cultural Center in Los Angeles, the Contemporary Jewish Museum in San Francisco, and the Madison Museum of Contemporary Art in Wisconsin. The directors of those institutions—Robert Kirschner, Connie Wolf, and Stephen Fleischman—have strongly endorsed bringing a fresh interpretation of Houdini to their audiences.

During the planning of the exhibition, we held two scholars' meetings to consider the themes of the project. Participants Jane Hammond, Neil Harris, John Kasson, Norman Kleeblatt, Karal Ann Marling, Anne Patterson, Edward Portnoy, James (The Amazing) Randi, Martha Sandweiss, and Kenneth Silverman offered innumerable insights that helped shape *Houdini: Art and Magic*. I also consulted colleagues throughout exhibition planning: Brooke Davis Anderson, Linda S. Ferber, Marilyn Kushner, Valerie Leeds, Patricia McDonnell, Joyce K. Schiller, Jim Tottis, Stuart Wrede, and Rebecca Zurier.

Kenneth Silverman, whose outstanding biography *Houdini!!! The Career of Ehrich Weiss* is the standard source, has been extraordinarily supportive and generous in his introductions to key participants in the magic field since this project's inception. In the earliest stages of conceptualization, I conferred with Mildred and Martin Friedman to discuss my thesis for the exhibition. Their support, ideas, and friendship have been immensely meaningful.

Joseph V. Melillo, executive producer of the Brooklyn Academy of Music, introduced us to the theater and opera designer Anne Patterson, who provided an extraordinary exhibition design that paid heed to the Houdini material and incorporated a new interpretation integrating the contemporary work. Anne was assisted by Molly Cronin of Sharon Davis Design in New York, whose contributions are greatly appreciated.

This exhibition could not have happened without the loans of objects from Houdini's day to the present. For this, I join Joan Rosenbaum in expressing gratitude to lenders whose names and institutions are listed on page 255. At the lending institutions, our colleagues have supported loan requests with generosity: Nancy Bryk and Jim Klodzen of the American Museum of Magic in Marshall, Michigan; Terry Dawson, director, Appleton Public Library; Arnold Lehman, director, Kevin Stayton, chief curator, Eugenie Tsai, John and Barbara Vogelstein Curator of Contemporary Art, and Patrick Amsellem, associate curator of photography, Brooklyn Museum; Christine Burgin at Christine Burgin Gallery, New York; Wataru Okada, director of collection management, George Eastman House in Rochester, New York; Rosalie Benitez, director, Gladstone Gallery; Ann Philbin, director, Hammer Museum, Los Angeles; Carrie McGinnis,

registrar, and William P. Stoneman, librarian, Houghton Library, Harvard University, and Frederic W. Wilson, curator, Harvard Theatre Collection; Sharon Clothier, former curator, and Matthew J. Carpenter, deputy director and curator of collections, History Museum at the Castle in Appleton, Wisconsin; Jack Rennert and Terry Shargel, International Poster Center, New York; Margo Leavin at the Margo Leavin Gallery, Los Angeles; Mark Dimunation, Barbara Natanson, and Tambra Johnson at the Library of Congress; Natalia Sacasa, senior director, Luhring Augustine, New York; Meg Malloy, director, Sikkema Jenkins, and Erika Benincasa at the Vik Muniz Studio; Kathleen Curry, assistant curator, and Connie Butler, Robert Lehman Foundation Chief Curator, Department of Drawings, Museum of Modern Art; Sean Corcoran, curator of prints and photographs, Museum of the City of New York; Frank Goodyear, associate curator of photographs, and Kristin Smith, exhibition and loan specialist, National Portrait Gallery of the Smithsonian Institution; Karen Nickeson and Jeremy Megraw at the Billy Rose Theatre Collection of the New York Public Library; Rick Watson, research associate, Harry Ransom Center at the University of Texas at Austin; Stacy Bengstson, associate director, Regen Projects, Los Angeles; Sarah Aibel, curator, Sender Collection, New York; Caroline Collier, director, Tate National, at the Tate, London; and Adam Weinberg, Alice Pratt Brown Director, Whitney Museum of American Art. Mary Sabbatino of Galerie Lelong in New York and Greg Kucera of the Greg Kucera Gallery in Seattle were key to locating Jane Hammond's work.

Colleagues and friends have been truly gracious with their time and in lending expertise. Natasha Staller, professor of the history of art at Amherst College, read and commented on a draft of my essay. Her perceptive insights are truly appreciated. Nancy Spector, chief curator, and Barry Hylton, senior exhibition technician at the Solomon R. Guggenheim Museum, and Bill Berloni of William Berloni Theatrical Animals have been generous with their expertise relating to the installation of Matthew Barney's *The Ehrich Weiss Suite.* Dr. Layla S. Diba has provided sound advice during exhibition planning. Blair Kamin and Barbara Mahany have been supportive and thoughtful. Virginia and Arthur Z. Kamin, who introduced me to The Amazing Randi when I was a child, have been unceasingly encouraging. This volume is for Richard and our sons.

Brooke Kamin Rapaport

OVERLEAF
Houdini jumping from Harvard Bridge, Boston, April 30, 1908. Photograph from lantern slide.
Library of Congress, Prints and Photographs Division

XVII

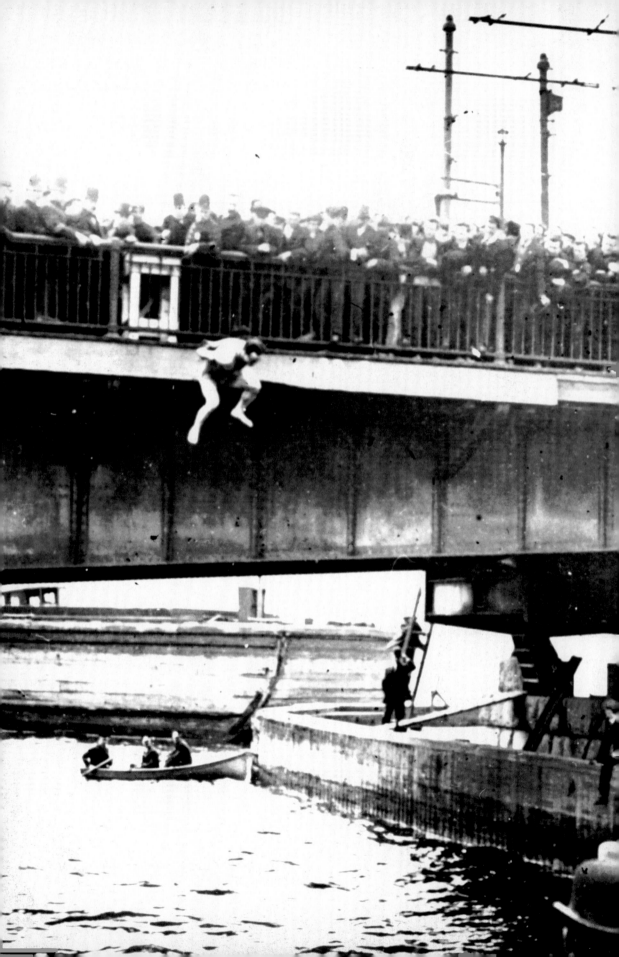

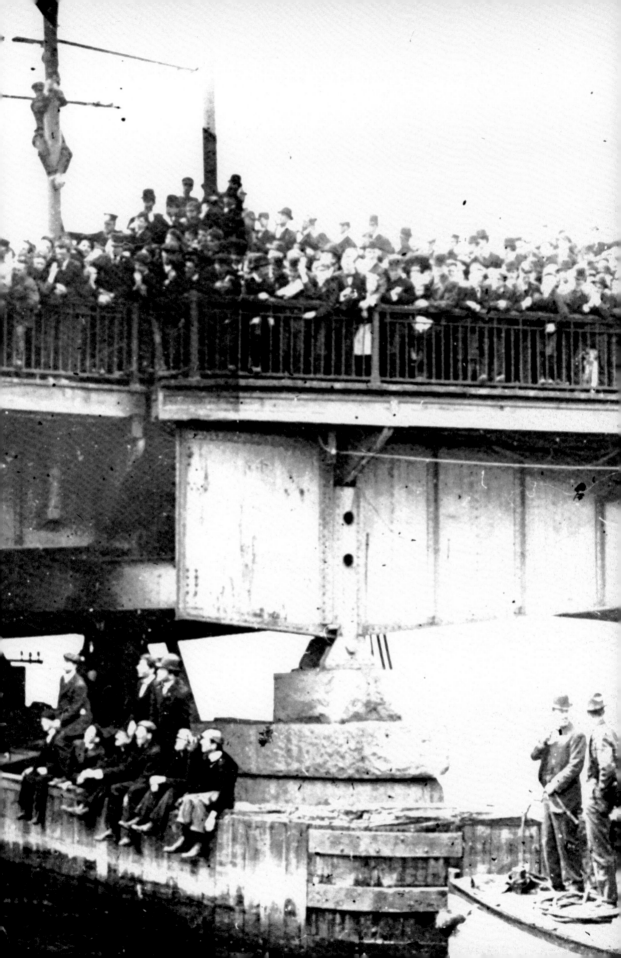

Houdini's Transformation in Visual Culture

Brooke Kamin Rapaport

On the eve of a 1917 performance at New York City's Hippodrome, Harry Houdini was cinched into a straitjacket and hoisted upside down from his ankles by a subway derrick. Thirty feet above Forty-Sixth Street and Broadway, he convulsed, wriggled, and swayed. Seconds later he maneuvered free, escaping the brutal bond, to a roar of applause from the throng of onlookers.[1] Typically, from his high perch, Houdini would brandish that straitjacket in the air as a sign of his conquest and his freedom. For the hundreds or often thousands of spectators who craned their necks to witness Houdini's outdoor performance, the trick may have seemed more important as a symbol than a stunt. Born Erik Weisz (later changed to Ehrich Weiss) in Hungary in 1874 as the son of a rabbi, Houdini was known to those observers as someone who could not only escape from straitjackets, water tanks, milk cans, and handcuffs, but as an individual who threw off his background, making an immigrant's getaway from Budapest to Appleton, Wisconsin, to New York and the international stage. His celebrity and the metaphor of escape have rightly become significant chapters in the Houdini storyline in biographies and biopics.[2] This message is similarly carried in the late-nineteenth- and early-twentieth-century posters, photographs, and film footage from Houdini's day. But following his death in Detroit on Halloween in 1926, when Houdini could no longer control that narrative, contemporary culture took hold. Popular culture held sway at mid-twentieth century, but by the 1970s contemporary artists had rescued his impaired mythic status, reviving Houdini's origins of brute prowess and edgy performance. What the visual culture from Houdini's lifetime and after reveals is how the interpretation of a famous individual evolves and is manipulated over time.

Houdini—the world-famous magician and escape artist, consummate showman, American superhero, and anti-Spiritualist crusader—found the bright lure of the big stage greater than the austere pulpit of his father's rabbinic profession. Houdini lived for only fifty-two years, but his significance as a Jew who made it into the mainstream, as a popular phenomenon who attracted huge crowds, and as a muse for artists working today is extraordinary. In his day he astonished audiences by breaking out of impossible enclosures and breaking into entertainment culture. His ambition emerged from an American archetype: ingenuity, modernity, and renewal conspired in his favor. He became a living legend for American presidents, for Hollywood stars, for fiction writers, and for masses of spectators

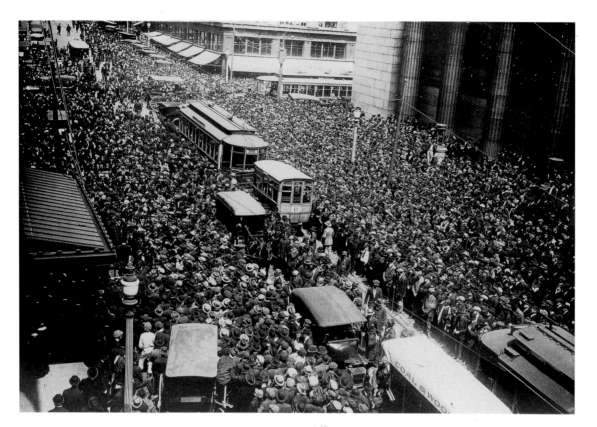

Crowd scene with trolley cars stopped while Houdini performs the Straitjacket Escape, c. 1915. Photograph, 5 x 7 in. (12.7 x 17.8 cm). Collection of Ken Trombly, Bethesda, Maryland

who crowded his outdoor and theater performances. His significance has been documented in extensive examples of the material culture of the period, now housed in prominent private and public collections, including the Library of Congress, the Harvard Theatre Collection, the New York Public Library, and the Harry Ransom Center at the University of Texas at Austin. Yet Houdini's celebrity was not without contradictions, which he faced and cultivated throughout his life and career. His role as an American icon was transformed across three centuries, first in the late nineteenth century by Houdini's own interpretation of his status, next by twentieth-century popular culture, and today by contemporary artists who conjure Houdini as an audacious performer and showman of raw physicality.

In discussing the metamorphosis of Houdini's identity it is especially revealing to examine visual culture. The first section of this essay focuses on the graphic design of the poster and considers how Houdini controlled his own image. Mass media promoted his status from a young sleight-of-hand magician, who may have appeared as a teenager along with belly dancers and snake charmers on the Midway of the 1893 World's Columbian Exposition, to a world-class performer. Posters were an art form popularized in the late nineteenth and early twentieth

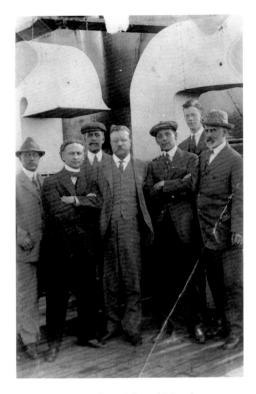

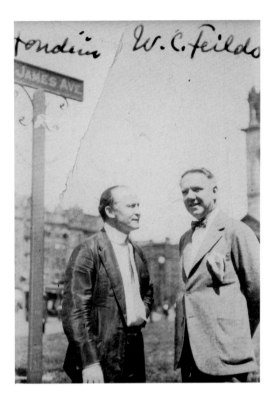

Houdini (second from left) and Theodore Roosevelt (center) aboard the *Imperator*, 1914. Photograph, 4¾ x 3 in. (12.1 x 7.6 cm). Library of Congress, Rare Book and Special Collections

Houdini and W. C. Fields, c. 1924. Photograph, 3 x 2¼ in. (7.6 x 5.7 cm). Courtesy of Fantasma Magic Shop, New York, www.fantasmamagic.com

centuries and were the perfect medium for Houdini: they rivaled his wide appeal in paper form. Next, Houdini will be considered in early twentieth-century fine art. While generic magicians, clowns, and ballet dancers were key subjects for American realist painters, in his day Houdini did not appear as a subject in their works—even though they may have attended his shows. In the final section, the depiction of the Straitjacket Escape across various disciplines shows how Houdini's feat was perceived in its original presentations and how it has been interpreted by succeeding generations. This menacing garment that, as Houdini wrote, bound the upper limbs of the "murderous insane," captured Houdini's fascination with bondage and with man's brutality to man.[3] Photographers and moviemakers seized on this curious escape, as did the spectators who witnessed Houdini's exploits. Contemporary artists found intrigue in Houdini's straitjacket performances because they evoked the metaphor of freedom and the costume had a creepy allure. The literal and symbolic interpretations merge across media.

Houdini appeals to artists because of his role as a daring performer whose body was his most significant prop, and because of his choice of mundane objects as stage apparatus. The disparate range of Houdini's activities—his magic performances in theaters, his perilous acrobatics during the outdoor escapes, his courting and repudiating of Spiritualists, his niche in popular culture—resonate for

contemporary artists in works that are as varied as Houdini's exploits.[4] As a figure from the entertainment world who once electrified working- and middle-class audiences, Houdini stands as a unique case for contemporary artists decades after his death; he penetrated the upper echelons of the avant-garde. Rarely has a showman sustained perpetual intrigue in the public imagination and in visual culture.

Houdini Chronicled in Posters

The carefully controlled visual record of Houdini's feats was a sophisticated act and illustrates how an individual defines himself as his fame accelerates. In his illusions and escapes Houdini embraced the latest, most modern tactics. He went from sleight-of-hand and needle-threading tricks to his early standby effect, called "Metamorphosis," to thrilling handcuff, milk can, water chamber, and straitjacket escapes.[5] Others had extricated themselves from handcuffs and ropes, but Houdini's command of the stage and his ability to market his work placed him firmly at the forefront of innovation in the entertainment field.[6] Audiences clamored for more, and Houdini's continual self-renewal did not disappoint. His image was soon appearing in cities worldwide.

Houdini seized on the poster as a new force to promote his work. The poster was a late-eighteenth-century graphic form popularized in the late nineteenth century.[7] It was the alliance of "nineteenth-century revolutionary advances in color printing by means of lithography" and public demand for notice of performances that led to the poster's effectiveness in Houdini's era.[8] Merchandise, the circus, and magic shows were natural subjects for the poster format: vivid scenes of vibrant color brought poster design into the modern era. It was a fresh medium of expression that attracted the same popular audience that Houdini had courted for his appearances.[9]

The poster artist's remarkable creativity and the subject's fame secured the longevity of Houdini posters. Their intended venue—the street—was eclipsed by the form's endurance in library and museum archives, where they serve as documents charting the brisk ascension of Houdini's career. Little survives about the firms that generated these posters.[10] Occasionally at the bottom of the sheet a credit, citing a printing house, is listed: Atelier J. Zier, Leipzig, and Daude Freres Printers, Paris (when Houdini was on his European tour); National Pr. and Eng. Co., Chicago, and Seymour and Muir Printing Co., Grand Rapids, Michigan, Donaldson Litho, Kentucky (recording Midwest performances); or The Smith-Brooks Co., Show Printers, Denver (when Houdini visited the West Coast as part of the Orpheum circuit). While Houdini chronicled his challenges in *Houdini on Magic,* a collection of his writings, the posters' dramatic representations and exuberant text overshadow a description of magic feats.[11]

The Metamorphosis is one example of how an effect is first advertised to the public in the poster format and how the imagery evolved. In the mid-1890s, Houdini, then in his early twenties, was performing the Metamorphosis with his

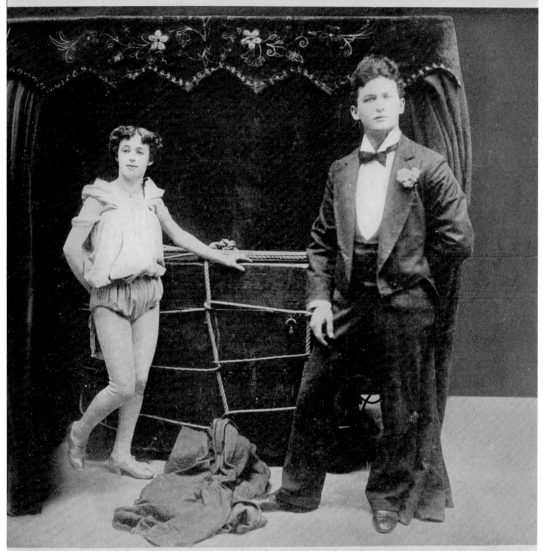

THE·SPHINX

An Independent Magazine For Magicians

The Houdinis Presenting "Metamorphosis"

VOLUME XXXV
NUMBER EIGHT

OCTOBER 1936

25¢ A COPY
35¢ OUTSIDE U.S.

The Sphinx, October 1936, with cover photograph of Bess and Harry Houdini, c. 1895. Magazine, 10⅞ x 8⅜ in. (27.6 x 21.3 cm)

new wife, Beatrice (Bess) Rahner Houdini.[12] In Metamorphosis, one performer is secured in a sack and then locked into a trunk. A curtain is drawn, the curtain opens, and the bagged person is free. The other performer, now contained in the sack, is then revealed. This transformation occurs in less than three seconds. It is a brief performance in which two bodies change places with lightning speed, outside of the viewer's gaze. The rapid exchange relinquishes any male/female dynamic: both must display acute physical agility, and Bess became equal to Harry. By its nature, the Metamorphosis allows for performance partners rather than a magician and his assistant. Metamorphosis posters—modest in scale, color, and composition—reflect Houdini's status as a newcomer. Indeed, Houdini is not billed as a solo performer but rather as one half of the duo called "The Houdinis." This arrangement would be short-lived.

The rough-hewn woodcuts of *The Houdinis, Metamorphosis, Exchange Made in 3 Seconds,* a black-and-white poster from around 1895, depict the couple in the act of transformation. A text explaining the performance takes longer to read than the three seconds the Metamorphosis takes to complete.

Two other posters advertising the Metamorphosis also stress the dispatch with which Harry and Bess change places. In both, bust-length portraits of the two bracket images of the effect's performance. Houdini's portrait in one poster includes a frame of chain link labeled "Harry, The King of Handcuffs." Bess's visage is circled by braided ribbon, and she is crowned "Beatrice, The Queen of Mystery." The realistic character of the portraits recalls posed period photos in which they appear in formal dress.

The first and last time that Bess was an active participant in promotional graphics was in Metamorphosis placards. By 1899, when the vaudeville impresario Martin Beck (1867–1940) signed Houdini on the Orpheum circuit, Bess—a song-and-dance performer who played Coney Island before marrying Houdini in 1894—disappeared from the visual record (even if she did not immediately recede from stage performances as Houdini's right hand). Biographer Kenneth Silverman cites the uptick in Houdini's fortunes: "Unexpectedly, in the early spring of 1899, after a half-dozen years idling in [dime] museums and small-town big tops, Harry's career skyrocketed. In fourteen dizzying months he became a star of American entertainment."[13] Just as drastic as Houdini's promotion to vaudeville—the upper tier of middle-class venues—was Bess's demotion from the visual record. As the magician's wife, her plight was a vanishing act documented in poster form. When Houdini made it big, Bess was out.

We don't know how involved Houdini was in selecting the subject, artist, or printing firms for the posters and can only surmise that Beck or his associates had a hand in the process. Beck's mastery of detail was part of his success in controlling the Orpheum circuit, which by 1905 had seventeen theaters from the Midwest to the West Coast. Beck was a theater innovator who "perfected a procedure, eventually adopted by the entire industry . . . that of a linked chain or circuit of consecutive bookings."[14] All elements of the performance were overseen by Beck,

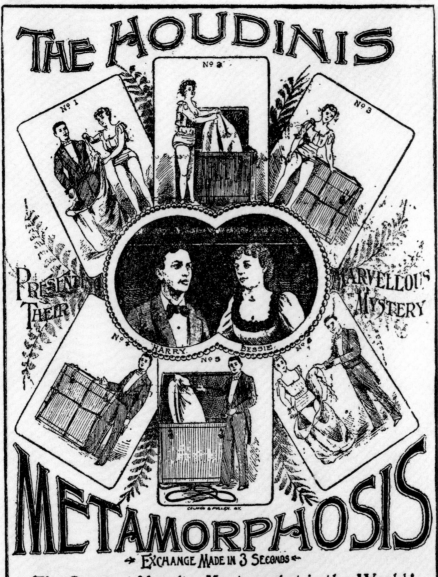

The Houdinis, Metamorphosis, Exchange Made in 3 Seconds, c. 1895. Lithograph, 6⅞ x 4½ in. (17.5 x 11.4 cm). Library of Congress, Rare Book and Special Collections

From left: Bess Houdini, Harry Houdini, and Martin Beck, c. 1900. Photograph, 8 x 7⅞ in. (20.3 x 20 cm). Harry Ransom Humanities Research Center, The University of Texas at Austin, Performing Arts Collection, Harry Houdini Collection

from programs to performers. Because the Orpheum theaters were connected and entertainers traveled from city to city, the same program distributed to an audience member in Chicago was given to another in San Francisco.[15] In fact, Beck has been cited as the first to distribute "fine booklet programs" in his houses, rather than one small sheet of paper, as most theaters used.[16] Given his detail-oriented management style, we can assume that posters were in his purview as well. Beck also booked the legendary stage actress Sarah Bernhardt in 1913, thereby strengthening vaudeville's legitimacy.[17] Soon after Beck discovered Houdini, the magician landed $400 a week, a daunting sum compared to the weekly $25 salary he earned for working up to twenty shows a day at dime museums. Posters from those early days are clear indicators of Houdini's professional rise.

Soon after the mid-1890s, posters feature Houdini as an independent performer. Imagery and the choice of language become bolder: "Nothing on Earth Can Hold Houdini a Prisoner," proclaims a handcuff escape poster from around 1906 in which he is billed as "Europe's Eclipsing Sensation." Houdini stands in white tie, his wrists and ankles locked in legcuffs and handcuffs. Surrounding him are enlargements of sets of handcuffs, demonstrating the thickset locks from which Houdini must break free.[18] Handcuff escapes were not new to magic, but Houdini endowed his performance with spectator participation. He invited audience members to submit their own handcuffs from which he would escape.

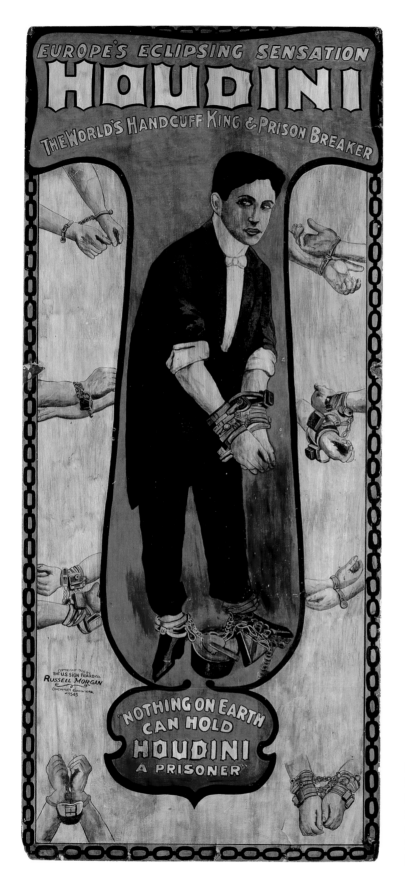

U.S. Sign Board Co., Russell
Morgan, Cincinnati, *Europe's
Eclipsing Sensation, Houdini*, lobby
display, c. 1906. Oil on plywood,
approx. 81 x 48 in. (274.3 x
121.9 cm). Kevin A. Connolly
Collection

Houdini called this the "Challenge Handcuff Act" and proclaimed that he was its originator.[19] He performed this feat in the United States and abroad.

A European tour brought Houdini to Germany where he performed in the Circus Busch. A German poster from around 1908 advertised Houdini's performance with the Circus Busch in Berlin, depicting four police officers (dressed in military garb) surrounding him, three of them securing his neck, wrist, and ankles in hefty cuffs. He was similarly trussed with handcuffs and legcuffs in an outsize poster, "The World Famous Houdini, the Original Jail Breaker." A chain-link border appears at the edge of the poster. While Houdini is seated and cuffs are fastened, however, the chains on those cuffs grow to surreal proportions competing in scale with his human figure.

Another battle of man versus obstacle was the Milk Can Escape, which Houdini debuted in 1908 on the Keith's Theater circuit, taking him to Boston, Washington, Pittsburgh, New Orleans, San Francisco, and other cities.[20] Houdini's extensive athletic training and rigorous endurance sessions in freezing cold baths enabled him to use water as a medium on stage. In one poster, Houdini is handcuffed and tucked into a constructed stage prop, a steel milk can, while bearded men pour gallons of water up to the top of the vessel before locking him in. Viewers are warned of the menacing character of a humble object: if Houdini cannot release himself from the milk can—the American symbol of rural life and comfort—"failure means a drowning death." In another poster, Houdini surpasses himself by being locked in a water-filled milk can placed in a

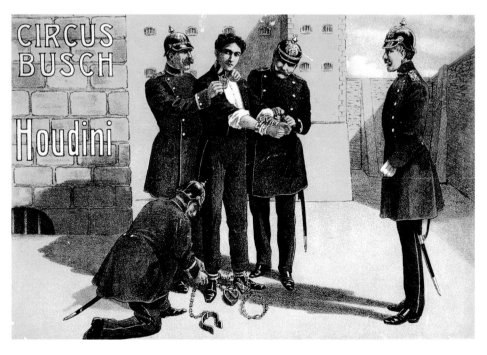

Houdini and the Circus Busch, 1908. Lithograph, 7⅞ x 11⅜ in. (20 x 28.9 cm). Library of Congress, Rare Book and Special Collections

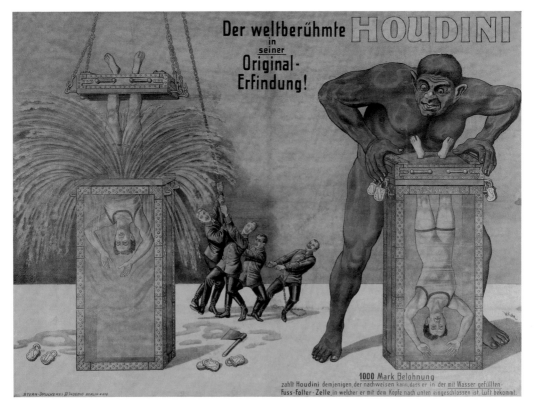

Der Weltberühmte, Houdini, c. 1912. Lithograph, 27 x 36½ (68.6 x 92.7 cm). Courtesy of Fantasma Magic Shop, New York, www.fantasmamagic.com

locked crate. Clearly the element of water, of gushing buckets on the theater stage and the flirtation with death by drowning, satisfied Houdini's audiences, who craved the magic of escape and personal brinksmanship. Several years later, however, the Milk Can Escape had become outmoded, and Houdini strove to one-up himself in a water escape that he built with parts from various manufacturers, labeled "Houdini's own original invention."[21]

Houdini's fascination with water continued in what is considered his most grueling stage escape: the Water Torture Cell (also called the Upside Down, USD, or Chinese Water Torture Cell). The cell's front wall was made of glass, allowing theatergoers to witness the overturned Houdini slowly lowered by his ankles into a watery casket. The escape debuted in Germany in 1912 at Circus Busch.[22] After an introduction calculated to increase suspense, Houdini left the stage and attendants filled the cell. The Amazing Randi recounts Houdini's performance:

> He lay on the floor as the stocks were fitted around his ankles and his hands were cuffed. Then the entire apparatus was raised and Houdini was slowly lowered head down into the water-filled cell. "The Justly World-Famous Self-Liberator" was then padlocked in, visible for all to see through the glass and the horizontal bars of the cage. A curtain was dropped over the entire cell, and

the orchestra struck up "Asleep in the Deep." [Assistants] Kukol and Collins took their places, with their fire axes poised for the moment when they might be needed. This was all high melodrama, and the audience responded with claustrophobic gasps and heart-wrenching shrieks. And then, a little over two minutes later, just as the axes were raised for the impending moment of truth, the curtains parted and a wet and smiling Houdini came out to the erupting roar of the German audience. The Chinese water torture cell with all its padlocks was still intact, but minus Houdini.[23]

Houdini had created a riveting performance in which competing objectives—courting mortality and the triumph of life—coexisted and exhilarated onlookers.

The posters of the Water Torture Cell evoke the high anxiety of a drowning death. Houdini is typically depicted upside down, immersed, hands outstretched and frantically thrust against the glass frame that encases him. His feet poke out from the top of the chamber and, in one poster, to emphasize Houdini's dilemma, water cascades down the sides as he is lowered by several men; on the same sheet, a grotesque tamps down the top of the crate.

While these images compel the viewer to experience the horror of being overwhelmed by water, a smaller poster focuses just on Houdini's pained face pressed into the glass facade. His lips are parted as he braces his lower arm against the cell's floor. Ripples in the water's surface glide across the picture plane, and the viewer perceives Houdini's absolute mental focus and acute duress. As his fame escalated, Houdini continued to use posters to advertise his appearances, but for different ends. By the 1920s a number of posters chronicled his public debunking of Spiritualism, the quasi-religion that began in 1848 when Kate, Margaret, and later Leah Fox, sisters in Hydesville, New York, claimed to have heard mysterious spirit rappings in their home. The Fox sisters' declarations and the activities of other mediums, including Ira and William Davenport (brothers from Buffalo, New York) and the Boston-based Mina Crandon (known as Margery), attracted individuals to private and public séances. Lights, object movements, noises, or writings emanating from the medium were considered signs of successful contact with the spirit world. During the post–Civil War period, when Americans were mourning the war dead, Spiritualism promised contact with those deceased family members. In Houdini's time, Spiritualism was again a salve to mourners whose loved ones had been lost in World War I. Houdini first investigated Spiritualism for personal reasons, but his prowess as an illusionist and escape artist, and his 1890s stint as a psychic medium, enabled him to see through a medium's hokum. As he told the *Los Angeles Times* in 1924, "It takes a flimflammer to catch a flimflammer."[24]

Houdini, whose beloved mother had died in 1913, skeptically sat in Spiritualist séances in an attempt to connect with her. Bess Houdini affirmed that after Cecilia Weiss's death, "Houdini's interest in so-called spirit phenomena increased."[25] Houdini wrote of attending, at an Atlantic City hotel, a 1922 séance

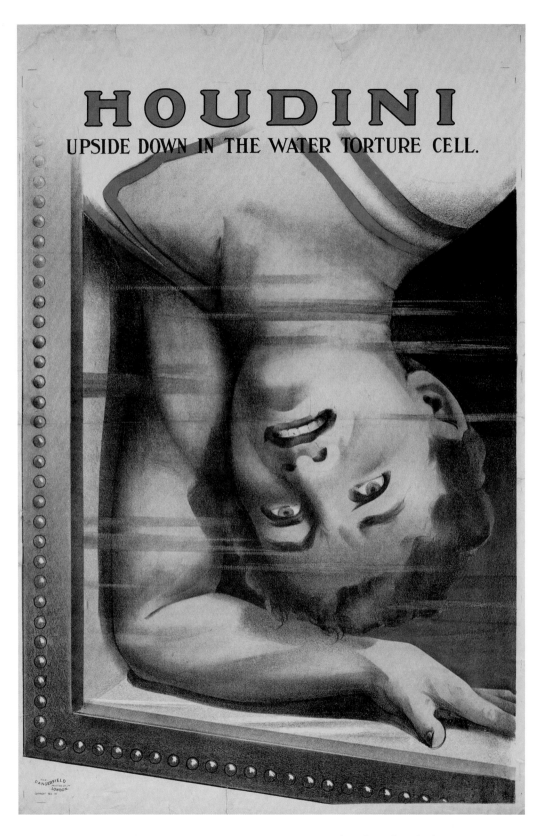

Houdini Upside Down in the Water Torture Cell, c. 1913. Lithograph, 24 x 16 in. (61 x 40.6 cm).
The New York Public Library for the Performing Arts, Billy Rose Theatre Collection

hosted by his friend Sir Arthur Conan Doyle, the creator of the character Sherlock Holmes. Kingsley Doyle, the author's son, had died in 1918 of pneumonia resulting from battle wounds sustained in World War I. Sir Arthur told Houdini that he had spoken six times with his son through spirit mediums.[26] On this occasion, Sir Arthur's wife, Lady Doyle, served as medium and was in a "trance state." Houdini wrote that she "produced a letter 'automatically' that purported to have been dictated by my sainted mother." The letter, however, was written in English, and Mrs. Weiss did not speak, read, or write English. Houdini asserted that "Spiritualists claim that when a medium is possessed by a Spirit who does not speak the language, she automatically writes, speaks or sings the language of the deceased."[27] To Houdini, this fix-it attempt at legitimacy was deeply suspect.

His skill as a magician enabled him to expose the fakery employed by the Spiritualists. Houdini never claimed to have supernatural powers, as he said to his audiences and in his writings: "It has been stated in print by a staunch believer in Spiritualism that I possess psychic power, but were I to accept that state-

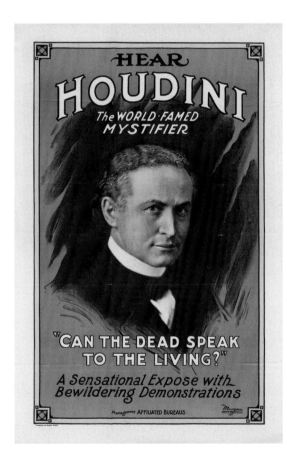

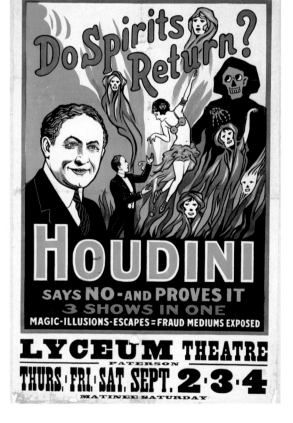

Hear Houdini, The World-Famed Mystifier, "Can the Dead Speak to the Living?" 1920s. Lithograph, 41 x 27 in. (104.1 x 68.6 cm). Harvard Theatre Collection, Cambridge, Massachusetts

Do Spirits Return? Houdini Says No and Proves It, 1926. Lithograph, 41¾ x 27¾ in. (106.1 x 70.5 cm). Library of Congress, Prints and Photographs Division

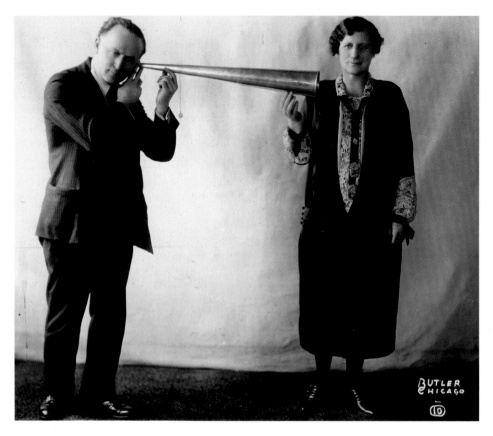

Houdini holding a spirit trumpet with Mina Crandon, also known as the medium Margery,
c. 1924. Photograph, 8 x 10 in. (20.3 x 25.4 cm). Courtesy of Fantasma Magic Shop, New York,
www.fantasmamagic.com

ment as being true, I should be pluming myself with false feathers."[28] He was
infuriated by Spiritualist guff and went on a crusade of lectures folded into his
performances to unmask fraudulent practices. Houdini testified against the Spir-
itualists before Congress in 1926, declaring that it was "impossible" to be a
genuine clairvoyant.[29] Nonetheless, Spiritualists persisted, even though Houdini's
campaign continued in newspapers, in posters, in issues of *Scientific American*
magazine in 1924 when he was on a committee to investigate Spiritualism, and
in his own performances.

While he fought to discredit the Spiritualists he was simultaneously battling
professional peers who were working to duplicate his signature tricks. Many feats,
such as the handcuff, milk can, and water torture cell escapes, were copied and
publicized by other magicians despite Houdini's protests. To ward off the imita-
tors he published books revealing some of his methods and credited himself with
originating certain performances. However, Houdini copycats proliferated dur-
ing and after his lifetime: Excello, the Great Raymond, and Torrini appeared in
chains and handcuffs; Kassner, "The Man in the Can," took on Houdini's Milk
Can Escape; and Miss Undina appeared in the Water Torture Cell. Contemporary

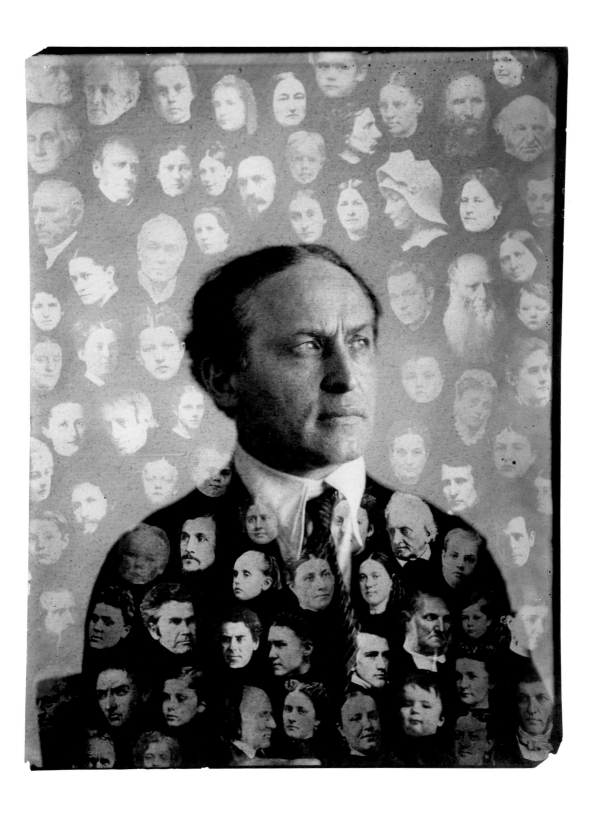

Houdini with spirits, c. 1924. Photograph, 8½ x 6½ in. (21.6 x 16.5 cm). Courtesy of Fantasma Magic Shop, New York, www.fantasmamagic.com

magicians, such as The Amazing Randi, Doug Henning, David Copperfield, David Blaine, and Penn and Teller, pay homage to the master and have openly discussed their indebtedness to him.[30] Not only were Houdini's performances a legacy to the field, but his use of posters inspired the promotional efforts of several generations of magicians.

Houdini in Fine Art

It was the medium of posters that emblazoned Houdini's image across major urban centers in the United States and abroad. The accessibility of those sheets fit perfectly with Houdini's goal of reaching as large an audience as possible in an era before the advent of talking motion pictures and the proliferation of television. While the graphic art of the poster captured Houdini in triumphant moments of his act, the world of fine art looked the other way.

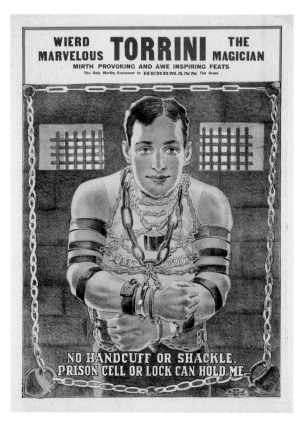

Weird, Marvelous Torrini, the Magician, c. 1910. Lithograph, 30 x 22 in. (76.2 x 55.9 cm). Collection of Ken Trombly, Bethesda, Maryland

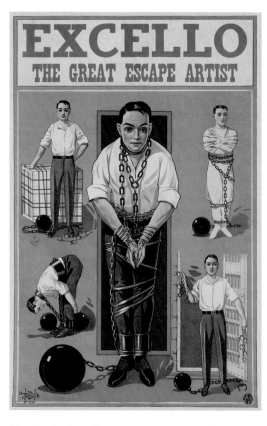

Excello, the Great Escape Artist, c. 1910. Lithograph, 31 x 22 in. (78.7 x 55.9 cm). Collection of Ken Trombly, Bethesda, Maryland

The art photographers of the day such as Alfred Stieglitz (1864–1946) and Edward Steichen (1879–1973) did not to the best of my knowledge take pictures of Houdini, but newspaper photographers did.[31] Painters who worked during this period did not spotlight him either—although they painted vaudeville halls and movie theaters, and individuals in those settings, such as magicians, acrobats, dancers, and theatergoers. It appears that neither John Sloan (1891–1951) nor Edward Hopper (1882–1967) painted Houdini.[32] Evidence suggests that Everett Shinn (1876–1953) and George Luks (1866–1933) did not touch him. And while George Bellows (1882–1925), Charles Demuth (1883–1935), Walt Kuhn (1877–1949), and William Glackens (1870–1938) were all contemporaries of Houdini's, they focused on the spectacle and brilliant color of the burgeoning theater scene. Painting realism in everyday life did not jibe with Houdini's otherworldliness.[33] Alexander Calder (1898–1976), whose *Circus* (1926–31) cap-

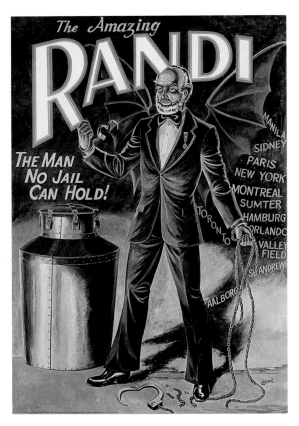

Jay Disbrow (American, born 1926), *The Amazing Randi, the Man No Jail Can Hold!* 1976. Lithograph, 36 x 24 in. (91.4 x 61 cm). Courtesy of International Poster Center, New York

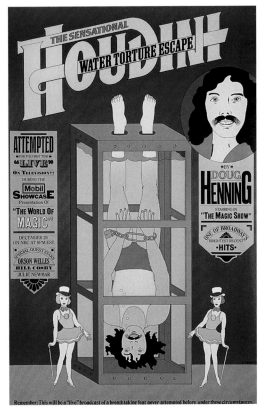

Seymour Chwast (American, born 1931), *The Sensational Houdini Water Torture Escape with Doug Henning,* 1974. Lithograph, 46 x 30 in. (116.8 x 76.2 cm). Courtesy of International Poster Center, New York

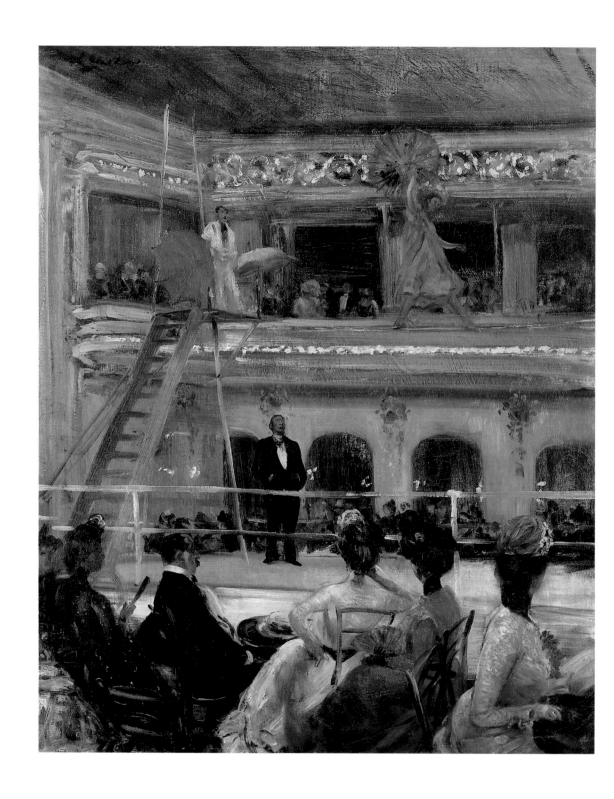

William J. Glackens (AMERICAN, 1870–1938)

Hammerstein's Roof Garden, c. 1901. Oil on canvas, 30 x 25 in. (76.2 x 63.5 cm). Whitney Museum
of American Art, New York, Purchase, 53.46

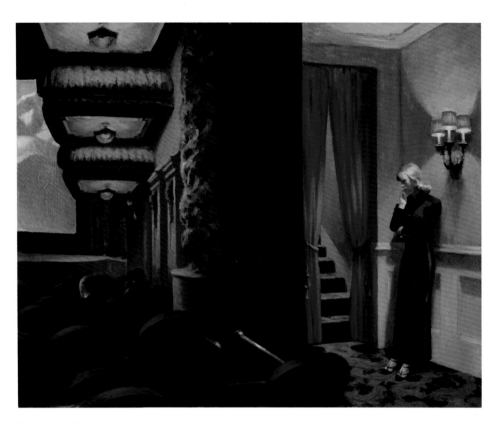

Edward Hopper (AMERICAN, 1882–1967)

New York Movie, 1939. Oil on canvas, 32¼ x 40⅛ in. (81.9 x 101.9 cm). The Museum of Modern Art, New York, Given anonymously

Alexander Calder (AMERICAN, 1898–1976)

Study for Houdini (1957), 1957. Graphite and colored pencil. Calder Foundation, New York

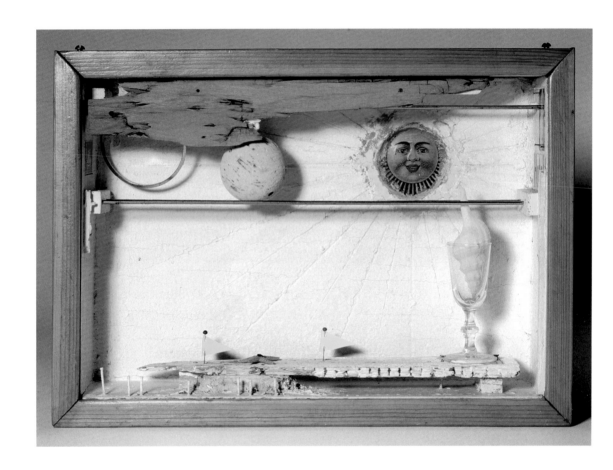

Joseph Cornell (AMERICAN, 1903–1972)

Suzy's Sun (For Judy Tyler), 1957. Box construction including wood, glass, plastic, metal, tempera, cork, seashell, and paper, 10¾ x 15 x 4 in. (27.3 x 38.1 x 10.2 cm). North Carolina Museum of Art, Raleigh, Purchased with funds from the State of North Carolina

OVERLEAF

Theater lobby display, Salem, Massachusetts, 1906. Photograph, 10⅛ x 14 in. (25.7 x 35.6 cm). Library of Congress, Rare Book and Special Collections

tured the movement and dynamism of the Big Top, did not introduce Houdini into that sculpture, although his exploits included the circus genre: dime museums and local circuses were Houdini's early performance venues. Rather, Calder debuted an enormous mobile titled *Houdini (1957)* at Galerie Artek in Helsinki in 1958.[34] The sculpture's rich black surface may have been the artist's response to the mysteries of the magician. Generally, however, vanguard European artists, like their twentieth-century American counterparts, paid scant attention to Houdini as a subject or symbol.

When Houdini was in London, Berlin, and Paris in 1900 and 1901, Pablo Picasso (1881–1973) was in Paris painting entertainers, but apparently not Houdini. Picasso's association with magic and mysticism was linked to his friendship with the poet Max Jacob (who was "deeply involved with the mysticism of palmistry, the tarot and the magical arts") and inspired further by his association with the Surrealists.[35] Yet Houdini's magic did not inspire the Spanish artist. Of course, a number of modern art movements, including Dada and Surrealism, have been associated with magic, but there do not seem to be any literal works based on Houdini by the artists in those groups. However, Joseph Cornell (1903–1972), whose work was included in the first show of Surrealist art in New York in 1932, was inspired by Houdini.

As a child, Cornell was profoundly moved by seeing Houdini perform escape challenges at New York's Hippodrome: "The metal rings and suspended chains that would later become common elements in his boxes refer at least partly to Houdini and the memory of a lonely boy who wished to vanish from the shackles of day-to-day reality. And the very form of the Box was already intriguing to Cornell; whereas Houdini escaped out of boxes, Cornell would one day escape into them."[36] While Cornell's interpretations of Houdini were not literal, there is a kinship between the mystery in Cornell's collaged boxes and the use of the stage as a great box where Houdini assembled his sophisticated performances.

Cornell met Marcel Duchamp (1887–1968) in 1934, but it cannot be verified if Houdini met Duchamp or knew his work; while they were peers in age and could have overlapped in Europe or the United States, their purposes were distinctly different. Still, the practice of incorporating everyday items into their work and transforming our reaction to them begs a comparison between the two. Duchamp considered a commonplace object sculpture. He put a urinal on a pedestal, titled the work *Fountain* (1917), and it was deemed subversive by viewers and critics. Houdini, by contrast, held on to the object's original purpose and imbued it with mystery by enigmatic association. Either way, the magic spectator or the art viewer was surprised to find great magic in the ordinary object.

Houdini's use of recognizable materials in his stage performances, like the rings and chains that persuaded Cornell and the Duchampian transformation of routine objects, is noteworthy and quite modern in conception. Houdini endowed regular objects with the transformative powers of illusion. Showmanship, the sparkle from the footlights, and the presence of other mundane stage props

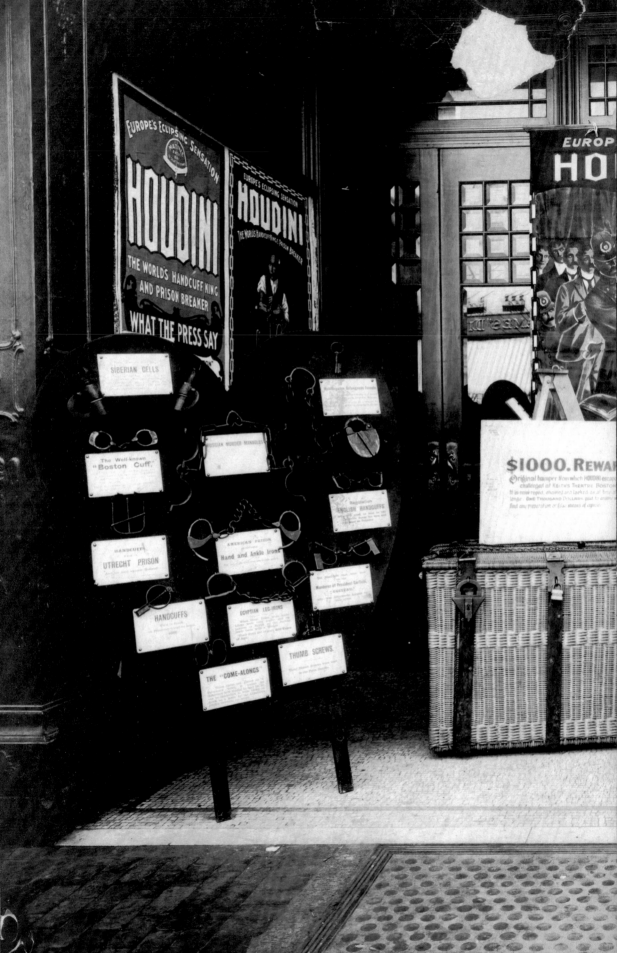

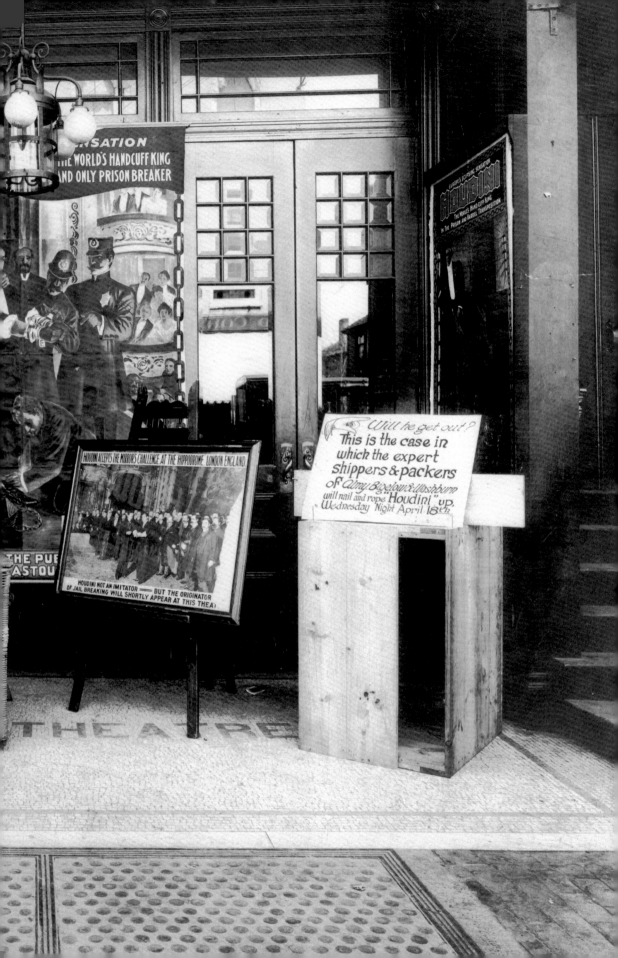

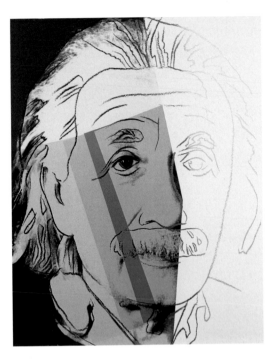

Andy Warhol
(AMERICAN, 1928–1987)

Albert Einstein, from *Ten Portraits of Jews of the Twentieth Century,* 1980. Screen print on Lenox Museum Board, 40 x 32 in. (101.6 x 81.3 cm). The Jewish Museum, New York, Gift of Lorraine and Martin Beitler, 2006-64.4

such as needles and thread, handcuffs, a milk can, a packing crate—these were the ingredients in a magic potion that intoxicated Houdini's audience. He even emphasized the verifiable quality of the objects in his act by displaying examples of them in theater lobbies for visitors to touch. The absolute power of the known object as the receptacle for otherworldly action was a force in Houdini's act.

If Houdini's performances did not attract the Ashcan School or other American realists, and his magical prowess did not move the Surrealists, neither did his celebrity take hold for the Pop artists of the 1960s, the next art movement that Houdini could have logically influenced.

Modern and contemporary artists have regularly created work based on famous people. Andy Warhol (1928–1987) began a series of celebrity paintings and prints in 1962 that drew on the artist's fascination with luminaries in popular culture. Marilyn Monroe, Elvis Presley, Elizabeth Taylor, Marlon Brando, and Princess Diana were all Warhol's subjects in his trademark style of a reduplicated, silkscreened portrait. In 1980, when Warhol created *Ten Portraits of Jews of the Twentieth Century* and included Sarah Bernhardt, Albert Einstein, Sigmund Freud, and others in his lineup of "Jewish geniuses," Houdini did not figure into the mix.[37] Jeff Koons (born 1955), who, like Warhol, personified the celebrity that he was creating, drew on famous subjects for his work, as in his porcelain sculpture *Michael Jackson and Bubbles* (1988). But Koons never created a work based on Houdini. The halftone dots in *Houdini-Pantheon (from Pictures of Ink)* (2000) by Vik Muniz (born 1961) certainly shares the formal language of Pop Art and its focus on celebrity.

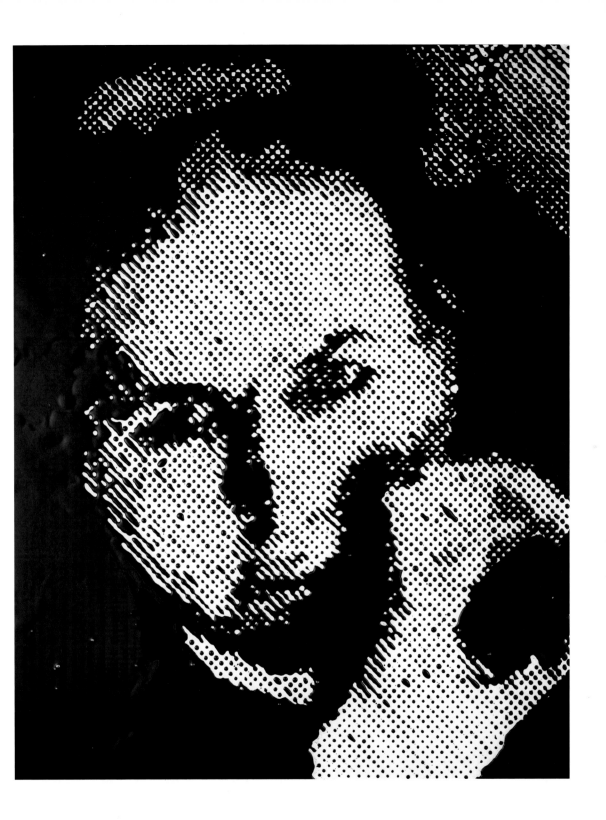

Vik Muniz (BRAZILIAN, BORN 1961)

Houdini, Pantheon (from *Pictures of Ink*), 2000. Digital C-print, AP 3, 60 x 45 in. (152.4 x 114.3 cm). Courtesy of the artist and Sikkema Jenkins & Co., New York

If Pop Art's focus on popular culture and commercialism did not embrace Houdini, a Conceptual artist did. "I just got fascinated with the personality of Houdini," Allen Ruppersberg (born 1944) said recently. "And this paralleled the idea of what it means to be an artist. I think I just abstracted that a bit and used the man himself as a surrogate of an artist."[38] By the 1970s, Ruppersberg had created several works related to Houdini, including the installation *Missing You* (1972), consisting of five magic tables, with a disappearing book on four of them, and a photograph. As documented in the installation, William Gresham's 1959 biography *Houdini: The Man Who Walked Through Walls* progressively disappears (it shrinks in size) until it has completely vanished and magically appears at Denny's, a Los Angeles fast-food restaurant. The work is a humorous riff on magic using Houdini as the foil who rematerializes in a new venue. Ruppersberg and later Conceptual artists have absorbed Houdini. More recently, abstract artists and realist painters of the 1980s and 1990s have found inspiration in Houdini's conjuring. Houdini has been identified as a force whose intensity is adaptable. "Yes, he is a Rorschach," said artist Jane Hammond (born 1950), who has included Houdini in her representational painting and collage for decades. "It isn't just

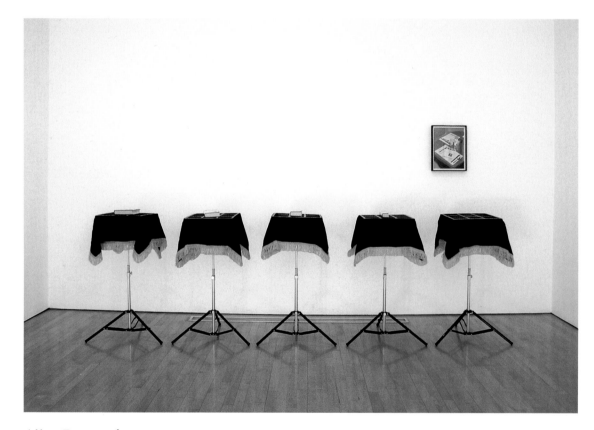

Allen Ruppersberg (AMERICAN, BORN 1944)

Missing You, 1972. Five magic tables, four books, and one vintage color photograph, overall: 68 x 138 x 30 in. (172.7 x 350.6 x 76.2 cm); photograph: 14 x 11 in. (35.6 x 27.9 cm). Courtesy of the artist and Margo Leavin Gallery, Los Angeles

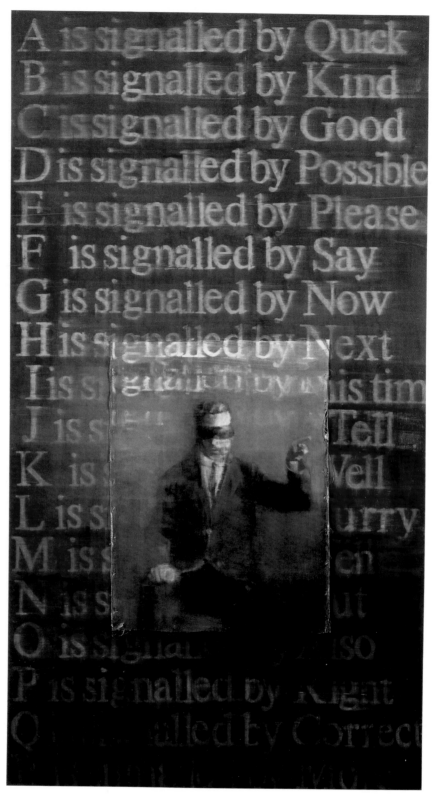

Deborah Oropallo (AMERICAN, BORN 1954)

Magician's Code, 1990. Oil on canvas, 90 x 50 in. (228.6 x 127 cm). Collection of Samuel and Ronnie Heyman

Christopher Wool (AMERICAN, BORN 1955)

Untitled (Houdini), 1985. Enamel on plywood, 72 x 48 in. (182.9 x 121.9 cm). Private collection, Seattle

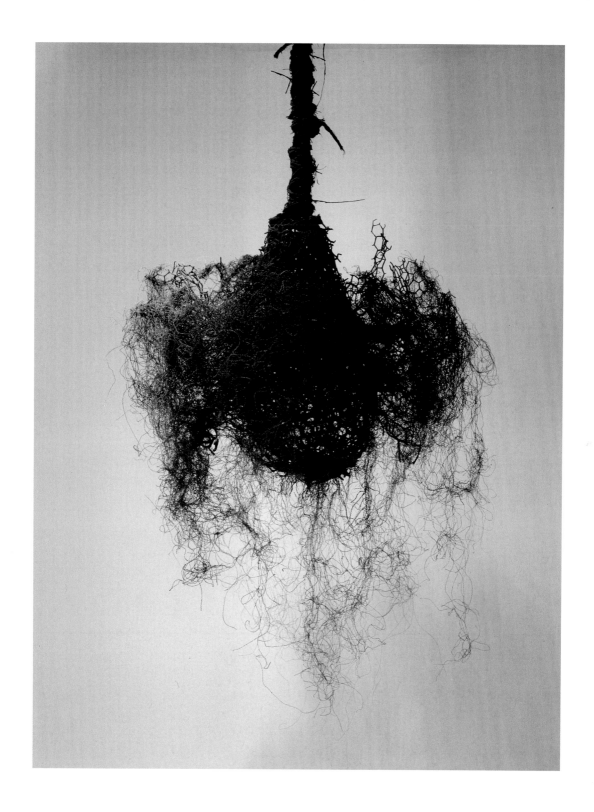

Petah Coyne (AMERICAN, BORN 1953)

Untitled #698 (Trying to Fly, Houdini's Chandelier), 1991. Mixed media, 58 x 36 x 32 in. (147.3 x 91.4 x 81.3 cm). Brooklyn Museum, Gift of the Rothfeld Family in memory of Harriet Weill Rothfeld

about what actually technically did or didn't happen in that box, it's also about how he is perceived in the public imagination."[39] In Hammond's painting *Untitled (193,184,141,109)* (1990; page 185), Houdini is poised to perform his needle-threading act. Yet rather than needles, silhouettes of two women in antebellum dress emerge. While performing this feat, Houdini straddles a tightrope, and a spotlight shines behind him. The tightrope becomes a metaphor, for Hammond conceives of Houdini as a breakthrough figure between the post–Civil War period and the modern era. In Hammond's *Untitled (221,181,275,156,227)* (1991–92; page 211), the magician huddles in a magic trunk as stage birds circle above. He whistles for the birds to return in a scene of humorous disarray.

There is a similar commotion in Christopher Wool's (born 1955) *Untitled (Houdini)* (1985), an abstract work in which black and silver gestures push the viewer to locate an unrecognizable image behind a façade of allover paint. Deborah Oropallo (born 1954) has also selected a nonrepresentational ground for her atmospheric oil painting *Escape Artist* (1993; page 203). Superimposed on that minimal white grid are repeated forms of handcuffs in the lower section of the painting, depictions of magician's hands in the upper register, and floating text reading "Handcuff King." Oropallo's numerous Houdini paintings began with her fascination with magic and the affinity between magic and art-making. She recently said: "Like painting, magic shares certain intangible qualities: illusion, sleight of hand, deception."[40] Sculptor Petah Coyne (born 1953) has also chosen an abstract language to summon both Houdini and a grim human condition. She beckons Houdini as a savior—one who can enact his magic powers to release war prisoners from their constraints. Coyne calls *Untitled #698 (Trying to Fly, Houdini's Chandelier)* (1991) "Houdini's Chandelier" because the work shares a suspended posture with the magician's escape performances. However befitting the somber predicament of the prisoners she describes, Coyne's is a dark rendition of a decorative ornament: it is black, ominous, and looming. Coyne grants Houdini the power to not only free himself, but to liberate others.[41]

That tremendous physical ability to escape constraints and the dexterity of an individual to perform superhuman feats has fascinated Matthew Barney (born 1967). Barney has been inspired by Houdini's raw agility, his endurance, and the symbolism of metamorphosis inherent in the work. Rarely has one artist gone to such lengths to interpret the work of a cultural icon for aesthetic means. The insular world in Barney's *Cremaster* series of films, photographs, sculpture, and installations includes a Houdini figure played by the author Norman Mailer (in *Cremaster 2*) and another by Barney himself (*Cremaster 5*). *Cremaster 5* recalls the triumph and tragedy of grand opera and is set in Budapest, Houdini's birthplace.[42] Houdini has mesmerized the artist who, in turn, has used myriad materials—film, plastic, wax, photographs—to summon the magician's aura. Barney's inquisitive use of various media is comparable in some ways to the methods of German artist Joseph Beuys, who similarly pushed the use of materials and who also created diverse personae in his work.

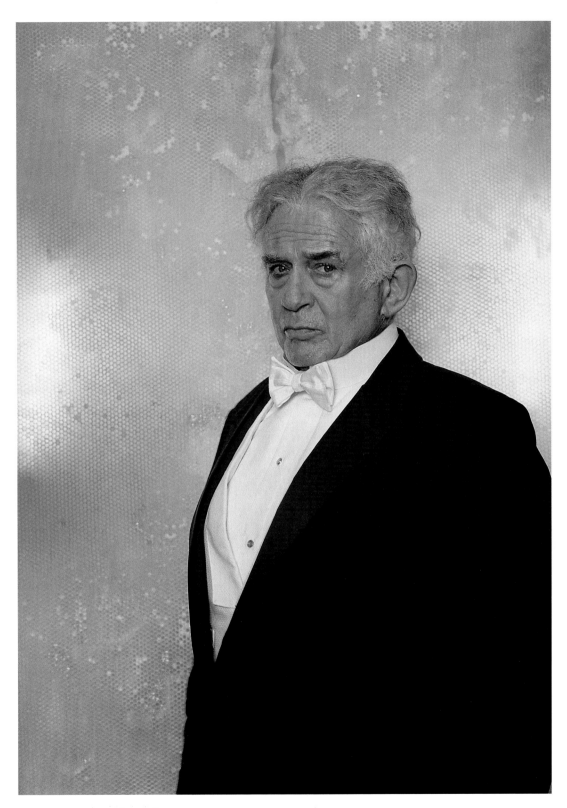

Matthew Barney (AMERICAN, BORN 1967)

Production still from *Cremaster 2* (with Norman Mailer as Houdini), 1999. Courtesy of the artist and Gladstone Gallery, New York

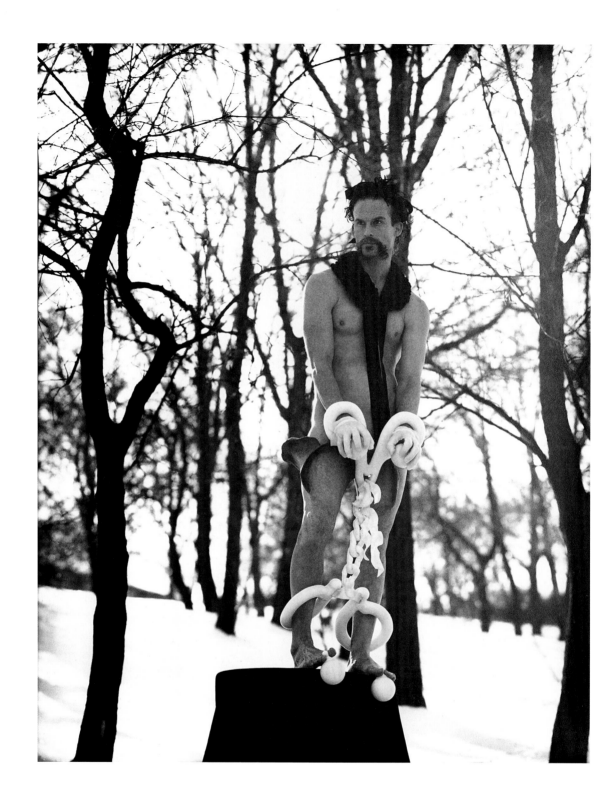

Matthew Barney

Production still from *Cremaster 5* (with Matthew Barney as Houdini), 1997. Courtesy of the artist
and Gladstone Gallery, New York

When a critic suggested a comparison between the two artists, Barney demurred, steering the discussion to Houdini: "Somehow Houdini's work might relate even more—the way he relentlessly studied and handled locks, to the extent that when a challenger imposed a foreign lock, Houdini intuitively 'absorbed' the lock, really making it an extension of his own body."[43] Barney created handcuffs and legcuffs out of prosthetic plastic and was photographed and filmed wearing them in *Cremaster 5* (1997); he has used them in a project that is an homage to Houdini, *The Ehrich Weiss Suite* (1997). The room-size installation incorporates conceits of the magician's escapes, including those cuffs and an acrylic casket. *The Ehrich Weiss Suite* is a memento mori, an environment ruminating on the brevity of life and the evanescence of fame. The *Suite* also incorporates seven live pigeons, which deface the coffin with excrement, a clear sign that nature endures while celebrity is fleeting. Barney mines Houdini's fate as well as reveals a deeper understanding of human frailty.

If Barney's objects are grand cinematic gestures, the Houdini-related drawings of Raymond Pettibon (born 1957) are episodic tales in one-panel cliffhangers (see pages 108–15). In the late 1970s and early 1980s, Pettibon's work was associated with the Los Angeles punk rock scene, where he created record album covers. His intense focus on drawing, first likened to comic books, transformed into a rich dialogue between image and text. Pettibon incorporates wide-ranging figures from mass culture into his art. The artist has mentioned Houdini, John Dillinger, Jimmy Piersall, Babe Ruth, and Lee Harvey Oswald as famous and infamous Americans who resonated in his youth. "They are archetypes, figures that I grew up with at a distance. Somehow [Houdini] resonated with me. . . . He's definitely in the Charles Lindbergh category of figures who still resonate because everything dwindles somewhere. To me, he's still vibrant."[44]

Often text surrounds image and does not follow an explicit narrative path. In one drawing, a male figure sits struggling atop a large cross and cries out a passage the artist attributes to Houdini: "I shall be quite master of spleen." And: "What I love best is making them wait, wait, wait." Pettibon has alluded to the practical aspects of Houdini's craft. In a pen-and-ink portrait of a pained figure, text above and below the face reads: "With each fading breath he (Houdini) vomited up another skeleton key. . . . What you hoard you soon spit out." In a 1991 work, the straitjacketed Houdini is trussed upside down with his back to the viewer. Text, like the surrounding clouds, billows around the figure. The words conjure an elaborate plotline—about Houdini's release from the straitjacket, his travel across town into the bed of an unnamed woman, and his escape through a

OVERLEAF
Matthew Barney

Cremaster 5: The Ehrich Weiss Suite, 1997. Acrylic, prosthetic plastic, Vivak, Pyrex, internally lubricating plastic, glass, and sterling silver; two C-prints and one gelatin silver print in acrylic frames; graphite, acrylic, and petroleum jelly on paper in acrylic frame; and seven Kite Jacobin pigeons; overall: 17 ft. 8 in. x 14 ft. 5 in. (538.4 x 439.4 cm). Sender Collection

bedroom window—in few words. The straitjacket intrigued Pettibon and has also motivated numerous artists for its inherent symbolism of confinement, restriction, and dominance. Release from that constraint is equally significant because of the implied liberation from bonds. The power of one garment to overthrow the individual resonated as much in Houdini's era as today.

Straitjacket as Metaphor

The Straitjacket Escape put a bold stamp on Houdini's career and became an iconic emblem for his fans, for the public, and for artists who would draw on this exploit decades later. When Houdini took to the urban outdoors for a free performance, one scholar wrote that he "netted the sky," a testament to his power to overcome his surroundings and become a singular form hovering above the streetscape.[45] Houdini often chose the skyscraper as a backdrop, then an inspiring emblem of American progress. The setting also promoted a dynamic contest between the human spirit and an urban symbol: a lone performer versus industrial might. Houdini always won. His first outdoor Straitjacket Escape probably took place in 1915 in front of the offices of the *Kansas City Post* and, three weeks later, at the building of the *Minneapolis Evening Tribune*.[46]

Straitjacket imagery charts Houdini's activities and documents how his turn as a contortionist has been altered and interpreted across a century in both popular and high culture. The literary critic Edmund Wilson was one of the few figures in the cultural elite who wrote of Houdini in his day. In 1925, Wilson commented admiringly on Houdini's boldness in pushing boundaries with the straitjacket performances: "It is characteristic of Houdini that, not content with the ingenuities of illusion and the perfection of sleight-of-hand, he should have chosen to excel in that branch of magic which offered the most dangerous challenge and the best chance of performing feats unlikely to be duplicated, and which also took him farthest from the masks of the theater."[47] So compelling were these aerial acrobatics in American popular life—even to an intellectual like Wilson—that, around 1917, New York's White Studio, a portrait and production agency, created a series of his straitjacket positions for sale. Houdini also regularly had one or more movie cameras in place to make black-and-white-films of his presentations.[48] The outdoor feats typically took place before an indoor stage show and often in front of the newspaper offices in the city where Houdini was to perform. It was a brilliant marketing ploy: reporters traveled just steps to get their story, photographers could lean out of the newspaper window to negotiate a close-up with front-page potential, and Houdini would sell out the house for a forthcoming magic act. Bess Houdini wrote, "To the watching reporters, just below, it seemed as if the man had no bones, or as if each bone were flexible."[49]

In the extensive documentation of his straitjacket exploits, there is a certain shared choreography. The camera pans a city street with skyscrapers, vast crowds, and halted traffic. The predominantly white male crowd wears proper hats, ties, and overcoats. On a platform above street level, Houdini first welcomes his out-

door congregation with a megaphone, or by sweeping hand gestures. He is then met by several burly men who fasten him into this unusual garment, tie his ankles, and prepare to hoist him above the sidewalk. Houdini is pulled upside down, several stories into the air. Filmmakers and photographers captured this topsy-turvy trip, Houdini's tight silhouette against the sky, wrapped in canvas and leather. It is the instant of greatest anticipation. Next, he squirms and jerks, bends at the waist, and yanks the offending jacket over his head. There are sustained seconds of footage with arms splayed and the jacket dangling before plummeting downward. Houdini often held that airborne pose to underline the tension and triumph in release. It is a hurly-burly display of swagger in the midst of escape.[50]

The Straitjacket Escape became the most chronicled and carefully managed work in Houdini's inventory, and he would even incorporate excerpts of the film footage into his stage performances.[51] Bess Houdini has, rightly or wrongly, been depicted as feeling queasy when watching these exploits. In one television movie account, she faints during a straitjacket performance.[52] The stereotypical juxtaposition pits Bess's frailties against Houdini's bravura. Ten years after Bess's death in 1943, Hollywood took hold of the straitjacket imagery and transformed Houdini from an audacious apostle of grueling physical activity into a leading man with silver-screen appeal with Tony Curtis in the title role of the 1953 Paramount Pictures film *Houdini*.[53] Although fascination with Houdini had not waned since his death a quarter-century earlier, biography segues into fairy tale as audiences hungered for a Technicolor romance between the handsome Curtis and his real-life wife, Janet Leigh, who played Bess. Critics largely panned *Houdini* for being short on fact and long on "standard screen fiction."[54] Or, as the *Chicago Daily Tribune* sniffed, Curtis "perspires a great deal during the process. . . . The film presents tricks aplenty, but in other respects it is rather soggy."[55]

That description captures Curtis's indoor escape in which, at a formal dinner, he is one of five magicians attempting to release himself from a straitjacket's bondage. Curtis's Houdini becomes weirdly fixated on a crystal chandelier prism as he contracts his body and is triumphant in his liberation. The guests cheer when Houdini emerges, his dress shirt drenched with sweat, his brow dripping, his wife adoring. Throughout *Houdini*—which includes an apocryphal denouement when he drowns because of a failed escape from the Water Torture Cell (rather than the factual peritonitis precipitated by a punch to the stomach from a student in Houdini's dressing room)—it is the love match between Harry and Bess that propels the star vehicle for the amorous Curtis and Leigh, who had married just two years earlier.[56]

Yet depictions of Houdini were not all adoring. As mainstream 1950s and early 1960s culture evolved from a postwar era of idealized family life, material excess, and upbeat mass culture into a turbulent 1970s period of cynicism and disillusionment in the aftermath of the Vietnam War and the Watergate scandal, the portrayal of Houdini changed markedly, his character syncopated with the

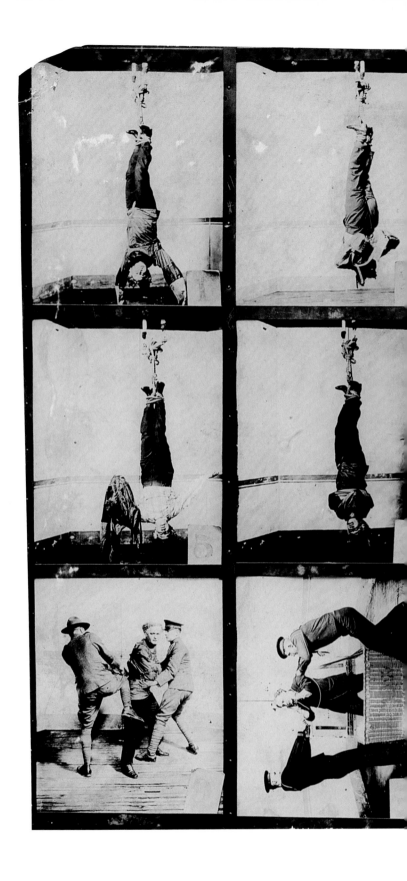

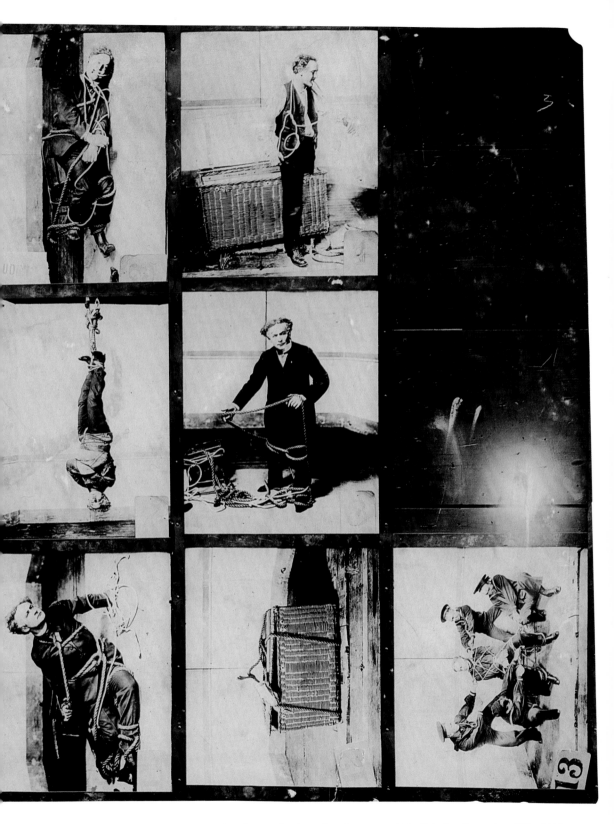

White Studio, New York, *Photographs of Houdini Escapes*, c. 1915. Gelatin silver print, 6¾ x 9¼ in. (19.7 x 23.5 cm). The New York Public Library for the Performing Arts, Billy Rose Theatre Collection

Poster for the 1953 film *Houdini*, starring Tony Curtis and Janet Leigh, released by Paramount Pictures. Lithograph, 40 x 27 in. (101.6 x 68.6 cm). Kevin A. Connolly Collection

times. E. L. Doctorow wove the character of Houdini into his acclaimed 1975 novel *Ragtime.* This was a more contemporary and complex Houdini, filled with self-doubt and inner conflict. At the outset, Doctorow writes that Houdini "seemed depressed. His success had brought into vaudeville a host of competitors. Consequently he had to think of more and more dangerous escapes."[57] Houdini is cast as uncertain, annoyed that celebrity does not provide contentment but only more anxiety related to upping the ante to maintain his fame.

In *Ragtime,* Houdini is resisted by the upper classes, "who did not respond to his art" and "made him feel foolish." He is demeaned by the immigrant family of a workman injured in digging the Brooklyn Battery Tunnel. His identity is confused by the Archduke Franz Ferdinand who, with "stupid heavy-lidded eyes," mistakenly congratulates Houdini "on the invention of the aeroplane." Houdini's attempts to interview the inventor and scientist Thomas Alva Edison are "rebuffed."[58] The collective admiration expressed by Houdini fans was too sweet and simplistic for *Ragtime.* Toward the novel's conclusion, as Houdini is hoisted skyward in a straitjacket above Times Square, the great magician is at last momentarily fulfilled by his physical and metaphorical station. "He breathed deeply

Raymond Jacobs (AMERICAN, 1923–1993)

Times Square: Houdini Movie, 1953. Gelatin silver print, 14 x 9¼ in. (35.6 x 23.5 cm). Collection of Eleanor Jacobs

and found the calmness in danger that years of physical discipline had made possible," Doctorow writes.[59] That complacency, however, was short-lived.

> Houdini had lately been feeling better about himself. His grief for his mother, his fears about losing his audience, his suspicions that his life was unimportant and his achievement laughable—all the weight of daily concern seemed easier to bear. . . . Houdini realized he was now raised to his assigned height. The breeze up here was somewhat stronger. He felt himself revolving. He faced the windows of the Times Tower, then the open spaces over Broadway and Seventh Avenue. Hey, Houdini, a voice called. The wind turned Houdini toward the building. A man was grinning at him, upside down, from a twelfth-floor window. Hey, Houdini, the man said, fuck you. Up yours, Jack, the magician replied.[60]

In this instant of peace, Houdini is taunted, derided by someone who perhaps represents the audience he struggled to maintain and compelled him to undertake increasingly dangerous escapes.

The edgier side of Houdini has had a similar appeal to contemporary artists. Several examples of the contemporary work inspired by Houdini's straitjacket performances were initially conceived as performance art, the movement that began in the 1960s and 1970s and was a branch of Conceptual Art in which the artist's body was the work's most significant prop. Of course Performance Art has different objectives from those of Houdini's stage work. His desire was to appeal to as broad an audience as possible, reaching across the cultural landscape. By contrast, Performance Art is directed primarily toward an art-world audience. Chris Burden (born 1946), who referred to Houdini in his 1970s work and whose daring, controversial performances courted danger, has summoned the brazen character of Houdini's projects. Other contemporary artists have scrutinized the performative aspects of Houdini's endeavors, and there are similarities between the way Houdini's straitjacket pieces were documented and the manner in which Performance Art is presented through photography, film, and video. It would be cavalier, however, to label Houdini the first Performance artist.

Allen Ruppersberg began his consideration of the Straitjacket Escape through a performance that evoked the complexity of Houdini's image. Ruppersberg first came to Houdini by comparing the transformative role of the artist in the studio with the magician on the stage. "I am an artist, and as an artist I can do anything," Ruppersberg explained.[61] Ruppersberg's 1972–73 performance *A Lecture on Houdini (for Terry Allen),* documented in a forty-five-minute video, shows the artist seated before a table, strapped in a straitjacket, delivering a lecture on Houdini. Ruppersberg recites Houdini's biography from a long script written by the artist as he struggles to free himself from the straitjacket buckled tight at the neck, chest, waist, and arms. His monotonous delivery of the text—he rarely looks up from the prepared manuscript—entraps the viewer in much the same

Allen Ruppersberg (AMERICAN, BORN 1944)

Still from *A Lecture on Houdini (for Terry Allen)*, 1972–73. Video. Courtesy of the artist and Christine Burgin

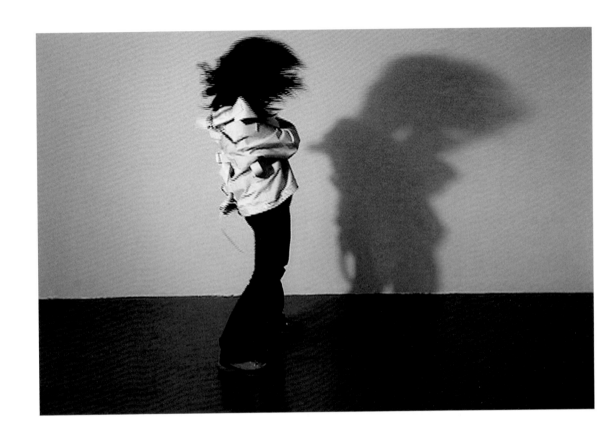

Sara Greenberger Rafferty (AMERICAN, BORN 1978)

Still from *De/Feat*, 2005. Digital video. Courtesy of the artist and Rachel Uffner Gallery, New York

way that the straitjacket envelops him. The artist has said, "This text is centered on the parallel idea of me escaping from the straightjacket and the story of Houdini and his relationship to the spiritualists who claimed they could contact the dead. It was his obsession to prove them as fakes and why—that is the essence of the text. He can't prove it and I can't escape, that is the structure of the tape."[62] Ruppersberg is never freed from the binds of the straitjacket; only when the recitation ceases is the viewer released.

Brooklyn artist Sara Greenberger Rafferty (born 1978) has put her own spin on the Straitjacket Escape and Houdini's charisma as an idealized male of great physicality. She created a series of drawings, sculpture, and a twelve-minute video document of a performance, De/Feat (2005). Through a feminist lens the artist strives to put herself *into* the straitjacket, a reversal of the Houdini escape. As Houdini and then Ruppersberg struggled to release themselves from the jacket whose long sleeves were wrapped around the upper body, Rafferty pulls the buckles in place with her teeth. Once secured on her torso, she throws the jacket off and walks away as a sign of ultimate rejection, perhaps a brush-off to the male club. Rafferty, who said that "Houdini is with me in my studio pretty much all the time," has noted that she identifies with his being "a tiny person, a Jewish man, and an immigrant."[63]

Vancouver-based Tim Lee (born 1975) performed an in-studio piece to realize his photograph, *Upside-down Water Torture Chamber, Harry Houdini, 1913* (2004; page 229), which seems to combine two of Houdini's punishing feats: the straitjacket and Water Torture Cell escapes. The artist engaged a crew from the Canadian troupe Cirque du Soleil and was rigged upside down in a wooden chair and bound to rehearse over and over. "I spent an entire day going up and down, up and down," he said recently, describing the creation of the image.[64] In the large photograph, Lee is tied to a chair while reading a book by Earthwork artist Robert Smithson. The book appears to be inverted because the photograph was taken with Lee upside down and then righted. As in Cindy Sherman's images of herself in costume, Lee becomes the unintentional, or second, subject of his photographs. Lee, who has paid homage to other cultural figures such as Steve Martin and rock singer Iggy Pop, concocted this "absurd [Houdini-like] scenario" to consider the "idea of destabilizing your own perspective in order to come across a more appropriate one."[65] He conflates Houdini and Smithson to establish an illogical duo of mythic figures. Lee's work, conceptual in nature, differs from those who rely on historical imagery to realize a more literal interpretation of Houdini.

Whitney Bedford (born 1976), a California painter, created a series of life-size portraits based on the escape artist. *Houdini (Upside Down)* (2007; page 239) is a six-foot-tall painting that captures the moment when Houdini extends his arms after releasing the straitjacket from an elevated perch. A cable, securing his feet to a pulley, bisects the figure's form. Bedford calls Houdini the "patron saint" of magic and has described how her childhood fascination with magic continued into her adult years.[66] She has collected books and literature and consulted the

image bank on the Library of Congress Web site in her search for Houdiniana. *Houdini (Upside Down)* is an example of a contemporary artist's faithful use of a period image: her color palette even mimics the black-and-white film of historic photographs. Yet unlike those newspaper and documentary photos, Bedford has eliminated any background—the viewer confronts Houdini exclusively, without reference to skyscrapers or crowds. The image is painted with ink and oil on unprimed paper so that they seep into the ground. According to the artist, "The piece is actually being destroyed—the image is actually disappearing before your eyes. . . . The pigment will sink into the paper and get an oil ring around it. . . . That is the idea: that they actually disappear. It supersedes the idea of Houdini, but Houdini would probably approve of the idea of the disappearing portrait."[67] Bedford not only encapsulates Houdini as a showman of escape, but her painting's physical status is endowed with parallel symbolism.

While Bedford's work captures the ecstatic moment of escape from the straitjacket with Houdini's back to the viewer, *The Man Who Walked Through Walls (Harry Houdini)* (1995) by Joe Coleman (born 1955) also presents his subject in a straitjacket in a fully frontal view. Rather than reiterating Houdini's adroitness, Coleman shows us a placid escape artist who emerges from a portrait of his mother, Cecelia Weiss. "He's growing out of her head," the artist said recently. "I thought of a gender switch: like Zeus giving birth to Athena. Houdini is coming out of her head or mind."[68] Coleman's methodical painting process—he uses a jeweler's lens, taking eight hours to complete one square inch of canvas or Masonite—creates a complete biography in a single painting. Houdini is at the scene's center and his mother primes the story with her presence. Within this "miniature world" are Houdini's airplane (which he flew in Australia in 1910), the Brooklyn Bridge (alluding to his famous bridge jumps), handcuff escapes, and the Water Torture Cell. A pocket-sized Bess stands at his right side, in cape and costume, saluting her husband.

Coleman has said that although the spotlight is trained on Houdini, the work is also a self-portrait. "They're all biographical and autobiographical, even when I'm not doing a self-portrait," he explained. "It's almost like method acting where I become Houdini. . . . There was one performance where I hung upside down over the audience. The priest robe that I wore for that performance is mounted between the frame and the actual painting."[69] The fetishistic nature of affixing a performance costume to a painting may be an extreme example of an artist who has summoned Houdini in his work. It underscores the physical connection to their subject that Coleman and other contemporary artists have had when conjuring Houdini.

The diverse contemporary practices related to Harry Houdini are perhaps an unexpected legacy of the magician. Certain media—literature and film—correspond precisely to Houdini's own ventures as a writer, published author, filmmaker, and media star. Distinguished twentieth- and twenty-first-century literary works

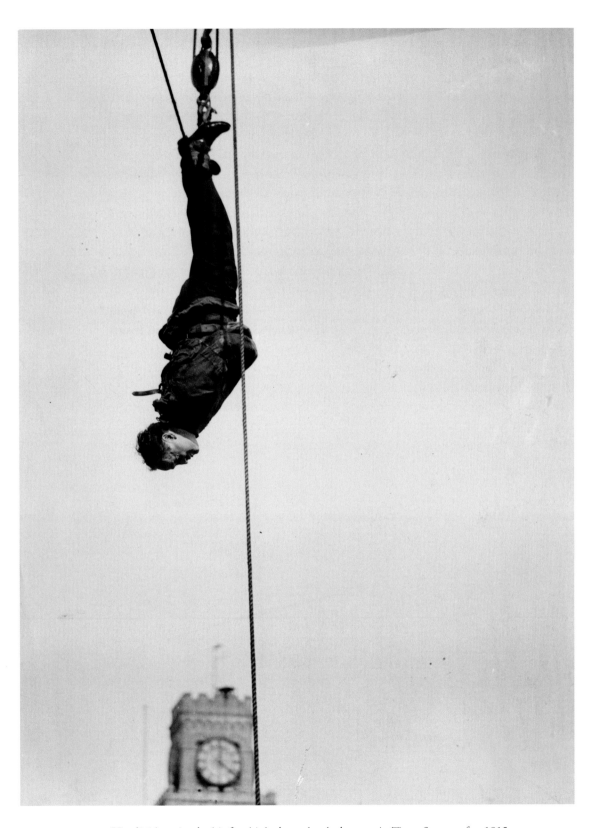

Houdini hanging by his feet high above the clock tower in Times Square, after 1915.
Photograph, 13 x 9½ in. (33 x 24.1 cm). Museum of the City of New York, Gift of Mr. and
Mrs. John A. Hinson

such as Isaac Bashevis Singer's *The Magician of Lublin* (1960), Doctorow's *Ragtime* (1975), and Michael Chabon's *The Amazing Adventures of Kavalier and Clay* (2000) have included fictional characters based on Houdini. And the spate of twentieth-century Hollywood and television films—in which Houdini has been played by Tony Curtis, Harvey Keitel, Paul Michael Glaser, and Guy Pearce—could have been foreseen. Yet a select group of painters, photographers, performance artists, and cutting-edge filmmakers have also been profoundly inspired by Houdini. Their fascination extends to several aspects of his performance: the daring use of his body as his greatest prop, the boldness of his stage and outdoor presentations, the deep-seated human fear of confinement, and his international celebrity.

Houdini's reputation evolved during his lifetime and has continued to do so since his death on October 31, 1926. After bursting onto the world stage at the turn of the last century, imagery of Houdini's fame, audacity, and mortality has been continuously modified, always reflecting contemporary culture. Artists in his day could not claim the gift of hindsight that contemporary artists have when channeling Houdini. Today, his venturesome core has been restored by vanguard artists. Magic collectors clamor for Houdiniana at auction, biographers still scrutinize the archive in the Library of Congress, and even now Broadway looks to Houdini for his crowd appeal. Alongside this hoopla, artists are mindful of the words he used to close his performances: "Will wonders never cease?" Through a diversity of formal and symbolic means, artists have interpreted and sustained Houdini's fundamental role: endowing the everyday with illusion and mystery.

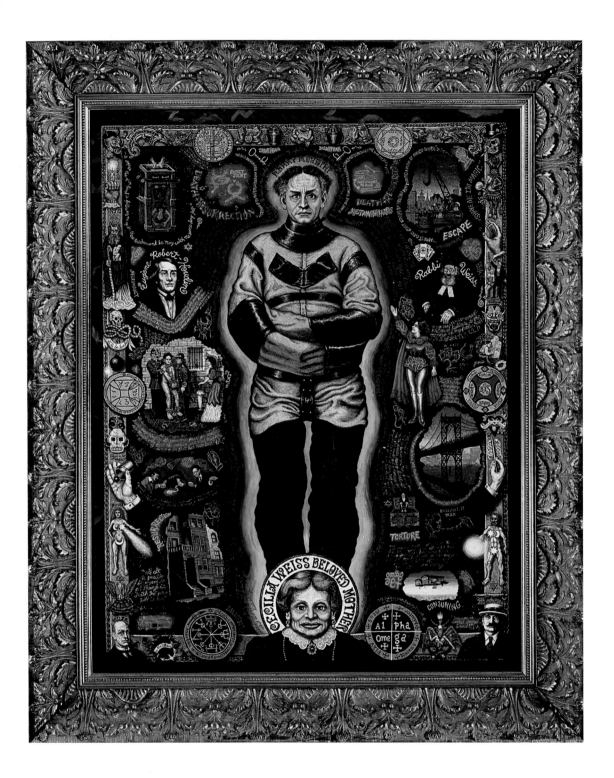

Joe Coleman (AMERICAN, BORN 1955)

The Man Who Walked Through Walls (Harry Houdini), 1995. Acrylic on Masonite,
26 x 20 in. (66 x 50.8 cm). Collection of David and Rhonda Denholtz

The Immigrant World
of Harry Houdini

Alan Brinkley

E hrich Weiss, who later became Harry Houdini and one of the most famous men of his time, was a product of the vast waves of immigration that transformed nations around the world.[1] His father, Mayer Samuel Weiss, emigrated from Budapest to the United States in 1876, leaving behind his young wife and their children—among them Ehrich, born in 1874. The family joined Mayer in 1878, once he was appointed rabbi of a small congregation in Appleton, Wisconsin—a position he did not hold for long. Like many such immigrant families, the Weisses (who as a small gesture of assimilation changed the spelling from Weisz) led an itinerant life. They relocated to Milwaukee and then to New York, but Mayer was consistently unable to find a congregation, or any other stable job. Despite his modest efforts to become more "American," he never learned to speak English, and he remained, like many first-generation immigrants, a foreigner in his new land until his death in 1892. Ehrich and his siblings early became the principal earners of the family—also a characteristic pattern for immigrant families. Unlike their father, but like other children of immigrants, they sought to assimilate to American culture. Ehrich did more than that. He lived much of his life as a symbol of what many immigrants dreamed of becoming.

By the time of Houdini's birth, the great social upheavals of the new industrial age were producing population movements all over the world, both between nations and within them. The United States was not the only country receiving massive numbers of foreign immigrants. There were major influxes of new peoples into, among other places, Argentina, Brazil, Canada, Australia, and South Africa. But the United States, with its rapidly growing industrial and agricultural economies and its image abroad as a magical place imbued with freedom, attracted more immigrants than anywhere else. There was substantial Mexican migration into the Southwest (where there was already a large native-born Hispanic society that had preexisted the attachment of much of the region to the United States). In the 1860s and 1870s, there was also a significant Chinese migration, mostly—but not entirely—on the Pacific Coast; more than 250,000 Chinese immigrants were living in the United States in 1882, when Congress barred any further immigration from China. In the next few decades, Japanese immigrants replaced the Chinese immigrants to some extent; there were more than 120,000 people of Japanese descent in the United States at the end of World War I, by which time Japanese immigration was also restricted.

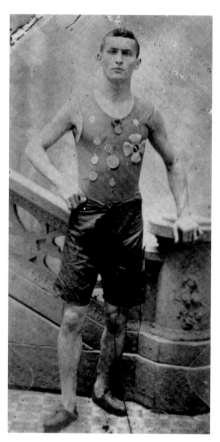

Ehrich Weiss, wearing athletic medals in New York, c. 1890. Gelatin silver print, 2 x 1⅞ in. (5.1 x 4.8 cm). Library of Congress, Rare Book and Special Collections

Flyleaf of Hebrew Bible of Rabbi Mayer Samuel Weiss, 1892. Book, 7½ x 5 x 1⅝ in. (19.1 x 12.7 x 4.1 cm). Library of Congress, Rare Book and Special Collections

College Avenue, Appleton, Wisconsin, 1867. Photograph, 5⁹⁄₁₆ x 9⁹⁄₁₆ in. (14.1 x 24.3 cm).
Appleton Public Library, Wisconsin

But the number of Asian immigrants was small compared with the great tide of immigration from Europe. Fourteen million immigrants moved to America from foreign lands in the last forty years of the nineteenth century, 13 million of them from Europe. In the first two decades of the twentieth century, another 15 million immigrants entered the United States—all but a few hundred thousand from Europe. The Weisz family's move to the relatively small midwestern town of Appleton was somewhat unusual. Most new immigrant families were concentrated in larger industrial cities, and the Weisz (now Weiss) family soon followed. By 1890, immigrants and their children made up 87 percent of the population of Chicago; 80 percent of New York; 84 percent of Milwaukee and Detroit. (In London, by comparison, 94 percent of the population was native-born.)[2]

Before the Civil War, the vast majority of European immigrants to the United States had come from northern and western Europe: Britain, Ireland, Scandinavia, Germany. During and after the Civil War, a different group of Europeans began to join the immigrant tide. Eight percent of new immigration came from Italy; 16 percent from eastern and central Europe (Hungary, Poland, Russia). In the first decades of the twentieth century, as the older sources of immigration began to decline, the newer and eastern and southern European sources expanded. Between 1900 and 1920, more than half the immigration came from Italy and from the Austro-Hungarian and Russian empires, which included Hungary, Poland, Slovakia, Ukraine, Russia, and other Slavic nations. It included a large Jewish population as well.

Ehrich Weiss at age eight, 1882. Photograph, 7 x 4¾ in. (17.8 x 12.1 cm). Harvard Theatre Collection, Cambridge, Massachusetts, Gift of George B. Beal

Immigrant life may have been better for many people than life in the countries they had left. But being an immigrant in America in the late nineteenth and early twentieth centuries was almost always difficult and often humiliating. One reason for that was the extraordinary hostility that newcomers often met from "older stock" Americans. The antipathy to foreigners helped create a significant anti-immigration movement, which had religious, political, and cultural sentiments and organizations behind it. This movement embraced great, and often irrational, fears—anti-Semitic fears of an international Jewish conspiracy; anti-Catholic fears of the presumedly growing power of the pope; eugenic fears of the way new immigrants would intermarry with the older-stock population and "pollute" the native gene pool; fears of crime and disorder from the teeming masses of "riff-raff." These anti-immigrant groups were not made up of marginal, uneducated people. They included some of the most prominent figures of their time.

Almost all of the concerns of the anti-immigrant movement were apparent in *Our Country* (1890), a book by Josiah Strong—an eminent Presbyterian minister, an active reformer, and a strong opponent of unregulated immigration. He wrote:

Jacob A. Riis (AMERICAN, BORN DENMARK, 1849–1914)

Necktie workshop in a Division Street tenement, c. 1890. Photograph, 4 x 5 in. (10.2 x 12.7 cm).
Museum of the City of New York, Jacob A. Riis Collection

The typical immigrant is a European peasant, whose horizon has been narrow, whose moral and religious training has been eager or false, and whose ideas of life are low. Not a few belong to the pauper or criminal classes. . . . Immigration not only furnishes the greater portion of our criminals, it is also seriously affecting the morals of the native population. . . . Most foreigners bring with them continental ideas of the Sabbath, and the result is sadly manifest in all our cities, where it is being transformed from a holy day into a holiday. But by far the most effective instrumentality for debauching popular morals is the liquor traffic, and this is chiefly carried on by foreigners.[3]

Even some eminent progressives joined the anti-immigrant movement. Edward A. Ross, a distinguished sociologist of the early twentieth century, and a progressive scholar and reformer, feared the impact of the new population:

That the Mediterranean people are morally below the races of northern Europe is as certain as any social fact. Even when they were dirty, ferocious barbarians,

Jacob A. Riis

A vegetable stand in the Mulberry Street Bend, c. 1890. Photograph, 4 x 5 in. (10.2 x 12.7 cm). Museum of the City of New York, Jacob A. Riis Collection

these blonds [the Aryans] were truthtellers. Be it pride or awkwardness or lack of imagination or fairplay sense, something has held them back from the nimble lying of the southern races. Immigration officials find that the different peoples are as day and night in point of veracity. . . . Nothing less than venomous is the readiness of the southern Europeans to prey upon their fellows.[4]

In 1887, Henry Bowers—a self-educated and somewhat paranoid lawyer consumed with fear and hatred of Catholics and Jews—founded the American Protective Association, an organization committed to barring further immigration. By 1894, it had half a million members. In that same year, a group of distinguished Harvard alumni founded a more genteel organization, the Immigration Restriction League, based in Boston and dedicated to the belief that immigrants should be carefully screened through literacy tests and other standards that might separate the desirable from the undesirable. In 1924, two years before Houdini's death, Congress passed the National Origins Act, which dramatically restricted immigration and gave preference for the remaining quota of immigrants to people from northern and western Europe.[5]

Another indication of the growing fear of foreigners can be seen in a pair of Supreme Court decisions before and after World War I, which used spurious scholarship to begin defining "race." Determining who was white was a longstanding preoccupation of many Americans, mostly focused on African Americans. But in the last decades of the nineteenth century, anti-immigrant groups began to make legal distinctions among other groups whom they sought to bar from entry or marginalize once they arrived. In the first decades of the twentieth century, the courts created new racist criteria for citizenship. In 1922, for example, the Supreme Court upheld a lower-court decision denying citizenship to a Japanese immigrant, Takao Ozawa, who had emigrated twenty years earlier. Ozawa argued that he was being barred from citizenship because of the color of his skin, but that in fact his skin was as white as, perhaps even whiter than, that of many "white" citizens. The court argued in its decision that judging a person's "whiteness" by skin color was not possible, and thus that color alone was not sufficient to define it. The court turned instead to the concept of the "Caucasian race."[6]

Three months later, in ruling on the application of a native of India to become an American citizen, the court went further. The applicant, Bhagat Singh Thind, taking his cue from the *Ozawa* decision, argued that he was entitled to citizenship because Asian Indians were officially classified by anthropologists as Caucasians. The question posed to the appeals court was: "Is a high caste Hindu of full Indian blood . . . a white person?" The court said no. "The average man knows perfectly well," it ruled, "that there are unmistakable and profound differences between them." That decision provided a legal basis for defining "whiteness" in whatever way the public and the courts wanted, and made it possible to include under the label "nonwhite" not just Africans, Native Americans, Asians, and Indians—but also Italians, Slovaks, Poles, and Jews.[7]

The hostility to Jews in America was particularly strong, especially after the great wave of new Jewish immigrants from eastern Europe in the late nineteenth century. These were poorer, less educated, and more insular people than earlier Jewish immigrants, and what many old-stock Americans considered their strangeness inspired a tremendous wave of anti-Semitism. They received no welcome from the established German Jews, who had adapted to American ways as an antidote to anti-Semitism. The arrival of these more "foreign" cohorts of Jewish immigrants threatened the precarious assimilation of the German Jews almost as much as that of the newer immigrants. Jews were barred from hotels, restaurants, and many stores, assimilated or not. They were barred from beaches and parks. "We cannot bring the highest social element to Manhattan Beach," the developer of one beach said, "if the Jews persist in coming." In the 1880s, the *New York Tribune* noted: "Numerous complaints have been made in regard to the Hebrew immigrants who hung about Battery Park. . . . Their filthy condition has caused many of the people who are accustomed to go to the park to seek a little recreation and fresh air to give up this practice. The immigrants also greatly annoy the persons who cross the park to take the boats to Coney Island, Staten Island, and Brooklyn."[8] The great chronicler—and to some degree champion—of the immigrant masses, Jacob Riis, tapped another element of anti-Semitism. He said of the Russian Jewish émigrés, "Money is their God."[9]

Jews were mostly excluded from private schools and universities. In the institutions in which they were admitted, there were severe restrictions on what they could do and where they could live. In cities across the United States, Jews were barred from all but a few neighborhoods, and this helped reinforce the insularity of Jewish life and fed anti-Semitic sentiments. They were subject to long-standing stereotypes, described as "shrewd," "greedy," "deceitful," "dirty," "coarse." Perhaps most of all, they suffered from being non-Christians in an era when Christianity defined the lives of most native-born Americans.

So it was not only by choice that first-generation immigrants tended to live together in self-contained communities. Like many other immigrants, recently arrived Jews were often traumatized by the strangeness of the new land and the hostility they encountered from other Americans. As a result, they tried to live in the New World as closely as possible to the way they had lived in the Old. Houdini's father in Appleton was an example, leading its tiny Jewish community while speaking only Hebrew and German and dressing in Old World rabbinical garb. Other examples of how first-generation immigrants clung to the past were the Jewish *landsmanshaftn* of the late nineteenth and early twentieth centuries. These communal organizations were designed to keep alive in America the societies of the shtetls (villages) in the eastern European pale from which the members of the community had come. They also tried to shut out as much of the American world as possible. Members of the landsmanshaftn socialized almost entirely with one another; in some cases, they went into business with one another, often businesses serving other members of the society. As members of the landsmanshaftn

grew old, they focused much of their remaining energies on ensuring that when they died, they would be in the same cemetery with fellow members.[10]

But not all immigrants remained so insular and ethnically exclusive, as Houdini's life makes clear. For there was another response to immigration, a response characteristic of the second and third generations of immigrant families. That was assimilation—the relentless effort to become "American." For some members of ethnic families, assimilation became almost an obsession. They repudiated as much of the Old World as possible. They learned English, and often jettisoned their native languages. They abandoned traditional dress. They changed their names. (Houdini himself adopted a name that suggested foreignness, but not Jewishness, just as his family had changed the spelling of their name earlier.) Many assimilating immigrants were determined to succeed in the New World on America's terms. They absorbed the capitalist work ethic and the Horatio Alger myth of easy social mobility.

Assimilation was not always easy, as Abraham Cahan—a Jewish socialist labor activist and editor of the Yiddish newspaper the *Forward*—made clear in a notable 1917 novel, *The Rise of David Levinsky*. Levinsky is a young Jewish immigrant who spends several agonizing years as a "greenhorn" in New York before finally discovering the secret to advancement in America—rampant, capitalist ambition. He advances quickly in the expanding garment industry in which he works (an industry dominated by Jews) and ultimately becomes wealthy, powerful, and—in his own mind at least—wholly American. He works constantly to shed his accent, to learn American slang, to adopt modern manners, and to wear American clothes. Cahan presents Levinsky's story as a tragedy—a man becoming rich and powerful and successful but ending up lonely and lost, having rejected the old ways but having formed no meaningful attachments to the new. Or as a character in "Tzinchadz," a Cahan short story, says: "I have money and I have friends, but you want to know whether I am happy; and that I am not, sir. Why? Because I yearn neither for my [new] country nor for [my old one], nor for anything else." But this dark view of assimilation reflected Cahan's own socialism and his contempt for those who became part of the capitalist world. Many immigrants, including many Jews, had no such reservations about success in the American world. They became convinced that their best chance for advancement was not insularity or rebellion but complete adaptation.[11]

Houdini was a bridge between the Old World and the New for many immigrants. He became an entertainer—a choice of work that Jews and other immigrants found more open to them than many more hierarchical business organizations. Houdini stood out not because of his choice of profession but because of his spectacular success at it. His magic acts and most of all his celebrated escapes became an integral part of American popular culture. But he also retained a deliberate level of exoticism that set him apart not just from mainstream

White Studio, New York, *Photographs of Houdini in Various Chains,* c. 1923. Gelatin silver print, 7¾ x 8¾ in. (19.7 x 22.2 cm). The New York Public Library for the Performing Arts, Billy Rose Theatre Collection

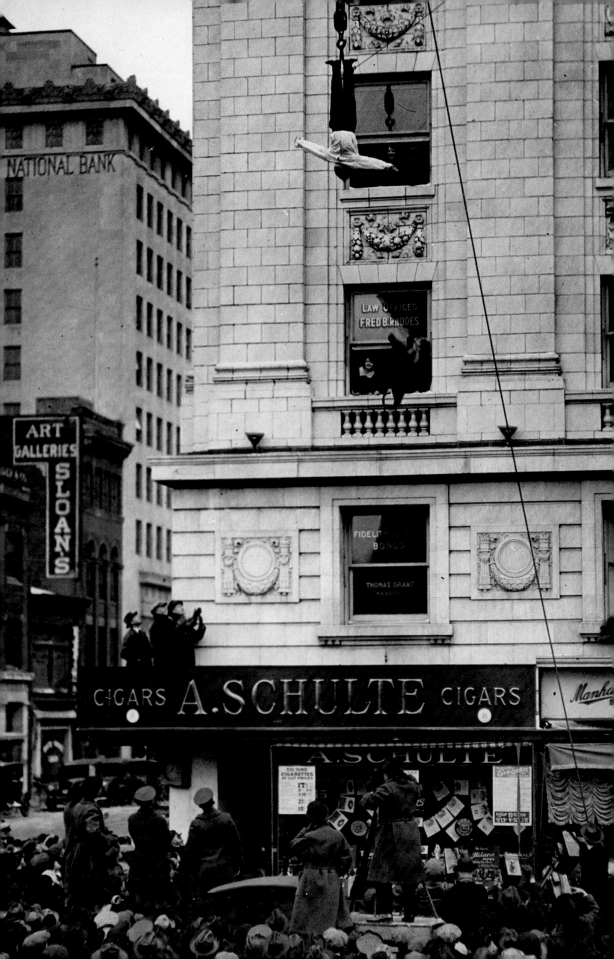

Americans but from most other immigrants as well—and helped spread his fame far beyond the United States.

Immigrants and natives alike were drawn to his acts, just as widely diverse groups of people were attracted to the enormous popular entertainments at Coney Island. Houdini's celebrity was the product in part of a new mass culture, which reached into almost every level of society. It relied on a stimulation of consumer appetites, the lure of material self-indulgence, and the aspiration for freedom and advancement. His fame was enhanced by descriptions of his feats over national radio, and by vivid photographs in the rapidly growing magazines of the late nineteenth and early twentieth centuries. America had become, as the historian William Leach has written, the "land of desire," and popular culture helped create the goals to which the urban masses, and especially the immigrant masses, aspired.[12]

At the peak of his fame, Houdini was known throughout much of the world, and many of the people who marveled at his escape acts were not even aware that he was a Jew. Nevertheless, American Jews took a special interest in Houdini. He symbolized the emergence of Jews into the larger world, and he helped them imagine their own rise to prominence in the United States and the world.

For people who felt imprisoned by poverty, prejudice, alienation, and tradition, Houdini was not just an entertainer. He was a symbol of escape from the figurative shackles that immigrants sought to shed. Industrial workers who felt chained to the assembly line could see Houdini as a symbol of escape from their drudgery. For Jews who felt frail and vulnerable in the New World, fearful of anti-Semitism and failure, Houdini—with his prodigious strength and his extraordinary talent—could be a symbol of physical power, challenging the stereotype of Jews as small and weak. He built himself into an exceptionally muscular man, and he had no inhibitions about displaying his body to his vast audiences. (His reputation as a kind of "iron man" may have helped lead him to his death—when a student at McGill University insisted on testing his strength with powerful blows to Houdini's stomach. The episode may have aggravated what was likely the untreated appendicitis that finally killed him.)

But Houdini could also be a symbol of success and upward mobility. He wore elegant clothes, shed his eastern European accent, created a polished oratorical voice, and found himself invited into homes and institutions into which Jews were not usually admitted. (Houdini did little to challenge assumptions that he was a Christian, and he remained seethingly silent when in the company of people who derided Jews.)

To the millions of people around the world who marveled at his extraordinary escapes—and to immigrants above all—Houdini was not just an entertainer.

Houdini hanging in mid-air over Schulte's Cigar Store, after 1915. Photograph, 8½ x 6⅝ in. (21.6 x 16.8 cm). Museum of the City of New York, Gift of Mr. and Mrs. John A. Hinson

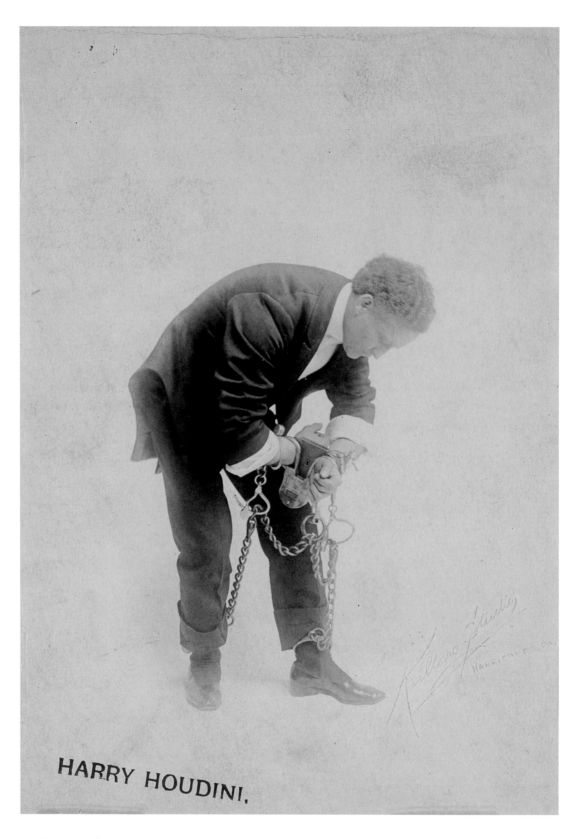

HARRY HOUDINI.

Houdini in shackles, n.d. Photograph, 7 x 5 in. (17.8 x 12.7 cm). Collection of
Dr. Bruce J. Averbook, Cleveland

Perhaps unknowingly, he was a symbol of hope. He called himself a "self-liberator," which to many people meant something more than merely escaping from handcuffs, chains, and safes. He had liberated himself from the poverty and isolation of his father's world and had embraced American ideas of social mobility and personal freedom. He was, one biography has claimed, "America's first superhero." He was, in some ways, the precursor of the sensational comic-book superheroes of the 1930s and beyond (conceived and written mostly by Jews)—Superman, Batman, the Green Lantern, and others—who represented the same kind of extraordinary strength and almost magical skills that Houdini had exhibited.[13]

In 1924, two years before his death, the humor magazine *Judge* published a cartoon that suggested what Houdini's extraordinary fame had come to mean— not just to *Judge*, but to many newly arrived Americans.[14] It portrayed a citizen gagged and bound by chains, ropes, locks, and other constraints, just as Houdini so often was. Surrounding him were signs of the many ways his life was blighted— "book, drama, and film censorship," "anti-evolution," "free speech gag," "blue laws," and "prohibition." As if to suggest that Houdini was more than a mere entertainer, that he was a true liberator who could help people escape not just from chains but also from intolerance and repression, the caption of the cartoon read: "Page Mr. Houdini!"

Cartoon from *Judge*, 1924.
The New York Public
Library

Page Mr. Houdini!

Houdini, the Rabbi's Son

Kenneth Silverman

"My birth occurred April 6th, 1874," Harry Houdini wrote, "in the small town of Appleton, in the State of Wisconsin, U.S.A." Actually, Ehrich Weiss (or Erik Weisz) was born on March 24, in Budapest, Hungary. Countless news stories about him helped establish his American origins. "Houdini is a Native American," ran a 1915 headline in the *Pittsburgh Gazette:* "He was born in Wisconsin and is a son of a Jewish rabbi of Hungarian extraction."

In fact, the professional status of Houdini's father, Mayer Samuel Weiss, is uncertain. A photo taken in America shows him wearing the four-cornered miter of German Reform Judaism. But the College of Rabbinical Studies in Budapest has no record of his having attended. Records of the Israelitische Kirche in Budapest list him as a soapmaker.

Houdini added to the confusion. A questionnaire for his entry in *The National Cyclopedia of American Biography* required him to provide a genealogy of his family. He wrote simply: "For hundreds of years descended Rabbis." Yet London's *Standard and Express* quoted him as saying, "Though my father was an Hungarian

THE ADVENTUROUS LIFE
OF A VERSATILE ARTIST

HOUDINI

The Adventurous Life of a Versatile Artist: Houdini, 1922. Private collection

Budapest from the Fortress,
c. 1870. Albumen print,
9¼ x 11¼ in. (23.5 x
28.6 cm). The New York
Public Library, Photography
Collection, Miriam and Ira
D. Wallach Division of Art,
Prints, and Photographs

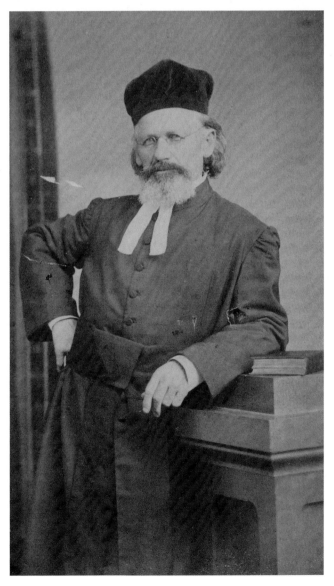

Rabbi Mayer Samuel Weiss,
c. 1875. Photograph, 4¼ x
2½ in. (10.8 x 6.4 cm). Courtesy
of Fantasma Magic Shop, New
York, www.fantasmamagic.com

lawyer, a whole generation of my ancestors were locksmiths." Mayer Samuel may have acquired the title of rabbi simply on the basis of his scholarly attainments. But personal reinvention among immigrants is recorded from at least the late first century C.E., when Juvenal, in his *Third Satire,* described the misrepresentations of Greeks seeking employment and acceptance in Rome. On my own birth certificate, my mother gave her place of birth as New Haven, Connecticut. Actually, she was born in Vilna, Lithuania.

Ehrich Weiss at nine years of age in the schoolyard, Appleton, Wisconsin, 1883. Photograph, 9½ x 7½ in. (24.1 x 19.1 cm). Collection of Dr. Bruce J. Averbook, Cleveland. The "x" indicates where the young Houdini stands.

Ehrich Weiss found life in America difficult for a young Jewish immigrant. His father hoped to work, and did after two years. Around September 1878 the family settled in Appleton, where Mayer Samuel secured a post as a rabbi. They seem to have lived comfortably at first in the growing town of nearly seven thousand. A Jewish congregation had formed a dozen years earlier, living amicably with Episcopal, Congregationalist, Baptist, and Catholic churches. Jewish-owned stores closed on Jewish holidays, and there was a Jewish cemetery. Mayer Samuel's congregation had some seventy-five members, representing about fifteen Jewish families in the town.

The German-language Appleton *Volksfreund* spoke of Rabbi Weiss as *"sehr gebildeter,"* very cultured. A learned, pious man who wrote essays and poems, he was nevertheless a failure professionally. After about four years his congregation dismissed him, by one account because they wanted an English-speaking rabbi, while he conducted services and spoke only in Hungarian-inflected German. Houdini later explained that leaders of the congregation wanted a younger rabbi than his fifty-three-year-old father: "One morning my father awoke to find himself thrown upon the world, his long locks of hair having silvered in service . . . and without any visible means of support."

Young Ehrich's family moved to Milwaukee, settling on Prairie Street, in a Jewish neighborhood. Here they did no better than in Appleton. As Houdini later summed up the experience, "Such hardships and hunger became our lot that the less said on the subject the better." Many Russian Jews were coming to Milwaukee at the time, escaping pogroms in Russia. But only a fourth of the city's five hundred or so Jewish families belonged to temples, and Jewish businesses stayed open on the Sabbath. Mayer Samuel Weiss found no settled congregation. Although he appears in city directories as "rev" or "Rabbi," neither of Milwaukee's two synagogues lists him as its rabbi. Within another year or two the city added a third and a fourth synagogue, but these do not list him as their rabbi, either.

Young Ehrich helped out the family by working as a newsboy for the *Milwaukee Journal*: "I sold [papers] every night," he later recalled, "for my father was an old rabbi, and we were dreadfully poor." Perhaps also to help out, he appeared before a circus audience as a nine-year-old trapeze performer, "Ehrich, The Prince of the Air." Houdini ever after gave the date—October 28, 1883—as the beginning of his career in show business. Still, he seems to have found his family's existence in Milwaukee intolerable. Three years later he left a note for his parents, signed "your truant son," saying that he was going to Galveston, Texas, and would return in about a year. He hopped a freight car and ended up in Kansas City, Missouri, and then back in Wisconsin, shining shoes in Delavan.

Ehrich and his family also did no better in New York City. Houdini described life in this haven for immigrant Jews as "hard and cruel years when I rarely had the bare necessities of life." Rabbi Weiss migrated to the city in 1887, taking thirteen-year-old Ehrich with him. For several months they lived in a boarding-

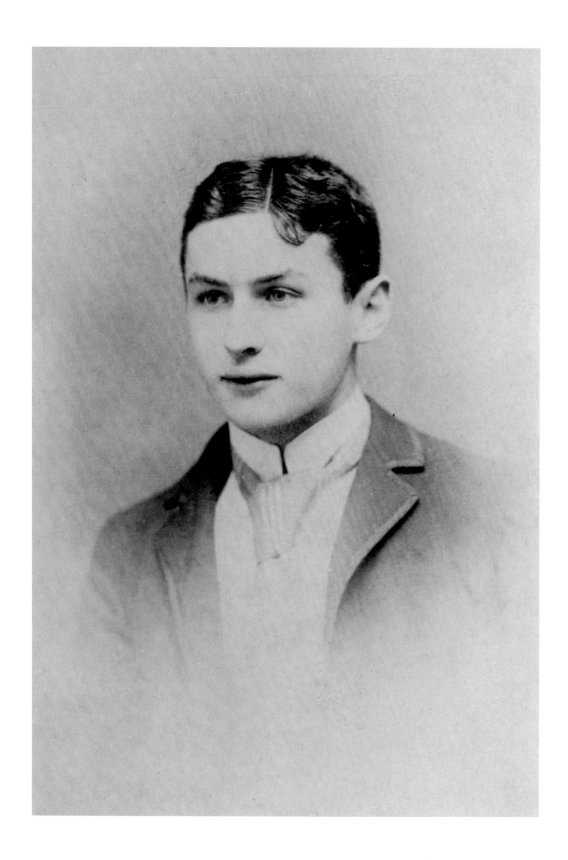

Portrait of Ehrich Weiss at age fifteen, 1889. Photograph, 7 x 4½ in. (17.8 x 11.4 cm). Harvard
Theatre Collection, Cambridge, Massachusetts, Gift of George B. Beal

house on East Seventy-Ninth Street in Manhattan, the rest of the family joining them in the city the following year. Mayer Samuel apparently sought income as a rabbinic jack-of-all-trades: "All religious Services a Specialty," his business card put it, "Marriages and Funerals, also practical MOHEL." He evidently had little such business, for he joined other Jewish immigrants in the readymade clothing industry, working at Richter's Sons necktie factory, on lower Broadway between Broome and Spring streets. Ehrich again tried to help out. After working as a uniformed messenger boy, he joined his father at Richter's as a necktie cutter.

Some five years after they moved to New York, Ehrich lost his father. Mayer Samuel Weiss began hemorrhaging from his mouth, his tongue enlarged. Diagnosed at Presbyterian Hospital on East Sixty-Ninth Street with tongue cancer, he died after surgery, of shock, at age sixty-three. His example shaped his son's interests and personality, as will be seen, and the adult Ehrich/Houdini remained devoted to him. He recorded some of his father's poems on a wax cylinder, in German, and kept a photo of the rabbi on his dressing room table.

Demeaning as it may have been, Ehrich Weiss's job at the necktie factory led him toward becoming Houdini, the mystifier whom his friend Will Rogers called "the greatest showman of our time by far." When he was about seventeen, Ehrich teamed up with a twenty-year-old fellow employee at Richter's, Jacob Hayman (or Hyman). In the 1890s, Hayman and his brother performed as Jewish comedians, singing parodies of popular songs. With Hayman, Ehrich created a magic act called "The Brothers Houdini," adopting the name of the French conjurer Jean-Eugène Robert-Houdin, considered by many the founder of modern magic.

The Brothers Houdini performed around New York, briefly toured Midwest dime museums, and may have played the Midway Plaisance at the 1893 World's Fair in Chicago. They split up, but Hayman continued performing as Houdini. The Brothers Houdini continued as well, when Ehrich took for his partner his brother Deszö, nicknamed Dash, who shared his interest in magic. Dash himself later became a well-known professional magician, Hardeen.

The Brothers Houdini became simply The Houdinis in 1894, when a young woman took Dash's place. She was nineteen-year-old Wilhelmina Beatrice Rahner, called Bess, who had worked in a song-and-dance act. That year she and Ehrich married, in Coney Island. Her mother reportedly refused to speak to her long afterward. Bess came from an immigrant German Catholic family, and as she later told a newspaper interviewer, "My mother objected to Houdini because he was Jewish."

To be both Jewish and a magician was far from unusual. Houdini explained that Jews had been performing magic since biblical times. As an example he offered the transformation of Aaron's staff into a serpent: "The theocrats of the Jews, like those of the Chaldeans, were wonderfully versed in conjuring." The long line of Jews in theatrical magic may be said to begin in the mid-eighteenth century with Jacob Meyer, who presented his trickery not only in Ireland, Portu-

gal, and Spain but also before Empress Catherine II in Saint Petersburg. When he converted to Christianity he took the name Jacob Philadelphia in homage to Benjamin Franklin.

Houdini was friendly with most of the leading Jewish magicians of his era. He considered himself distantly related to the German Jew Carl Herrmann (1816–1887), his father's first wife having been a cousin to Herrmann's first wife. Often deemed the greatest magician of his time, "The Wonder of the World," Herrmann was apparently the first magician to perform at the White House— in 1861, at the invitation of President Lincoln. At home Houdini entertained Carl's conjuring sister-in-law, Adelaide Herrmann (1853–1932). Adelaide, "The Queen of Magic," had demonstrated bullet-catching at New York's Metropolitan Opera House.

Houdini found many such colleagues among his contemporaries, mostly immigrants like him. As the Yiddish-language *Forward* headlined an article, "Leading American Magicians Are Jews." The distinguished group included The Great Leon (Leon Harry Levy, 1876–1951), a vaudeville star whose Death Ray Gun could send an assistant flying through a sheet of steel; Nate Leipzig (Nathan Leipziger, 1873–1939), a Jewish immigrant from Stockholm, greatly admired by fellow magicians for his sleight-of-hand artistry; and Ostrov-born Max Malini (Max Katz Breit, 1873–1942), who could produce a block of ice from under a borrowed hat and who gave command performances at Buckingham Palace.

Houdini became especially close to three other immigrant Jewish magicians. When young, his friend The Great Lafayette (Sigmund Neuberger, 1872–1911) had come to America with his family from Munich. His specialty was the Lion's Bride: a female assistant entered the cage of a lion, which roared loudly and prepared to pounce. Suddenly its skin dropped off, revealing The Great Lafayette. As a gift, Houdini gave his friend a pet bull terrier named Beauty. Lafayette pampered the dog, letting it sleep on velvet pillows. Four days before Lafayette was to open in Edinburgh, Beauty died of apoplexy after being overfed. The magician kept to his schedule of shows but made front-page news when he himself died four days later, consumed in a large onstage fire when he was about to change into his lion skin.

Of his two other close Jewish associates in magic, Houdini maintained a long-time friendship with Vilna-born Horace Goldin (Hyman Elias Goldstein, 1873–1939). Goldin and his family came to America when he was sixteen, settling in Nashville. In his rapid-fire act he caught live, squirming goldfish on a fishing line that he cast into the air; he also developed the sawing-a-woman-in-half illusion. Born in the Netherlands, Houdini's friend Okito (Tobias Bamberg, 1875–1963) began his career as an eight-year-old assistant to his father, who had been official court conjurer to the Dutch king William III. Remarkably, Okito represented the sixth generation of a family dynasty of Jewish magicians. He became a U.S. citizen, and at one time offered himself as a stage director to Houdini, who exchanged many letters with him. Okito toured vaudeville with his Oriental-

style act, crafted beautiful magic equipment, and invented the versatile Okito box for vanishing, producing, and transforming coins.

The line of first-rate Jewish American magicians did not end with Houdini's immigrant generation. It continues today with such performers as Ricky Jay (Richard Jay Potash, born 1948); the half-Jewish Teller (Raymond Joseph Teller, born 1948) and half-Jewish David Blaine (David Blaine White, born 1973); and the internationally celebrated David Copperfield (David Seth Kotkin, born 1956). No other magician before or since, however, has become a figure in American history, as Houdini is—a national symbol of freedom.

Quite apart from the busy world of conjuring, Houdini involved himself deeply in Jewish theatrical culture. "It is surprising," he told the *New York Times,* "how many sons of Jewish clergymen there are on the stage." He knew this well as a founder of the Rabbis' Sons Theatrical Benevolent Association, organized, he said, "in my father's honor." Its purpose, he told the *Times,* was to bring together all the sons of rabbis in show business. Members were required to aid the Red Cross, the YMHA, or a similar group by some good deed or philanthropic act. Houdini's fellow rabbis' sons in the association included its vice president, Al Jolson (Asa Yoelson), and its secretary, Irving Berlin (Israel Baline). Houdini also pledged himself to life membership in the Jewish Theatrical Guild, under its German Jewish immigrant president, William Morris, and its vice president, Eddie Cantor (Israel Iskowitz).

Houdini worked closely with Jews in the film business as well. In 1919 he signed a long-term contract with Famous Players–Lasky. This Hollywood company had been formed by an immigrant Hungarian Jew, Adolph Zukor, and the California-born Jew Jesse Lasky, who coproduced the first full-length Hollywood film. Located on Sunset Boulevard, Famous Players–Lasky employed such stars as Mary Pickford, John Barrymore, and Rudolph Valentino. Houdini made two films for FPL—*The Grim Game,* a murder mystery, and *Terror Island,* involving a sunken treasure ship—before starting his own film company.

Houdini's Jewish piety was undogmatic but respectful. During his teenage years in New York he became a pupil of Talmud Torah in a neighborhood congregation. Bernard Drachman, the American-born rabbi who bar mitzvahed him, remarked later that Houdini's "attainments" in Hebrew were "extremely weak," but that he had a "profound reverence for the Jewish faith." Houdini annually observed the day of his father's death by reciting Kaddish, the ritual Hebrew prayer of mourning, as the dying Mayer Samuel Weiss had asked his sons to do. "I have said Kaddish in twenty-five different parts of the world," Houdini noted. "No matter where I may happen to be in my professional capacity or under what circumstances I manage somehow to keep that observance."

However limited his "attainments," Houdini clearly enjoyed what he knew of Jewish custom and *mameloshn,* the mother tongue. He saved an opening-night good-luck cable wishing him simply *"Moseltoff,"* and recorded many bits of house-

Harry and Bess Houdini with other members of the Welsh Brothers Circus, 1895 or 1896. Photograph, 9¼ x 10¾ in. (23.5 x 27.3 cm). Kevin A. Connolly Collection

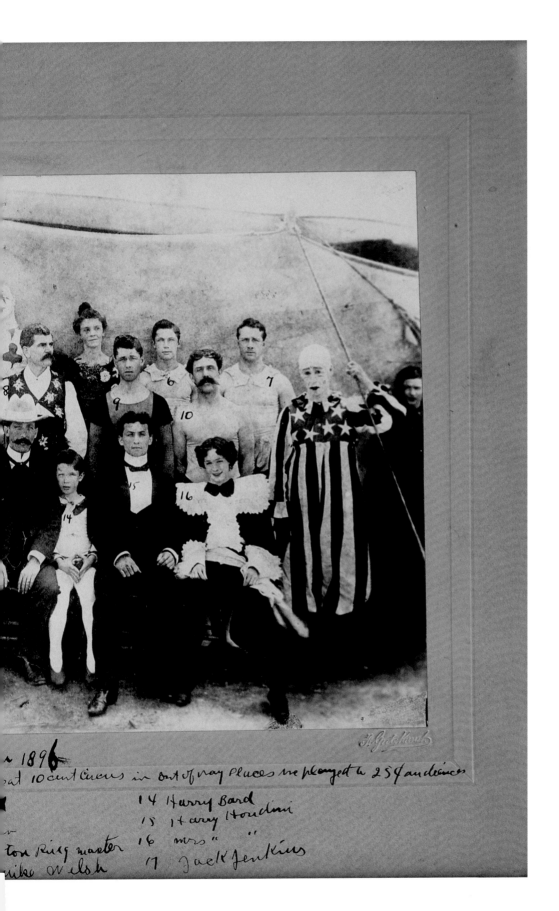

Publicity sheet from *Terror Island,* 1920. Lobby card, 11 x 14 in. (27.9 x 35.6 cm). Kevin A. Connolly Collection

"The final stand in the hut" scene from *Terror Island,* 1920. Lobby card, 11 x 14 in. (27.9 x 35.6 cm). Kevin A. Connolly Collection

hold Yiddishkeit. His letters and diaries speak of eating at a kosher restaurant with his brother Nat; of his sister Gladys's being nicknamed "Gittle"; of going with his mother to a market to buy goose fat, and of her baking noodle or potato kugel, and hamantaschen for Purim. When she fell ill, he and other family members sent her for recuperation to the Jewish Catskills, to Monticello, New York, a developing Borscht Belt town that already contained the largest theater in Sullivan County.

For all that, as an American Jew married to a Catholic woman whom he greatly loved, Houdini also enjoyed and observed Christmas. In 1919 he and Bess hosted a Christmas dinner for twenty-five guests.

Anti-Semitism always roused Houdini's indignation. "I never was ashamed to acknowledge that I was a Jew, and never will be," he wrote to a friend in 1902, "but it is awful what I hear from people that are Jew Haters, and do not know that I am a Sheeney." He preserved a pamphlet titled *The Jew: Is He a Menace to Civilization?*—a pro-Jewish work attacking Henry Ford and the *Dearborn Independent.* He collected clippings about anti-Semitism from newspapers and magazines: "Attacks on Jews Renewed in Hungary" (*New York Times*); "The Jews Innocent of the Crucifixion" (*Literary Digest*); "The Jews in Finland" (New York *Sun,* concerning the expulsion of Jews by Finnish Junkers). He clipped a newspaper item from the *New York World-Telegram* about an address in which America's renowned Christian evangelist Billy Sunday praised Jews as "wonderful people" who remained financially independent and seldom committed crimes. Some time later Houdini spoke with Sunday, who talked to him about the Bible and made him, he said, "a better Jew than I had ever been in my life."

Houdini reported on anti-Semitism himself, mostly in letters he sent from abroad for publication in the *Dramatic Mirror,* the nation's leading theatrical trade journal. Detecting a "secret feeling among the Europeans against Jews," he wrote home about charges levied against a manager of the Jubiläums theater by the "Antisimets of Vienna," and about a German comedian in Hannover who told a "very anti-Hebrew story." It was worse in Russia. How he managed to enter the country to perform for several months in 1903 is unclear, since, as he revealed to the *Dramatic Mirror,* "there are no Jews allowed to enter Moscow, and Jews are not allowed to perform on the stage of any theatre." However he got into Russia, Houdini thrilled audiences there, as he did everywhere. The *Moscow Newspaper* reported that he created a "sensation" in the spring of 1903 and that "high society of the city attend each of his performances."

Houdini's appearances in Moscow coincided with a notorious pogrom. After many violent outbursts of anti-Semitism in Russia since the late nineteenth century, April 1903 brought a massacre of the Jewish community in Kishinev, a city of about 150,000. Jews there were accused of murdering a Christian boy and using his blood to prepare matzoh. Peasants from the countryside and toughs from nearby towns joined in. Over two days of murder, gang rape, looting, and

WALTER C. JORDAN'S

National Theatre

41st Street, West of Broadway
'Phone Pennsylvania 0808
Lessees
Direction of LEE and J. J. SHUBERT
WALTER C. JORDAN and SAM S. and LEE SHUBERT, INC.

NOTICE: This Theatre, with every seat occupied, can be emptied in less than three minutes. Choose NOW the Exit nearest to your seat, and in case of fire walk (do not run) to that Exit.
THOMAS J. DRENNAN, Fire Commissioner.

WEEK BEGINNING MONDAY EVENING, DECEMBER 28, 1925

Matinees Wednesday and Saturday

L. LAWRENCE WEBER
Has the Honor to Offer
MASTER MYSTIFIER

HOUDINI

Acclaimed by Press and Public
"The Greatest Necromancer of the Age—Perhaps of all Times"
(Literary Digest)
Who Presents
AN ENTIRE EVENING'S ENTERTAINMENT
Consisting of Many Original Mysteries Never Before Equaled
in the Realm of Magic Art
"THREE SHOWS IN ONE"
Magic—Illusions—Escapes—and Fraud Mediums Exposed
NOTE—During Houdini's performance it will be necessary to invite a committee of investigators on the stage, and the management assures all volunteers that no practical jokes of any kind will be perpetrated on anyone.
Almost every experiment presented by Houdini is his original invention and creation.
PROGRAM SUBJECT TO CHANGE
In the event that challenges are made and accepted, certain features of the program will be deleted to make space for those added.
SPECIAL MUSICAL SCORE COMPOSED AND ARRANGED BY
ORVILLE MAYHOOD.

PROGRAM
ACT I.
MAGIC

The Crystal Casket	Izaak Walton Eclipsed
Conradi's Aladdin's Lamp	The Mystical Huntsman
The Magical Rose Bush	The Flying Handkerchief
Queen Bess' Bunny	Intelligent Fingers
The Arrival and Departure of Ponzi	Fleurette's Transition

DR. LYNN
Mysterious Effects That Startled and Pleased Your Grand and
Great-Grandparents

PROGRAM CONTINUED ON SECOND PAGE FOLLOWING

Advertisement for Walter C. Jordan's National Theatre for "Master Mystifier Houdini, Acclaimed by Press and Public," December 1925. Private collection

torture, crying "Kill the Jews," they and citizens of Kishinev destroyed seven hundred houses, killed forty-seven Jews, and wounded about six hundred.

Houdini visited Kishinev after the massacre, "horrified." Nothing like it, he declared, could happen in any country but Russia. In a column for the *Dramatic Mirror* two years later, he offered fellow entertainers bitter advice on managing to perform in Moscow despite the ban on Jews: "This is easily overcome by simply denying your religion . . . or you can go into Russia with a license, like a dog."

Houdini encountered a less overt anti-Semitism in his determined campaign against Spiritualism. He believed in a supreme being and an afterlife. But he also believed that spirits of the dead had no ability to contact the living. As he summed it up, "I question any claim to existence of spirits as being in any way interested, physically or mentally, in the welfare of mortal man." Around 1920, acting on this view, he began a crusade against Spiritualism that lasted to the end of his life. He exposed the trickery that mediums used to deceive and rob thousands of people every year by supposedly contacting spirits of their departed ones.

Houdini attended hundreds of séances. He employed a young woman named Rose Mackenberg to attend hundreds more and report to him. She posed as a bereaved mother or wife, under the name Frances Raud (F. Raud=Fraud).

Title page with photograph of Sir Arthur Conan Doyle and Houdini from Houdini's *A Magician Among the Spirits*, 1924. Book, 8 x 5 x 2¼ in. (20.3 x 12.7 x 5.7 cm). Private collection

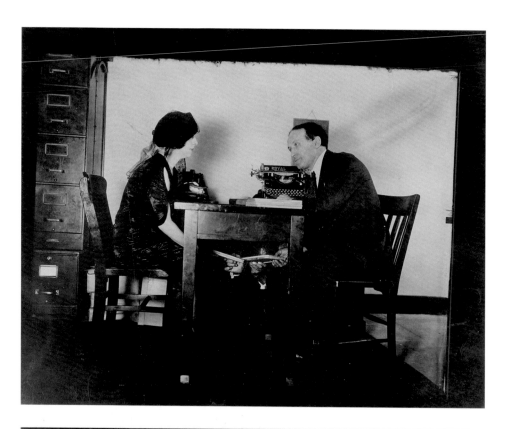

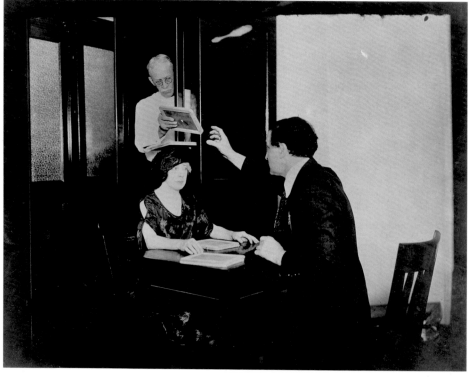

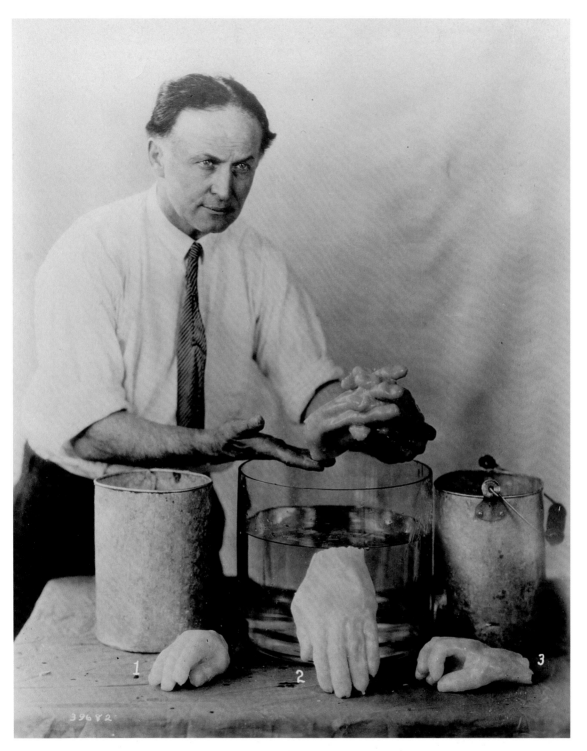

Harry and Bess Houdini exposing Spiritualist tricks, c. 1926. Seven photographs, 8 x 10⅛ in. (20.3 x 25.7 cm) or 10 x 8 in. (25.4 x 20.3 cm). Harry Ransom Humanities Research Center, The University of Texas at Austin, Performing Arts Collection, Harry Houdini Collection. In the first two photographs (opposite), Houdini, his wife, and Oscar S. Teale reveal the phony methods behind slate writing, which reputedly revealed messages from the deceased. In the remaining five images (above and on following pages), Houdini shows how "fraud mediums" made floating "spirit" hands used during séances.

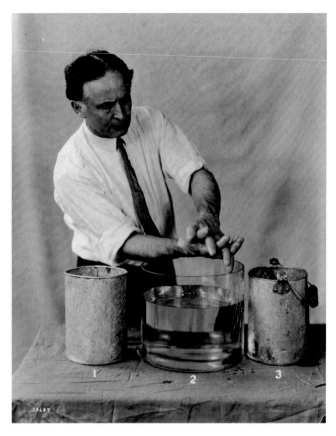

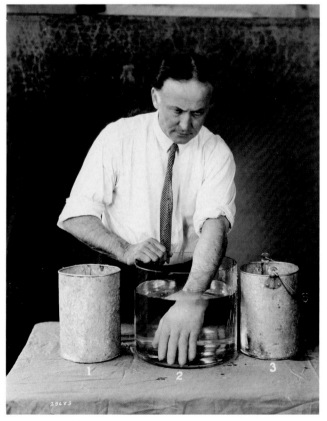

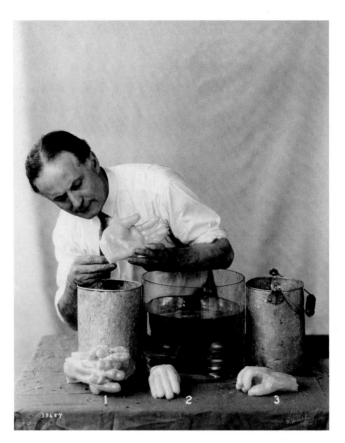

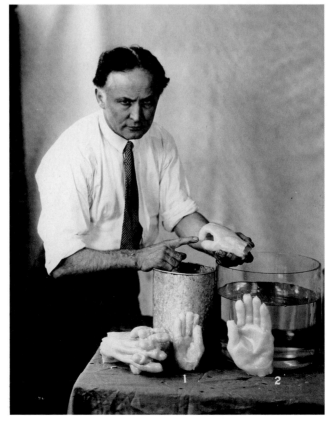

Houdini lectured widely on what he and Mackenberg learned, to detectives and rookies at the New York Police Academy, and to such groups as the New York Federation of Churches. He also forwarded to President Calvin Coolidge a petition for a government investigation of fraudulent mediums. Having become an internationally recognized authority on the subject, he brought his exposés to the stage. Audiences saw him perform methods of supposedly spirit-produced bell-ringing, slate-writing, and ectoplasm production. Reviewing his show at the New York Hippodrome theater in 1925, *Variety* wrote that although Houdini was already the "greatest showman in vaudeville today," his new act "surpasses anything he has ever attempted before on account of the world-wide interest in spiritualism."

During Houdini's anti-Spiritualist campaign, his Jewish origin came in for praise or attack. As the *New York Herald Tribune* put it, "Jew and Gentile in their churches have for centuries been figuring this battle that Houdini, the son of a rabbi, now wages in his shrewd, dogged manner." The *Forward* published an article on his exposures of mediums, and the weekly *American Hebrew* another, titled "Houdini Unmasks Spiritualism." By contrast, the *National Spiritualist* informed its readers that Houdini's real name was "Harry Weiss" and that he was "racially a Jew"; his attacks on Spiritualism were "racial bombast." Rose Mackenberg described a sitting by the Chicago Spiritualist Dr. C. A. Burgess in which he dis-

Sir Arthur Conan Doyle. Library of Congress, George Grantham Bain Collection

cussed the "Jews as bad" and commented that Houdini was a "leader of these Jews." A dark-haired young woman with a large sloping nose, Mackenberg herself was denounced by a medium named O'Malley as a "Jewess." And Houdini's much-publicized exposure of the famous Boston medium "Margery"—who called forth rosebuds and psychic lights from the spirit of her dead brother—brought anti-Semitic scorn from her husband, a surgeon who taught at Harvard Medical School: "My deep regret is that this low-minded Jew has any claim on the word American."

Houdini's Jewishness proved a trap for his friend Arthur Conan Doyle. The burly, mustached creator of Sherlock Holmes regarded Spiritualism as a replacement for Christianity. He became an evangelist for the cause after a London medium caused his son, killed during World War I, to lay a spirit hand on Doyle's head and kiss his brow. To prove his case to Houdini, Doyle offered him a private automatic-writing séance, given by his wife. In the Doyles' Atlantic City hotel suite, curtains drawn, Lady Doyle took down spirit messages from Houdini's deceased beloved mother, writing jerkily on a pad with a pencil. "Oh, my darling, thank God, thank God, at last I'm through," the messages began. Lady Doyle filled fifteen sheets with automatic spirit writing from Houdini's mother.

Doyle believed the séance impressed and moved Houdini—who in fact was unconvinced, and miffed. Among the supposed communications from Cecilia Weiss, Lady Doyle had set down a cross—a message no rabbi's wife would send. Even more improbable, the spirit communicated in English, a language Houdini's mother could neither read nor write. Doyle explained to Houdini that any trance medium might get "the Hebrew" through, but a normal automatic writer would not. He obviously did not realize that Cecilia Weiss and her family spoke not Hebrew or Yiddish at home but German—the chief language of Jews in Austro-Hungarian Budapest. Houdini always conversed with his mother in his own imperfect German. Once after he performed in Frankfurt, the local *Sonne* newspaper spoofed some of his stage patter: *"Sie musse endschuldige mein slechte Sprackm"*—You must excuse my bad speech . . . more or less.

Many of Houdini's escapes were exhausting to perform, and to keep in shape he exercised strenuously. A doctor at Massachusetts General Hospital, quoted in the *Boston Post,* judged him the "most remarkable man I ever examined. I have examined [bodybuilder Eugen] Sandow and most all of the physical wonders of the country, but Houdini is in a class by himself." A sports enthusiast, Houdini befriended the Bavarian strongman Georg Hackenschmidt, "positively the greatest wrestler in the world to-day," he said. Attending a fight in San Francisco between Jimmy Brett and lightweight champion Joe Ganz, he was pleased to be introduced at ringside. And he knew Joe McCarthy, who did sleight-of-hand himself and once appeared with Houdini on a Toledo stage before going on to manage the Joe DiMaggio New York Yankees.

For all his professional athletic interests and physical prowess, Houdini was

Title page from Houdini's *Miracle Mongers and Their Methods,* 1920. Private collection

distinctly literary and intellectual. His list of the ten works he most enjoyed began with the Bible, Shakespeare, and Boswell's life of Johnson, and contained Eugène Sue's *The Wandering Jew*—a "great story," he called it. Apart from Arthur Conan Doyle, his bookish friends and acquaintances included Carl Sandburg, who played golf with him; Jack London, with whose widow, Charmian, he had a brief affair, perhaps his only one; the journalist Walter Lippmann, the son of German Jews, who had assisted Woodrow Wilson in drafting the Fourteen Points; and the literary critic Edmund Wilson, himself an amateur magician.

Houdini traced his literary interests to Appleton. As a child there, he later explained, he devoured the biblical tales and Talmudic legends in his father's theological collection: "In those delightful hours was fostered the intense desire for books." To keep going financially in New York, Mayer Samuel Weiss had sold off part of his large Hebrew library. But he bequeathed what remained to Ehrich, and Houdini later bought back his father's set of the *Codes of Maimonides* from its owner, to keep in memory of his father.

With Mayer Samuel Weiss much in mind, "who instilled in me love of study," Houdini himself became a passionate, distinguished book collector. To his father's Maimonides he added a Bible signed by Martin Luther. In buying books he expressed not only respect for his father but also the intense patriotism he shared

with other immigrants. When he was sixteen, he said, "[Abraham] Lincoln was my hero of heroes," and later in life he "read and studied every Lincoln book that was available." In collecting Lincolniana for his library he corresponded with and visited the eminent Lincoln collector Oliver R. Barrett. Sifting the evidence about Lincoln's assassination, he bought one hundred letters of Edwin Booth, and one letter of his brother John Wilkes Booth. Among much other important Americana he bought twenty-four letters of Francis Scott Key and the writing desk of Edgar Allan Poe.

"Coming from a race of scholars," as he put it, Houdini concentrated on building two comprehensive research libraries—one of magic, one of theater. He bought magic literature from the library of the Davenport Brothers, a famous nineteenth-century magic team; from Will Goldston's collection of manuscripts; from antiquarian book dealers in Stuttgart, Edinburgh, and elsewhere. Sometimes he purchased entire libraries of magic books. He obtained choice items from the collection of London-born Henry Evans, known as Evanion. At one time a professional magician and ventriloquist, Evanion had accumulated, over a fifty-year period, a huge collection of playbills and programs, some of which he sold to the British Museum. Houdini apparently saw something of his father in the elderly Evanion. During Evanion's final illness, Houdini visited him at Lambeth Infirmary, and later made arrangements for his burial and the care of his wife.

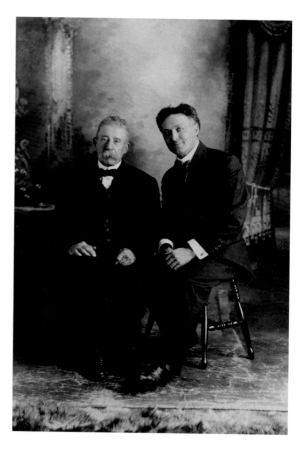

Houdini with escape artist Ira Davenport, c. 1910. Photograph, 9 x 7¾ in. (22.9 x 19.7 cm). Collection of Kenneth Silverman

The many treasures of Houdini's magic library included a letter from Buatier De Kolta, inventor of the vanishing birdcage; items from the seventeenth and eighteenth centuries; works in every European language, as well as Chinese; and playbills of his adopted father Robert-Houdin, a bookful given him by the ailing Evanion—the "central jewel of my collection." Houdini justly considered his collection a uniquely complete record of the history of conjuring and conjurers: "If all the libraries in the world were to put all their magical literature under one roof, they would not match mine."

However large and precious, Houdini's gathering of magicana was less extensive and valuable than his library of drama and theater. Fiercely competitive about collecting, as about everything else he attempted, he aimed for the top. He corresponded with A. S. W. Rosenbach and often stopped by his famous Philadelphia bookshop—the finest in the world, Houdini believed. He looked over the California library founded by the railroad magnate Henry E. Huntington, "well worth going miles to see." Especially he cultivated the friendship of Robert Gould Shaw, curator of the Harvard Theatre Collection, a world-class archive of performing arts. He visited Shaw in Cambridge, Massachusetts, invited him as a guest of honor to an annual dinner of the Society of American Magicians, and sent him rare magic books and programs to fill out the library's conjuring section, often receiving rare American playbills in return.

Houdini's theater collection came to include box after box of Covent Garden and Drury Lane programs from the mid-eighteenth century onward, and many singular or unusual pieces: a thirty-page diary of David Garrick; correspondence of such stars as Jenny Lind, Fanny Kemble, and Joseph Jefferson; a collection

Harry and Bess Houdini with actress Sarah Bernhardt, c. 1916. Photograph, 7¾ x 9½ in. (19.7 x 24.1 cm). Collection of Dr. Bruce J. Averbook, Cleveland

Society of American Magicians banquet in honor of Houdini (front row, second from right), Great Northern Hotel, Chicago, February 1922. Photograph, 14½ x 22 in. (36.8 x 55.9 cm). Collection of Kenneth Silverman

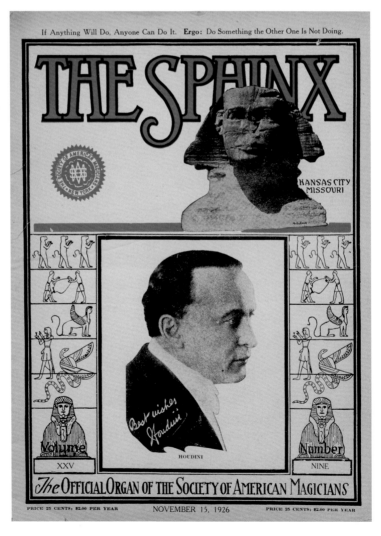

The Sphinx, November 15, 1926. Private collection

of minstrel bills and programs; and more than fifty extremely rare playbills of eighteenth-century theater in South Carolina and Virginia.

Houdini sometimes purchased dramatic material on a gigantic scale: "Programmes by the thousands, and mezzotints until you hate to go on." He claimed to have bought from the Strobridge lithography company of Cincinnati "at least four tons of lithographs of old timers of the theater. They run from the smallest size to the great big billboard size lithographs." To index and catalogue his massive collection he hired a full-time librarian, Alfred Becks, recommended to him by Shaw. Then in his seventies, a boyhood immigrant from Manchester, England, Becks had overseen the Harvard drama library for ten years. Under his new employer he found much to do. In 1925 the *New York Times* reported that Houdini had amassed "more than three hundred thousand theater programs."

Houdini believed he had the fifth-largest dramatic library in the world, outclassed only by the collections at Harvard, the British Museum, and the Huntington, and by the Shakespeare library of Henry Clay Folger, president of Standard Oil of New York. Houdini ranked his drama library, however—appraised in 1927 at half a million dollars—as "the *greatest private*" library in America, and his collection overall as "one of the libraries of the world."

A reporter from the *American Hebrew* who visited Houdini at home in 1924 saw little to suggest the dwelling of a magician. "Only books. They seemed to be imprisoned there as in a dungeon. They lined the walls on all sides, pressing against one another for elbow-room and well-nigh touching the ceiling." Houdini housed it all on the top floors of an elegant brownstone he purchased around 1910 at 278 West 113th Street, in Harlem. At the time, Harlem was home to the second-largest concentration of immigrant eastern European Jews in the United States. Three blocks from Houdini's brownstone stood Synagogue Ohab Zedek, a congregation founded earlier on the Lower East Side to serve Jewish immigrants from Austro-Hungary. Its rabbi was Bernard Drachman, who had bar mitzvahed Houdini and officiated at Mayer Samuel Weiss's funeral.

As noted earlier, Rabbi Weiss had moved young Ehrich and his family in 1887–88 from Milwaukee to New York. Despite his constant touring, Houdini became a settled and devoted New Yorker. For his fellow citizens he performed some of his most spectacular magic and escapes. Among many other miracles, he vanished a two-ton elephant from the stage of New York's Hippodrome. An estimated hundred thousand people watched him escape from a straitjacket while dangling upside down by his ankles outside the Palace Theatre. In 1916 he was nailed into a packing case, shackled, and dumped into New York Harbor. After a minute, his head bobbed out of the water, smiling, to cheers from the crowd in Battery Park. Reversing the effect, in 1926 he was soldered into a galvanized iron casket and lowered into the swimming pool of the Shelton Hotel on Lexington Avenue. He remained submerged for an hour and thirty-one minutes, without any source of air.

Feelingly, Houdini revisited the places he and his family had lived in New York. Nearly all lay in the tenement district of the East Sixties and Seventies between Second and Third avenues in Manhattan. He returned to the boarding-house at 224 East Seventy-Ninth Street where he had stayed with Mayer Samuel Weiss when he was thirteen, and the cold-water flat at 227 East Seventy-Fifth Street where they moved after summoning the rest of the family from Wisconsin. He stood half an hour in front of the tenement at 305 East Sixty-Ninth Street from which the body of his sixty-three-year-old father had been removed for burial at a Jewish cemetery in Glendale, Queens.

Houdini later bought a family plot at the cemetery. He had Rabbi Weiss's remains moved there, to lie with Cecilia Weiss and the rest of the immediate family. He marked the site with a commanding memorial exedra, a semicircular stone platform with stone benches. Costing some $40,000, it was hewn during two years of work from a thousand tons of granite from Barre, Vermont.

Houdini provided in his will that after his death a large bronze bust of himself be placed on the exedra, as it was. And as he surely knew, the cemetery took its name—Machpelah—from the ancient cave in Hebron whose adjoining field is the burial place of Abraham, Isaac, and Jacob.

Houdini at the Machpelah Cemetery in Queens, New York, where he established a gravesite for his father, mother, himself, and other members of the Weiss family, c. 1916. Library of Congress, Edward Saint Collection

Bess

The Magician's Assistant,
the Magician's Wife

Hasia R. Diner

n 1941, the Midwest Magic Service of Portsmouth, Ohio, published Geraldine Conrad Larsen's short and breezy *Diary of a Magician's Wife,* a fictionalized, humorous account of one month in the life of "Mrs. Lotta Hocus, the fascinating young wife of that famous amateur magician, Al Hocus." The author, herself the wife of a magician, wangled an introduction to her book by the most notable woman in the world of magic and the widow of America's most important magician, "Mrs. Harry Houdini." Bess Houdini's glowing words may well have helped boost sales of the book among the country's magicians and their wives, but they also revealed much about her and her relationship to both her husband and magic entertainment.

In her piece, written a decade and a half after Harry Houdini's death, Bess Houdini paid homage to the role of magician's wife and assistant that she had filled for thirty-two years. She pointed out how she and other magicians' wives, despite their auxiliary roles, always functioned as the "power behind the throne." Reflecting the reality that she had long stood in the shadows as a foil and helpmate to the world-renowned escapologist and entertainer, Bess declared that "in the past it was always the magician's life that was portrayed, but now the curtain is gently pulled aside, allowing *The Diary of a Magician's Wife* to unfold the hidden mysteries in the heart and mind of the magician's better half." In introducing the author, Houdini actually described herself, defining her role as having been that of an "active assistant to her magician husband," an aide who had "gained a definite knowledge of magic and . . . love for the mystic art." Like the author and Lotta Hocus, Bess Houdini managed, despite being "just" the assistant, to become a "full-fledged magician, booking and filling professional engagements rivaling a lot of the Old Timers." Surveying her own personal history, Bess concluded her endorsement of Larsen's book with a call for solidarity: "We magicians' wives must stick together."[1]

Although for most of her adult life she went where her husband went, did what he told her, acted as he saw fit, filled roles that suited his professional vision, and facilitated the global acclaim that he achieved as the world's greatest escape artist, Bess Houdini eventually found a place for herself among the community of magicians, on and off the stage. Her biography as such deserves scrutiny.

The comments she provided for Larsen's book may serve as an introduction to the life of Bess Houdini—born Wilhelmina Beatrice Rahner—who in her adoles-

Bess Houdini, c. 1900. Library of Congress, Rare Book and Special Collections

cence had decided on entertainment as a way to make something of herself, and then stepped aside to assist the man she married. She lived very much against the backdrop of Harry's looming shadow but spent her widowhood as an active member of the magic profession, serving as the custodian of her husband's memory, returning to the public eye as a performer on her own, and working organizationally on behalf of magic, helping to boost its place in the world of entertainment.

Wilhelmina Rahner began her life on January 22, 1876, in an immigrant German Catholic home at 192 Meserole Street, in Brooklyn's Williamsburg neighborhood, the daughter of Balbina and Gebhardt Rahner.[2] The working-

Bess Houdini in tights, c. 1894. Photograph, 6½ x 4 in. (16.5 x 10.2 cm). Collection of Ken Trombly, Bethesda, Maryland

class community, made up of German and Irish immigrants, was home to families associated with such industries as printing, glassmaking, and foundry work, as well as shipbuilding and the bustling waterborne commerce that made use of the East River on the western boundary of the area. Wilhelmina's father died during her childhood, and she grew up in a poor family that included her mother, nine sisters, and a brother.[3]

Despite the importance of religion and parish life in German Catholic urban enclaves of America such as Brooklyn, Rahner spent her adult life almost completely disconnected from that part of her upbringing.[4] Catholicism surfaced only sporadically as something of note in her life history beyond her youth. Her mother balked at Bess's 1894 marriage to Houdini, a Jew, and went so far as to sever her bonds with her daughter for more than a decade. Balbina Rahner's deeply Catholic and presumably anti-Jewish views did not, however, deter Bess from the marriage and from an enduring devotion to her Jewish husband.

Yet in one of her often contradictory narratives about her life with Ehrich Weiss—who had by 1894 appropriated the name Harry Houdini—she claimed that their marriage had been solemnized by a Catholic priest, as well as a justice of the peace and a rabbi, thus indicating either a continuing affection for the Church or a wish to placate her mother. Whether or not a priest did perform the ceremony, Balbina would not budge, and for those many years she refused to recognize her errant daughter's marriage outside the faith, and to a Jew on top of that. Mother and daughter reconciled only after Bess fell ill in 1905 and Harry went to Balbina's home, begging her to forgive and forget and come to her sick daughter's bedside.[5]

Otherwise Catholicism intruded little on Harry and Bess's life together. While not particularly observant, Harry maintained ties to Judaism and Jewishness; for her part, Bess did not manifest a similar relationship to her Catholicism. He observed the anniversary of his father's death every year, going to a synagogue wherever he found himself, to recite Kaddish.[6] On Tisha B'Av, the summer fast day commemorating the destruction of the Temple in Jerusalem, Harry paid a yearly visit, when it was possible, to the cemetery where his father and, later, his mother were buried. He belonged to the Jewish Theatrical Guild and after his death Bess continued a relationship with the group, showing up at meetings.[7]

Even after Harry's death Bess seems not to have reengaged the religion of her youth. Her scrapbooks, the best source we have of her interests, concerns, and affiliations in the years of widowhood, suggest no interest in or commitment to Catholicism. She did arrange to be buried in a Catholic cemetery, Gates of Heaven in Hawthorne, New York, but only after learning that she could not be buried next to her husband, who had been interred in the Jewish cemetery, Machpelah, in Queens, where his parents were buried. Jewish law forbade her, as a non-Jew, to lie next to him.

In their three decades together, Bess and Harry did spar over what he considered her irrational superstitions—a legacy, he believed, of her Catholic child-

hood. For Bess, ghosts really existed, rooms could be haunted, and evil spirits in fact hovered about. Curiously, for a couple who in their early years on the stage concocted acts that involved séances and summoning spirits from the dead, she believed in such matters and he sneered at them. Harry, who prided himself on his rationalism, sought to liberate her from what he considered the primitivism of her religious upbringing.[8]

If Catholicism did not shape Bess's attitudes and behaviors, the standards of Victorian respectability did. She was a slender woman, short in stature, youthful in her bearing even into middle age, and was described as a "petite soubrette." Bess subscribed unerringly to many of the sensibilities of the late nineteenth century, especially those pertaining to the appropriate behavior of a proper lady. She balked when Harry instructed her, after their wedding and her becoming the second half of the new act, The Houdinis, to don tights for her onstage role as his assistant. She considered it disgraceful to have her body exposed to public scrutiny. But Harry won out, and she put on the tights.[9] So, too, at a time when makeup marked a woman as cheap or lewd, Bess did not use cosmetics. She had no idea how to put on makeup, although she had to for her stage appearances. Maggie Cline, one of the most famous singers of her day, had to teach Bess how to apply rouge and lipstick.[10] The fact that she was a "working girl," a young woman who labored in a tailor shop owned by her brother-in-law, did not lessen her desire to conform to the social standards set for women of the bourgeois class.[11]

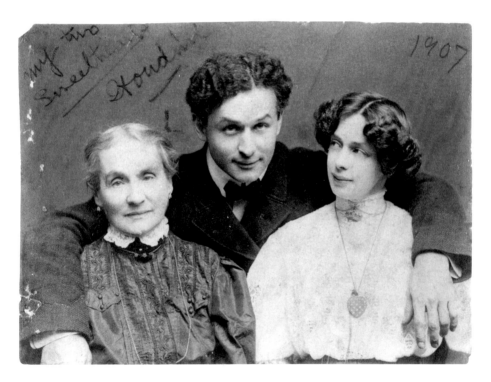

Harry Houdini with his mother, Cecilia Weiss, and Bess, 1907. Gelatin silver print, 4¹⁄₁₆ x 5⁹⁄₁₆ in. (10.3 x 14.1 cm). Library of Congress, Rare Book and Special Collections

By the later decades of the nineteenth century it had become increasingly respectable for women, under the right circumstances, not only to work in factories, offices, and department stores, but also to try their hand at the world of entertainment. Wilhelmina Rahner joined those attracted to the stage, its allure, and its wages.[12] In the 1890s, as a teenager, she joined with two other girls to form "The Floral Sisters, Neat Songs and Dance Artists."[13] One Houdini biographer, Manny Weltman, has claimed that Bess ran away from home in order to take up life as a performer and adopted the stage name Bess Raymond; other biographers have her still living in her mother's home when she became a Floral Sister and sang and danced in front of enthusiastic audiences.[14]

Whichever was true, and whether her widowed mother objected to her daughter's parading herself onstage or considered it perfectly appropriate, in the summer of 1894 Bess found herself with the two other Floral Sisters entertaining the crowds not far from her Brooklyn home, at the Sea Beach Palace in Coney Island, near the working-class resort's mammoth elephant statue. Women performers set the tone for Coney Island, giving the amusement park its distinctive flavor. In the musical venues that abounded there, women onstage helped make it, in the historian John Kasson's words, a "liberating social setting," which "loosened the rigors of a structured society simply by contrasting scenes at the resort with the city street scenes of the same period."[15]

It certainly loosened some of the inhibitions of this prim and proper young Catholic woman, and that summer, after an exceedingly brief courtship, Wilhelmina Rahner married a not very successful twenty-year-old Hungarian-born magician, the son of a rabbi, who was then performing at the nearby Vacca's Theater with his brother Theodore, known onstage as Dash.[16] Who officiated at this marriage of a Catholic and a Jew, and where did the wedding take place? Were they actually married? One account has the two married by a justice of the peace only, while another maintains that after the civil ceremony (Bess claimed she had to pay for the two-dollar license), the young couple sought out a priest and then a rabbi, presumably to soothe the possible objections of his mother as well as hers. Some accounts have speculated that the couple was never legally married.[17]

Regardless of which story is accurate, on June 28, 1894, the *Coney Island Clipper* published a brief announcement of the nuptials and informed the public of the end of The Brothers Houdini. Dash, the *Clipper* article noted, had been replaced by the petite newlywed Wilhelmina, who was now to be called Bess Houdini.[18]

By marrying Bess and by advertising the wedding as he did, Houdini followed a well-established convention in the entertainment world of his times. The circus historian Janet Davis has noted that "marriage was good publicity fodder" for entertainers, as it permitted them to engage with the public as "ordinary people" and gave them a way to generate attention with audiences, agents, and theatrical booking services. Being married and performing with his wife helped the male performer skirt the terrain between the forbidden and transgressive on the one hand, and the domestic and sentimental on the other, a necessary strategy

for entertainers and theater owners wishing to attract families as opposed to just crowds of rowdy men.[19] The historian Ronald Walters has commented that Houdini, like several other notable illusionists of his time, consciously used his wife as a partner "in a bit of on-stage domesticity."[20]

Harry Houdini drew attention not only to the fact that the act had changed and would now appear under a new name, but also to the news that it had changed from two men, presumably equals, to a man and a woman, inherently unequal, with the man clearly the dominant force. When he had shared the billing with his brother, Harry could not play the role of the "commanding male," with an assistant to help him as he needed. But with Bess on the stage and on its margins, he could showcase his masculinity, his superiority, and his entitlement to a helper. Bess, who stood less than five feet tall, could make Harry, who was only about five feet, six inches (according to his passport application), seem bigger than he really was.[21] Harry often appeared nearly naked on the stage, a stark contrast next to the demurely dressed Bess, and if she considered the tights he made her wear risqué, she in fact performed in an outfit that covered her entire body. Indeed, her costume accentuated her childishness and innocence. This, too, made Harry appear like a "real" man, in contrast to the girlishly subordinate Bess.[22]

Bess and Harry embarked on their peripatetic early career, enduring years of privation, drifting from one marginal entertainment venue to another, including beer halls, dime museums, circuses, medicine shows, vaudeville houses, dance halls, storefronts transformed into temporary entertainment spaces, even street corners. They went across the country, presenting themselves to audiences in big cities and remote hinterland towns. They slept in makeshift tents and decrepit rooms, hungry at times, often down to their last penny. They took whatever jobs they could get, performing any kind of act, publicized through newspaper advertisements and handbills, that brought in some wages. Augmenting the magic tricks and illusions in which Harry specialized and with which she assisted, Bess branched out on her own, singing, dancing, doing card tricks, and clowning. She presented herself to audiences with an affected little-girl voice that matched her childish appearance and girlish figure, a big bow in her hair.[23] At times she walked out among the crowd, hawking patent medicines to spectators, doing whatever she could to support the pair and to get their joint career on track.[24]

For all her enforced versatility, Bess functioned primarily as facilitator to Harry's magic numbers. Most important, she made possible the perfection of Metamorphosis, an escape in which Harry and Bess miraculously switched places within a locked trunk. Previously, Dash had been the one who hid inside, but the much smaller Bess provided a better and faster assistant for this act. As the signature of the Houdinis' repertoire, Metamorphosis epitomized Bess as the magician's assistant. Paid notices in local newspapers touted the spectacle and gave Bess prominent, although obviously secondary, billing. In June 1899, the *Los Angeles Times* announced that the performers appearing at the Orpheum theater were "HOUDINI, The King of Handcuffs—A veritable wonder—assisted by M'lle

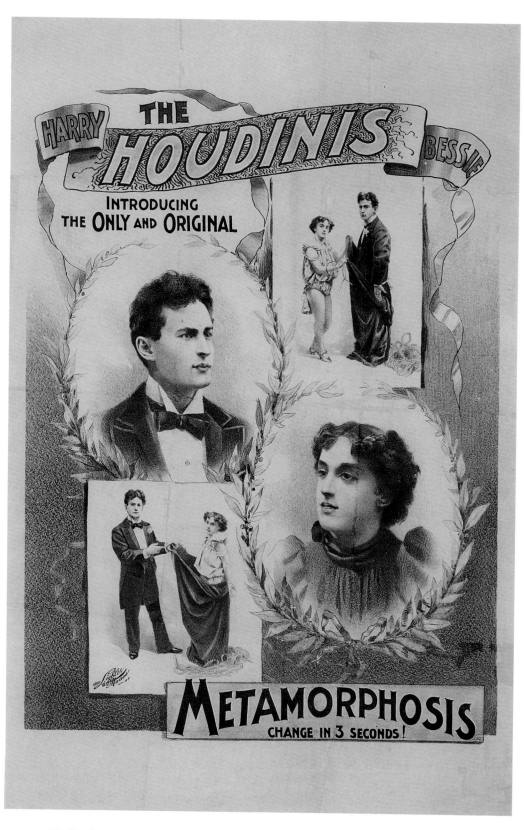

The Houdinis, Introducing the Only and Original Metamorphosis, Change in 3 Seconds! 1895. Lithograph, 31 x 22 in. (78.7 x 55.9 cm). Collection of Ken Trombly, Bethesda, Maryland

Harry and Bess Houdini in Nice, France, 1913. Library of Congress, Rare Book and
Special Collections

Beatrice Houdini. (The Trunk Mystery will startle the town.)"[25] While Harry would, by the first decade of the twentieth century, focus nearly exclusively on dramatic escapes that took place in jails, on bridges, off the sides of buildings, far from the protected space of the theater, whenever he revived Metamorphosis, Bess returned to take her accustomed place inside the trunk and at his side.[26]

In the frustrating early years they traveled extensively as an act, seemingly never ahead of where they had been the day, week, month, or year before. During this time, they also dabbled in performances of the occult. In January 1895, for instance, they toured as "Professor and Mlle. Houdini, the Occult Expositors," and did séance work to make ends meet.[27] Bess, among other duties, was the voice of the spirits called up from beyond the grave.[28]

Not until the end of the 1890s did she begin to move off the stage, although even after that she occasionally returned to be the magician's assistant, as Harry wanted.[29] By shifting from magician to escape artist, he increasingly had no need for her assistance in his act, and as The Houdinis gave way to "The King of Handcuffs," he had to be the solo male liberating himself from society's shackles.[30] While his stunts required a bevy of assistants to set up the paraphernalia and otherwise provide help, Houdini appeared in photographs and in the public eye as the self-reliant man who could overcome all the odds.[31] Including Bess or any other assistant was unnecessary when his acts emphasized "raw physical power and dramas of self-liberation," with the emphasis on "self."[32]

Despite the asymmetry of their relationship, despite the emergence of Harry Houdini as a performer whose presence could draw huge crowds on several continents, and whose name became synonymous around the world with escapology and magic, Bess continued to play a critical role in his work and his life after her official "retirement" from the stage. He depended on her in multiple ways. She managed their finances and made sure that the slovenly Harry had clean clothes to wear, and she monitored his personal hygiene, something he could not be bothered with.[33] Perhaps because they never had children, Bess mothered Harry, both before and after the death of his mother, Cecilia, to whom his devotion evidently had no bounds. Since Bess ostensibly had no activities beyond Harry and his needs, and no outside interests, they collaborated in maintaining their independence from others.

Bess and Harry, by all accounts, remained deeply devoted to each other throughout his life, and she maintained her intense bond with him even after his death. He sent her love notes and little poems, many times a day, even when neither of them left the Harlem townhouse that he bought and later transferred to her name in 1918.[34]

Bess was his sounding board, and Harry consulted with her whenever he tried to tackle a new stunt or improve on one he had already developed.[35] She traveled with him wherever he went and attended his performances, no matter how frightening she found the more dramatic and dangerous of the escapes. She served, according to one biographer, as a prime member of his "supporting cast—un-

questioningly," and their marriage constituted a "genuine partnership." Wherever Harry went, figuratively or literally, she was there to facilitate his interests and decisions.[36]

When Harry took a stab at moviemaking, Bess appeared in some of his films. When he became fascinated with the thrill of piloting airplanes, she set aside her fears and sat as a passenger in the cockpit with him.[37] In the 1920s, Harry took on fake mediums, organizers of séances, and fortune-tellers, challenging the authenticity of those who claimed that they could communicate with the spirits of the dead. This became something of a crusade for him, and in 1926 he testified before subcommittees of the U.S. House and Senate. In this, too, he enlisted Bess, as a character witness and as a prop for his flamboyant testimony. A previous witness had characterized him as "crazy," a "brute," so Harry asked Bess to speak under oath on his behalf. In one of the most unconventional of congressional hearings on record, he orchestrated the proceedings and called his wife to the stand. He declared to her and to the members of the House subcommittee that "one of the witnesses said that I was a brute and that I was vile and that I was crazy. . . . I will have been married on June 22, thirty-two years to this girl. . . . Outside of my great mother, Mrs. Houdini has been my great friend. Have I shown traces of being crazy, unless it was about you?" he asked Bess. Needless to say, she answered in the negative, defending him stalwartly.[38]

Harry set the standards for her behavior. Several biographers have told the story of how, when he and Bess were still a young couple struggling on the road, he had forbidden her to see a particular show that he found inappropriate; he threatened to send her away if she defied him. Bess did what he had forbidden, saw the show, and he followed through on his threat. "I always keep my word. Good-by, Mrs. Houdini," he told her, as he put her on a train and exiled her to her sister's home. When he later came to collect her, he explained, "Darling, I told you I would send you away if you disobeyed, but I didn't say I wouldn't fly after you and bring you back."[39] So, too, years later, at the height of his fame, a more mature Bess, at a party, reportedly sat down on the knee of another man and drank a glass of champagne with him. When Harry saw this, he reacted in horror. "His knees sagged," Bess recounted, and he fell down in "utter prostration of spirit. He wept bitterly far into the night. For days he dragged himself about, brooding and dejected."[40]

In the main, though, their lives together seem to have been harmonious. Bess voiced no obvious objection to having her life pivot around Harry. His death, on October 31, 1926, utterly transformed her life. From then on, until her own death, in early 1943, she was the custodian of his memory.

She assumed that role in a number of ways. She provided information and material to Harold Kellock for what might be considered the only authorized biography of Houdini, the 1928 *Houdini: His Life-Story,* suitably subtitled *From the Recollections and Documents of Beatrice Houdini.*[41] She faithfully clipped newspaper and magazine articles that made any reference to Houdini. She also kept track

Bess Houdini, 1928. Library of
Congress, Rare Book and
Special Collections

of the proliferating uses of his name in advertising, as well as newspaper accounts
of daring rescues and miraculous escapes that were likened to his exploits. She
monitored the numerous instances when people claiming to be the next Houdini
acted like him. The scrapbooks she carefully assembled chronicled the diffusion
of his name into the public consciousness after his death.[42] By making and then
donating these huge collections of clippings, pasted into scrapbooks, to the Li-
brary of Congress, she clearly sought to preserve his name and ensure that his
memory would not fade. Yearly she sent greetings to magic publications and to
the program books of magic conventions, invoking the memory of her beloved
Harry, "Who Went Away October 31, 1926," as she declared in a full-page ad-
vertisement in the magic magazine *The Sphinx* in 1934, one of dozens of such
statements that maintained her involvement in the magic community, helped
underwrite the publications and associations that constituted the life of the pro-
fession, and assured that Harry's memory would endure.

Bess did this also by issuing public statements to clarify or discredit claims
made by others about her husband, especially those that purported to expose the
secrets behind his bold escapes and masterly illusions.[43] She preserved Houdini's
handwritten "stacks of notes" that described his tricks, making sure that they
remained intact and became part of the historical record of magic in America.[44]

Wherever and whenever she could, she provided the link connecting the public, the magic world, and the legacy of Houdini.

She did this for a decade after his death in another, much more dramatic way. On his deathbed, Harry, the rationalist who had long chided her for her superstitions and belief in spirits, had her promise that she would try to communicate with him on the anniversary of his death, wherever he was beyond the grave. Since, coincidentally, Houdini died on October 31, for ten years after his demise Bess held an annual séance on Halloween. In 1926, upon Harry's death, she went so far as to offer $10,000 to any medium who could absolutely prove any contact made with Harry. Two years later she withdrew the offer, having been "advised by spiritualists that they could get in touch with the spirit of Houdini more easily if the reward were withdrawn."[45] So for the next eight years the Halloween-night ritual séance took place, complete with extensive press coverage. "Widow Believes Houdini Will Call," "No Word Received," and "Magician's Widow Fails to Raise the Ghost" were typical headlines; such press kept Houdini in the public's mind and helped make Bess a celebrity in her own right.[46]

It took ten years for Bess to finally defy Houdini, this time without fear of punishment or chastisement. In 1936, despite the promise she had made to him as he lay dying (which she had made without a sunset clause), she called off any further attempts to engage with him or his spirit. Too many years had passed, she said, and obviously he had no intention of making contact with her.

Breaking the vow she had made to him allowed her to focus on the last phase of her life, as she returned to the stage and performed solo in the world of magic. As early as 1927, one year into her widowhood, she announced that she would "take up his work" by bringing Houdini's Ice Trick, which involved freezing someone in a block of ice, to vaudeville. In returning to show business she combined two missions: fulfilling her own ambitions while supporting the more wifely project of bearing Harry's legacy. The *New York Times* reported, in December of that year, that for a performance "in a vacant store at 420 West Fifty-third Street . . . [Bess] planned to combine the [Ice Trick] with legerdemain from her husband's repertory, including an escape from handcuffs or a strait-jacket. When her husband was alive, she assisted him in his stage work under an assumed name. Her forthcoming appearance will be her first in the role of magician."[47]

Not for long did Bess have to scrape together an audience in a makeshift space. Within a year the *Times* was informing that "Mrs. Harry Houdini, widow of the one and only, will try Loew vaudeville, opening at the Commodore," and from then on, into the late 1930s, she was a fixture of the magic circuit.[48] She hired a business manager, Edward Saint, and embarked on a career that took her around the country, showcasing her talents in theaters and at magicians' professional gatherings. Annual meetings of Los Mágicos in Southern California, the Magicians of Southern California, the Jewish Theatrical Guild, and naturally the Houdini Club repeatedly found Bess onstage, and newspapers described her as the "Queen of Magic."[49] A flier of 1939 titled "Magicians You Should Know"

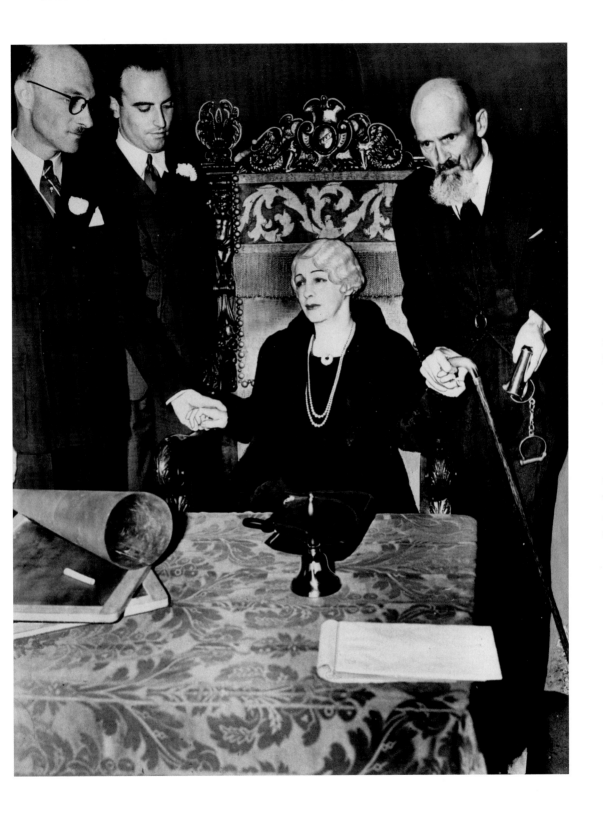

Bess Houdini with Edward Saint, her business manager (right), and Carl S. Fleming, head of the
Pacific Coast Magicians Association (far left), at the final Houdini séance, 1936. Photograph,
9 x 7⅛ in. (22.9 x 18.1 cm). Library of Congress, Prints and Photographs Division,
NYWT&S Collection

67 PAYSON AVENUE
NEW YORK CITY

28 RIDGELAND TER.,
RYE, NEW YORK

MRS. HARRY HOUDINI
1616 N. CURSON AVE.
HOLLYWOOD, CALIF.

The Oldest Living Lady Magician
in the World
Wishes You a Merry Christmas
and the Magic of
Good Health, Peace and Contentment
for the New Year
Sincerely,

Beatrice Houdini

Bess Houdini's Christmas card, 1935. Library of Congress, Rare Book and Special Collections

Bess Houdini with Edward Saint (left) and Harry Houdini's brother Theodore Hardeen (right), c. 1936. Library of Congress, Rare Book and Special Collections

featured a picture of Bess, captioned as "Houdini," demonstrating the degree to which she had become a star on the basis of her talents and as the living embodiment of her dead husband.[50]

Magic became her life, as it allowed her to achieve fame on her own, served by the name and reputation of Harry Houdini. Capitalizing on that memory was the theme of her later years. She spearheaded an effort in the late 1930s to have October 31, the anniversary of Houdini's death, declared National Magic Day.[51] She participated in performances and in the associational life of American magic as, at one and the same time, Beatrice Houdini, magician, and Beatrice Houdini, widow of Harry Houdini.

Bess died on February 11, 1943, in California, a continent away from her working-class Brooklyn birthplace. She had made a leap from being a magician's assistant to performing as a magician who stood confidently before the footlights. While Harry Houdini's name continues to embody the idea and history of magic in America and Bess has remained a shadowy side character, her life offers a lesson. Like the fictional magician's wife Lotta Hocus, Bess combined utter devotion and subservience to the man in her life; her devotion paid off and ultimately opened doors for her. As she wrote in the introduction to *The Diary of a Magician's Wife,* the story of the woman who silently assisted her husband and eventually got a chance to stand on her own at center stage resembled the arc of her experiences. That, she wrote, "is *my* story" and that of "the wife of every magician in the land."

Drawings by Raymond Pettibon

Raymond Pettibon (AMERICAN, BORN 1957)

No Title (Houdini let your), 1990. Black and colored ink on paper, 22⅜ x 10⅝ in. (56.8 x 27 cm). The Museum of Modern Art, New York, Gift of the Friends of Contemporary Drawing, 1996

No Title (With each fading), 1991. Pen and ink on paper, 22 x 10½ in. (55.9 x 26.7 cm). Courtesy of Regen Projects, Los Angeles

No Title (I shall be), 1992. Pen and ink on paper, 13 x 9½ in. (33 x 24.1 cm). Private collection, New York

No Title (All agreed that), 2009. Pen, ink, gouache, and acrylic on paper, 26 x 40 in. (66 x 101.6 cm). Courtesy of Regen Projects, Los Angeles

No Title (One arm freed), 2001. Pen and ink on paper, 18 x 12 in. (45.7 x 30.5 cm). Courtesy of Regen Projects, Los Angeles

No Title (The Desire to), 2009. Pen, ink, and gouache on paper, 30 x 22 in. (76.2 x 55.9 cm). Courtesy of Regen Projects, Los Angeles

HOUDINI LET YOUR HAIR HANG DOWN.

"I THOUGHT, IF I WERE SURROUNDED BY ENEMIES, WHO WERE VENTING THEIR MALICE AND CRUELTY UPON ME, IN TORMENTING ME, IT WOULD STILL BE IMPOSSIBLE THAT I SHOULD CHERISH ANY FEELINGS TOWARDS THEM BUT THOSE OF LOVE, AND PITY."

I KNOW THEIR DEVICES.

BOY BEATEN DOWN BY WOMAN:
"AND HOW SHOULD I HAVE CRIED, SINCE I WAS SWOONING WITH HAPPINESS WITHIN?"

WITH EACH FADING BREATH HE (HOUDINI)
VOMITED UP ANOTHER SKELETON KEY.

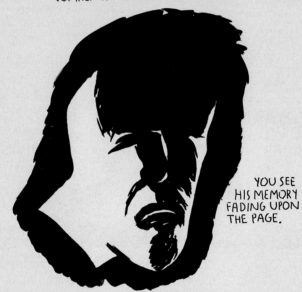

YOU SEE
HIS MEMORY
FADING UPON
THE PAGE.

A COUNTED NUMBER OF PULSES ONLY
IS GIVEN TO US OF A VARIEGATED,
DRAMATIC LIFE.

WHAT YOU HOARD YOU SOON
SPIT OUT.

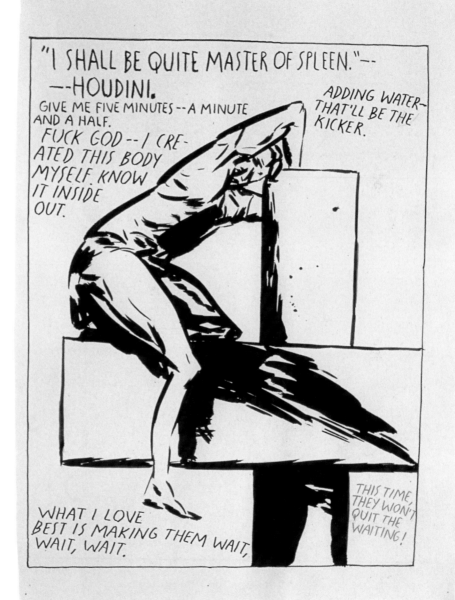

111

ALL AGREED THAT IT WAS JUST WHAT IT APPEARED TO ANODIZED ALUMINUM, SECURELY RIVETED.

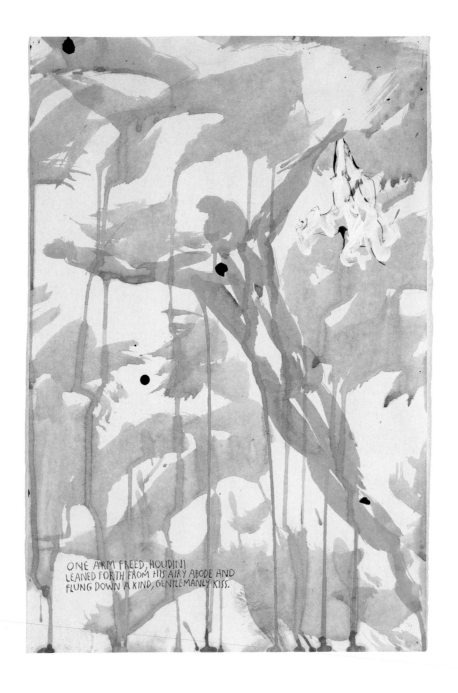

ONE ARM FREED, HOUDINI
LEANED FORTH FROM HIS AIRY ABODE AND
FLUNG DOWN A KIND, GENTLEMANLY KISS.

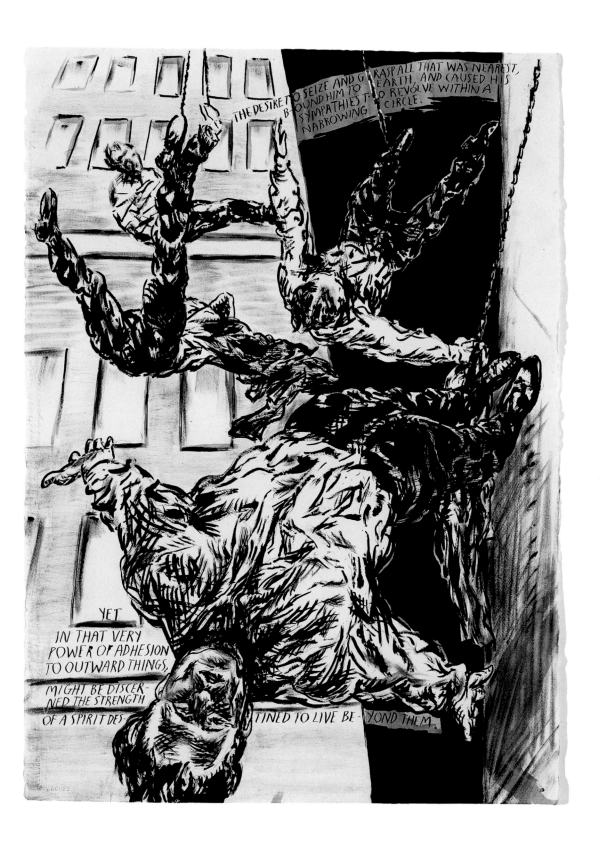

115

Considering Houdini

Interviews

E. L. Doctorow

Houdini plays a central role in E. L. Doctorow's novel *Ragtime,* which brings the magician to life as a man of astounding achievements and inner doubts. In the book's teeming portrayal of turn-of-the-twentieth-century New York, Houdini embodies the rise of the enterprising immigrant and the perils of show-business success. Doctorow's other celebrated works of fiction, which include *Homer & Langley, The March, The Waterworks, Billy Bathgate, World's Fair, Loon Lake, The Book of Daniel,* and *Welcome to Hard Times,* delve vividly into American history and have been honored with the National Book Award, three National Book Critics Circle awards, two PEN/Faulkner awards, the Edith Wharton Citation for Fiction, the William Dean Howells Medal of the American Academy of Arts and Letters, and the National Humanities Medal. In this interview, Doctorow reflects on Houdini as a mythical figure and a psychologically complex man, and as a crucial inspiration in the composition of *Ragtime.*

Brooke Kamin Rapaport: When I reread *Ragtime* and was focusing on the Houdini sections in anticipation of this conversation, I found that you describe his feats in a visual and painterly manner. Can you talk about how Houdini became a visual force for you as a writer?

E. L. Doctorow: Perhaps that has to do with the narrative convention of the book. It is a chronicle. As a writer, you're looking at these people in the book—including Houdini—from the middle distance. You're not in intimate relation with the characters, you're something of a commentator. And so the narrative advances by means of images. Each of Houdini's stage tricks, each of his escapes, provided me an image.

Q: But some of the things you describe him escaping from were your tricks, not his.

A: Oh no, he did escape from all of those things, I checked on that. They were actual tricks he invented. The only trick I invented was the one in which he was put in a grave and couldn't escape and had to be rescued.

THE LAST FOUR PAGES: EDITED BY THE OFFICE DOG

HOW I GET OUT OF MY ROPE TIES

REVEALED FOR THE FIRST TIME IN "CLOSE UP" PICTURES AND EXPLAINED

BY HARRY HOUDINI

1. The Sailor Boys, Whom I Had Never Seen Before, Had the Time of Their Lives Tying Me to That Chair. And Not One of Them Observed the Sort of Shoes I Wore

3. With Both Feet Now Out of My Shoes, it Wasn't Difficult to Extricate Myself From the Tie

4. Until Finally the Loosened Ropes Dropped Off Me and I Was Free in 54 Seconds

2. Upsetting Myself, I Was Able to Extract My Foot From My Congress-Gaiter Shoe

PHOTOGRAPHS BY
WHITE STUDIO

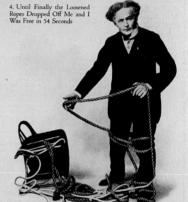

I HAVE never employed "fake" knots, "fake" ropes, "fake" chairs or "fake" men in my rope ties. The sailors who tied me to a chair in front of the camera for these pictures were regular United States sailors whom I had never seen. The chair was a regular ordinary "kitchen" chair.

By the larger rope my upper body was tied to the chair, around my neck, behind my back and the chair back, under the seat, around my legs above the knees and to my ankles, which were doubly bound to the front legs of the chair, as in Picture No. 1. The smaller cotton rope was used to tie my arms to my sides and my crossed hands.

Now notice two things in this Picture No. 1: The "squareness" of my shoulders and the sort of shoes I am wearing. They are soft kid, reaching well above the ankles and of the ancient side-elastic or Congress-gaiter variety.

I "square" my shoulders and wear those ancient shoes for these reasons: To free myself, I first of all drop my shoulders. Naturally this serves to loosen the cords binding my arms

to my sides and my upper body to the chair back. Then I wriggle my body. The ropes begin to slip and slide and constantly become looser. Then I sway my entire body until I overbalance and fall over on my side, chair and all. In this position I have leverage in my legs to which, sitting upright, the floor had been a barrier.

Now these Congress gaiters: I point my toes and so bend down my foot that the front of my leg from knee to toe tip is one straight line. Then I draw my feet out of those elastic-sided shoes, as in Picture No. 2. Now I curve my hands to such an extent that, with the ropes loosened as they have been by my writhings, I am able to withdraw them. Sometimes I can't, however. Then I use my teeth. Then, getting one of my free feet, or both of them, if need be, on the rung at the front of the chair, I press myself free of the ropes, as in Picture No. 3. An instant only is required now to slip from the entirely loose coils of rope (No. 4) and I am free.
[Mr. Houdini freed himself in fifty-four seconds.—EDITOR.]

A WORD OF EXPLANATION

ALL of Mr. Houdini's "escapes," as they are called in the language of magic, are made in a closed cabinet in which, tied and shackled, he is placed by assistants. The methods employed are never seen by his audiences. For The Ladies' Home Journal he made these "escapes" before a camera and the eyes of one of the editors of this magazine. Obviously not every move made by him could be photographed, but the pictures shown here, together with the details given in his article, form a disclosure, the first that Mr. Houdini, the greatest living American magician, has ever made in his quarter century of "escapes," and even now only with the permission of the American Society of Magicians.
—THE EDITORS.

FOR my "escape" from a hamper, I was tied by the sailors as in Picture No. 5. My legs were also tied. Notice that I am wearing my coat, waistcoat and collar. The sailors then pushed me down into the hamper, closed the lid and corded the hamper with one-inch hemp rope.

Now when the sailors had tied me I had expanded my chest—I am fortunate in being able to expand my chest slightly over six inches—and had held my wrists in such a position that by a law of leverage I could not have had my wrists tied closer together without breaking them, which the sailor boys were not powerful enough to do. Reducing that leverage, once the hamper was corded, contracting my chest and employing my teeth on the knot, my hands were almost instantly free. Drawing up my knees, another instant was all that was required to free my legs from my hips to my ankles. Having all my life practiced contortion, once free of the ropes in the hamper I divest myself of my coat, collar and tie.

Why do I use a hamper? Simply and solely because it is flexible. However tight the ropes that cord it may be drawn, this flexibility is such that it is possible for me to strain the lid and front sufficiently to permit me to project my arm, as in Picture No. 6. No matter where the knot of the outer cording may be, it is possible for me, by rocking the hamper, as in the present case, and pulling any one of the ropes to bring the knot finally within the reach of my hand! Then I step out, as in Picture No. 7!
[It took Mr. Houdini just one minute and twenty seconds to make this "escape."—EDITOR.]

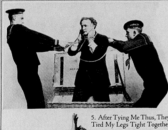

5. After Tying Me Thus, They Tied My Legs Tight Together

6. My Hand Found the Lead Rope

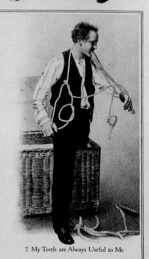

7. My Teeth are Always Useful to Me

"How I Get Out of My Rope Ties" by Harry Houdini, *Ladies Home Journal,* June 1918. Magazine, 16 x 10½ in. (40.6 x 26.7 cm). Collection of Ken Trombly, Bethesda, Maryland

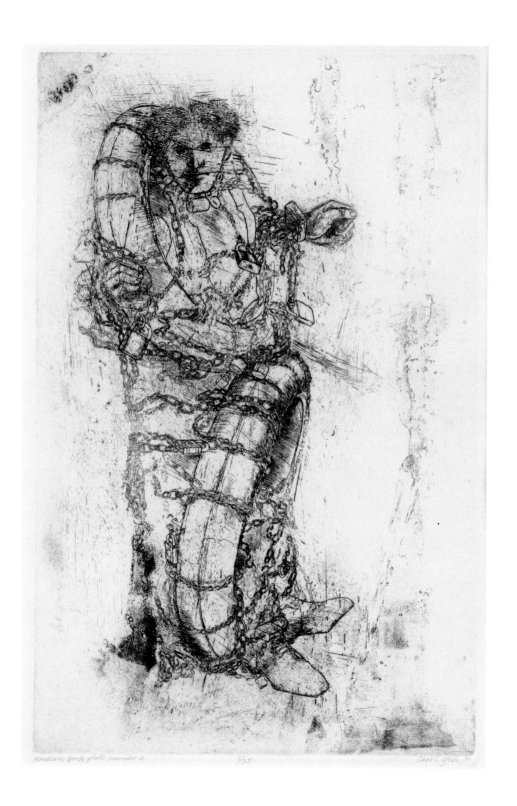

Houdini book plate number 4 1/25 Carol Yeh 71

Carol Yeh (AMERICAN, 1938–1994)

Houdini/Etchings, 1971. Etchings, 30½ x 39¼ in. (77.5 x 99.7 cm). Collection of Mr. and Mrs. E. L. Doctorow, New York. The etching at left was included in a special edition of E. L. Doctorow's novel *Ragtime* published by Bantam Books in 1976.

Houdini book plate number 5 5/25 Carol Yeh '91

Q: I'm interested to know that he was someone from your childhood.

A: When I was a boy, he had a certain mythic standing as the iconic magician and escape artist. He served as one of the models for a child's fantasy life. We children had a lot of them. There was Tom Mix, the cowboy, or the great comic-book heroes like Superman, or Joe DiMaggio, or Jack Armstrong, the All-American Boy. Some of them real, some fictitious. And in that pantheon was Harry Houdini. Kids in my generation—I don't know if it's true of children today, given all their electronic diversions—loved learning card tricks and sleight-of-hand, making coins disappear, trying to hypnotize one another, that sort of thing. And behind all that tomfoolery stood the figure of Houdini. Even though he was long since dead. Perhaps because he was long since dead.

I should point out that *Ragtime* was written not from any preconceived plan or clear intention. The book came upon me, it was improvisatory. I wondered one day about the house I lived in, at the top of the Broadview Avenue hill in New Rochelle. It had been built in 1902. I imagined what life was like at that time—streetcars running down to Long Island Sound, women wearing white and carrying parasols against the sun, men in straw boaters. An upper-middle-class neighborhood in which no black people or immigrants were visible. That's how the book began—it's all right there on the first page. And I created this family I had no names for—Father, Mother, Mother's Younger Brother, Grandfather, and the Little Boy. Somehow I felt the boy should be given some sort of preternatural talent. And so this car drove up the hill and crashed into the telephone pole in front of the house, and almost as if the boy had wished it, out from the car stepped Harry Houdini. That was an important moment for me: Houdini made the way for the book's other personages—J. P. Morgan, Henry Ford, Emma Goldman. He was the first.

Q: Houdini appears in *Ragtime* at times as someone who is miffed that celebrity cannot provide him access.

A: Once I had found Houdini as a character, I wove him into the fabric of the book. I portrayed his dissatisfaction with himself as a mere performer because while he is doing his stage tricks, real-life achievements are taking place outside the theater.

Q: Toward the beginning of the book, there is that scene in a hospital when the family of the injured sandhog turns Houdini away.

A: The sandhog was working on a tunnel under the East River when an explosion blew him up through the water. Houdini regards this as an amazing real-life escape, and he comes to see this fellow who's wrapped in a cast from head to foot.

Houdini is envious, he thinks maybe there's something in it for him. He is rudely hustled out of the hospital.

Q: And then there's the scene when Houdini decides to learn to fly. Aviation is in its glamorous infancy, and while he's in Europe to perform, he buys a fragile French biplane and learns to fly it . . . and he attracts the attention of the Austro-Hungarian Archduke Franz Ferdinand.

A: There again you have the leitmotif for this character. The archduke and his staff don't know who Houdini is. They think he's invented the airplane.

No matter what he achieves, or how spectacularly he performs, Houdini will find the real world either disdainful or ignorant of his celebrity. You understand, all this is my reading of Houdini. It is very much in the spirit of the book.

Q: Would you say that he is a model for the narrative form of the book? He blurs the line between reality and illusion. Is *Ragtime* also doing that?

A: Some critics see my portrayal of Houdini as standing for all artists.

Q: At the end of the book, Houdini is in a straitjacket being raised by cable very high over Broadway, in a public act of derring-do, as he will attempt to free himself while hanging upside down over the street, with a big crowd watching. A man peering out of a window as Houdini swings there says, "Fuck you."

A: Yes, I laughed as I wrote that. The judgmental voice delivering its sentence.

Q: You write about Houdini and Spiritualism: "Houdini had lately been feeling better about himself. His grief for his [recently deceased] mother, his fears of losing his audience, his suspicions that his life was unimportant and his achievements laughable—all the weight of daily concern seemed easier to bear. He attributed this to his new pursuit, the unmasking of spirit fraud wherever he found it."

A: That's what he called it: "spirit fraud." His words.

Q: When he went on tour and turned his stage shows in part into Spiritualist exposés, he received enormous attention, headlines. Did you think about this debunking of Spiritualism as, in a sense, reviving Houdini?

A: If you mean did it bring him new audiences and help his career—absolutely. His debunkings were great show business. Houdini was ever the showman, and something of a publicity genius. And there was a dynamic to all this—by attacking a form, a dishonest form, of show business, he attested to the honesty of his

own declared illusions and so positioned himself in the real world outside show business.

But if you mean does all that anti-Spiritualism make him more current, I doubt it. Spiritualism had a cultural presence in the 1920s that it doesn't have now. Today we have more sophisticated and successful forms of spirit fraud.

When a medium got in touch with Houdini's deceased mother, he was incensed. She "spoke" through the medium in English, whereas in her life she spoke only German or Yiddish. I think two things were going on then—triumphant satisfaction at exposing the fraud, and keen disappointment that it was a fraud. It's likely that his obsession, disrupting séances, showing up the tricks of mediums, reflected his own secret wish that some sort of spiritual communication with the dead might be possible, and the fact that these fraudulent practitioners were discrediting the idea.

Q: The question of Houdini's Jewishness is important. His father was a rabbi, his family was religious, but those weren't things that he proclaimed in his celebrity. In 1918 he appeared at benefits as a rabbi's son alongside Al Jolson and Irving Berlin. And Houdini is buried at the Jewish Machpelah Cemetery in Queens, where his mother was buried. His wife, Bess, is not buried there; she was Catholic.

A: It probably was important for him, as an extremely physical performer seeking a nationwide if not international audience there at the beginning of the twentieth century, to transform Ehrich Weiss into the magically alliterative Harry Houdini, presumed heir of the great French illusionist Robert-Houdin. That was a show business form of assimilation. Of course, there may have been some value in letting people in the Jewish community know he was a Jew. The Jewish immigrant community loved it when a Jewish prizefighter like Benny Leonard came along. And so they loved a world-famous escape artist who was Jewish. Houdini maintained a double identity all his adult life.

Q: Well, right. And for a while there he claimed that Appleton was his birthplace, not Budapest.

A: I wonder if he knew the symbolic meaning of his endlessly contrived escapes. Why his immigrant audiences adored him. The poor, the working class. He had that first-generation strength of purpose to somehow succeed in America, to do whatever it took.

Those escapes could have been pantomimed sermons. He could never let up. He was Houdini offstage, too, with that boastful habit of his of inviting someone to punch him in the stomach to see how ironclad it was. But that one punch, when he was least expecting it, is what did him in. That was the last trick, the one that didn't work.

Teller

Penn and Teller, the Las Vegas–based magicians, have often cited Houdini as a touchstone in their work. They have used a Water Torture Cell and a straitjacket in their stage shows and have disproved psychics who claim to commune with a spirit world. Penn and Teller have won acclaim for their brazen and unconventional Broadway and Off-Broadway shows; have appeared countless times on television, including PBS specials, *Late Night with David Letterman,* the *Tonight Show with Jay Leno, Saturday Night Live,* and their Showtime series; and regularly perform in Las Vegas. In this interview, Teller, the typically silent half of the duo, describes Houdini's significance to him as a magician and as a scholar of the magic field. Teller also speaks of Houdini's legacy and how no living magician has attained his international acclaim and prominence.

Brooke Kamin Rapaport: You mentioned that your show is a direct offshoot of Houdini's work. How great is the specter of Houdini for magicians today? Or how great is that shadow? Does Houdini remain a force?

Teller: Houdini seems to have been, as far as the public is concerned, the only magician who ever mattered. In the magic world, if you ask magicians which magicians matter, they'll mention Houdini's namesake, Robert-Houdin. But for the public, if you say, "Name a magician," they'll name Houdini, even though he's been dead since 1926.

Why? Because Houdini was so multidimensional, because he was a force of nature. If there was a new medium, a new technology, if there was a new idea that was center stage in the culture, Houdini was right there. Kenneth Silverman's wonderful biography *Houdini!!!* has in its closing passages some very worthwhile things to say about why Houdini touched so many. Silverman mentions the fact that Houdini was an immigrant who was showing by example how you become an American, and the fact that Houdini was an impressive physical specimen, in an age when people were becoming flabby from factory work.

Q: I understand what you are saying, and I agree: If you ask the public to name a magician, people immediately think of Houdini. How about for magicians, though?

A: People went to Blackstone and Kellar and Thurston and all those guys for entertainment. Houdini crossed over into meaning. It wasn't that, for example, escapes or exposés on Spiritualism were utterly original. There were lots of anti-Spiritualists in his day, but Houdini fueled his performances with a level of conflict and drama that nobody else could touch.

Houdini would send out advance people, disguised as bereaved people, to get

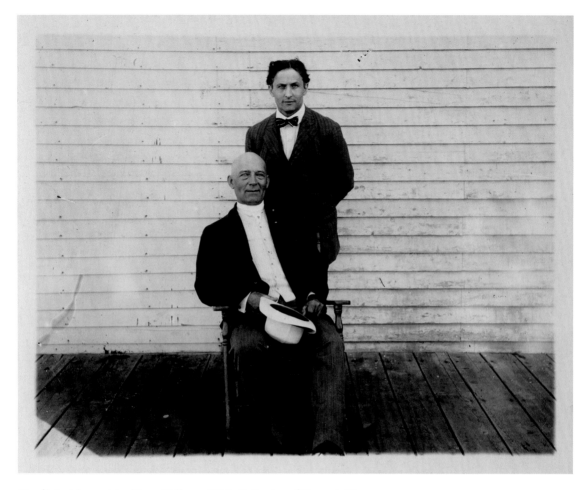

Houdini with magician Harry Kellar, c. 1912. Collection of Kenneth Silverman

the lowdown on the local "psychic" so that when he came into a new town, he could create unforgettable dramatic confrontations.

Other anti-Spiritualists would be crusaders on general moral grounds. But Houdini's passion was fueled by rage at the loss of his mother and the anger he felt toward people who were trying to exploit that. He could feel for all the people being ripped off.

Q: Houdini's penchant for debunking the Spiritualists relates to your own antipathy for hoaxes that are perpetuated today. You and Penn Jillette have been vocal, working to unmask some of the fraud of purported psychics who say they can contact the "other side" and who dupe the public.

As I have been researching Houdini, some scholars and other magicians have suggested to me that behind his drive to reveal the Spiritualist trickery was the fact that he truly believed that the other side was something attainable. Do you agree?

A: No. You'll find in Houdini vague references to God, but that's about as much as you'll find. You don't really find text that says, "I actually expect to run into Mom again."

Let me take a step back. In the nineteenth century, the scientific method generated a great deal of uneasiness. People began to want scientific proof of their religion, instead of just trusting the Bible about an afterlife. Houdini is part of that age. When his mother died, he wanted to explore the new technology, Spiritualism, to see if it held any value for him.

And he encountered Lady Doyle, the wife of the creator of Sherlock Holmes, who gave him a silly and trite message from his mother and put a cross at the top of it, which is certainly an odd choice for a rabbi's wife. [Laughter.]

Initially, he was very much struck by this because, of course, he had that huge hole in his heart. And then when he sat back and thought about it, because he was a bright guy, he was first skeptical, then angry. The more he looked into it, the more crooks he found. And that discovery turned into the whole last act of his career.

So though there was a moment shortly after the death of his mother when he was open to the idea that Spiritualism might be valid, it faded quickly.

Was Houdini religious? I think anybody who says he was is doing him a disservice.

Q: In Houdini's time, there were magicians who imitated his work. Even their stage names—Mourdini, Torrini, Miss Undina—mimicked his name. And more recently The Amazing Randi and Doug Henning have re-created or updated certain signature tricks of his. I've seen work that you and Penn performed that put me in mind of Houdini's famous Water Torture Cell.

A: Sure.

Q: Could you discuss the idea of recycling or reinterpreting certain magic tricks or performances? Houdini did that himself when he used historic pieces such as the Needle Threading Trick or specific card tricks from past magic acts. As you have said, he was very modern in his choice of materials and in invention, but he was also indebted to the past. What is your sense of Houdini as an innovator in the field, and what do you think about how magicians reuse or reinterpret certain performances of his?

A: In his biography of Houdini, Kenneth Silverman points out that Houdini's escapes always left intact the containers he escaped from. If he was nailed inside a crate, he exited leaving the crate nailed shut. That points back to the escapes done in spirit séances. There the medium was contained (by ropes or by being sealed inside something like a trunk), secretly released himself, created "spirit" manifes-

tations in the dark, and then was found still restrained when the lights came on. This was supposed to mean the manifestations had been done by spirits.

Houdini did the exact same technological feat, that is to say, getting out of bonds and leaving them intact, but did it *as an escape trick.* That is to say, he called that spade a spade. This allowed him to present his work honestly. But the fact that Houdini always left the bonds intact, left the jail cell still locked, left the milk can still closed up and still locked, betrays the fact that this plot essentially comes out of Spiritualism.

What Houdini did was add the light of day—that is, present it so that a modern audience did not have to believe in anything other than physical prowess and ingenuity to enjoy it. He took the fundamental idea of escaping out of the dark and brought it into the light, where people could watch him with self-respect.

So yes, he is indebted to the past, and yes, he is creating an innovation. His other enormous innovation was to make sure—this is from Screenwriting 101— you take whatever your event is and you hang it on a conflict. His discovery that you could make conflicts absolutely enormous and that these conflicts could be co-produced with people who were self-promoting is an enormous innovation.

Houdini is the person who brought co-promotion and product placement into magic. So if, let's say, he's working in a city whose principal industry is beer, he goes to the head of the beer company and says, "I would like you to challenge me to escape from one of your kegs." The beer company and Houdini both get in the newspapers, and it's presented as a conflict, a challenge. That's another way he took material that had historic precedent and turned it into something entirely different.

If you're asking whether all magic is just a rehash, I would reply: Every time someone sits down at the computer keyboard and writes a new novel, are you going to say: "Well, this novel is derivative because it uses words in the English language"?

I regard Houdini as a serious, serious innovator because of how he transformed material into something that was unrecognizable. The Needle Trick was brought over in 1813 by Khia Khan Khruse and made its way into the sideshow repertoire. It was never something you would do in the New York Hippodrome.

Q: Because the trick is so small scale?

A: Yes, it's just needles and thread. It's a close-up trick. The idea of taking that trick and, through sheer chutzpah and presentation and styling, turning it into a theater-filling piece is a huge idea. It's about taking something as innocent as your grandmother's sewing box and turning it into a life-and-death struggle. And again Houdini had great taste on that sort of thing.

Q: In my research I've been struck by the mundane nature of Houdini's magic apparatus: a milk can, a packing trunk, the needle and thread. These are everyday

objects that he imbued with a sense of illusion and mystery, and that's one reason the public found him so fascinating—because they were recognizable objects.

A: Yes, during the bulk of his career, Houdini put emphasis on real-world objects that are very, very, very identifiable and definable, and very different from the more popular kind of stage magic at the time, which emphasized exotic props. In fact, when Houdini used standard magic apparatus, he was less good. All of that stuff has an otherworldly quality that was not part of what he was good at. His magic or escapes—his mystification, as he called it—were grounded in the real world, and that may be a big part of why we all remember him.

Q: From the art perspective, if you think of the Dadaist and Surrealist Marcel Duchamp, who was working at the same time, he also used mundane, basic objects in his work. A urinal, a bicycle wheel. Duchamp and Houdini didn't know each other, but there is a correlation between the two in their using everyday items and endowing them with much more.

A: That's a good point. They're doing different things, but they're coming from the same idea, that art does not have to be grounded in the far away and long ago but can be very present in the here and now.

Q: Sadly, it doesn't seem like Houdini and Duchamp ever met.

A: It doesn't seem like they would cross paths. Houdini was too much of a ruffian.

Q: Well, he was a regular guy.

A: You must know some very extraordinary regular guys.

Q: Do you think that stage magic today is indebted to Houdini?

A: I wish it were more indebted to him. The big innovation of Robert-Houdin, Houdini's namesake, was in behaving like any other, as though he were a human being and dressing exactly like audience members, in an age when the primary way you would dress if you were performing onstage would be in an exotic costume.

I wouldn't be surprised if Houdini was heavily influenced by some of the tales that Robert-Houdin tells in his memoirs, including of course his involvement in political events. The fact that he was assigned by the French government to help quell the Algerian rebellion [in 1856] is analogous to Houdini's testifying before Congress about the Spiritualists. Knowing the skill of deception gave Houdini authority to have some voice in the larger culture.

Q: The magic world was a platform.

A: If you make a living fooling people legitimately, you resent those who use the same art for evil. Take me back to your question, though.

Q: Would you say, from your perch on the stage, that audiences have changed dramatically since you began in the field? Do you have insight into audiences today? There remains a huge appetite for magic, but do you think the audience is different?

A: Fundamentally my answer is no. I deal primarily with live theater. Live theater means that you place people in a room and one person stands on the stage and does things to communicate with the other people. It's a very flesh-and-blood thing. And people aren't really that different from what they were in Houdini's day.

You have big spectacles, the Cirque du Soleil types of shows in Vegas, for example. Those big-spectacle shows existed in Houdini's day as well. They had armies of people in armor marching out of swimming pools. [Laughter.] In the 1890s, there was a version of *The Tempest* that was all full of magic tricks, full of huge stage mechanics. So we can't say that audiences have changed very much in that respect. Some people still like to watch machinery onstage.

Q: I am wondering more about the question of contemporary magicians' reinterpreting or using Houdini's act. When you and Penn used the apparatus that recalls the Water Torture Cell, were you thinking of Houdini?

A: Sure, we were alluding to the water tank. Now, with Houdini the idea was to challenge him to be submerged in a tank of water and make his escape. In our version, the challenge is that I've voluntarily agreed *not* to escape—to remain underwater until Penn does the most trivial act in magic, that is, finds a selected card.

In the story of our piece, I am so determined that Penn is going to find that card that I lose my life over it. Ours is the plot of Houdini's tank turned inside out.

I'm surprised you're not asking me what I think of Houdini's Jewishness.

Q: Ken Silverman tackles that in his essay for our book. But what do you think of Houdini's Jewishness?

A: To me, it was almost irrelevant. Houdini created his own name. Created his own personality. And was showing precisely that an individual can be an individual and not a member of a group—and that is one of his biggest heroic as-

Houdini being lowered upside down into the Water Torture Cell, c. 1913. Photograph, 5 x 3½ in. (12.7 x 8.9 cm). Library of Congress, Rare Book and Special Collections

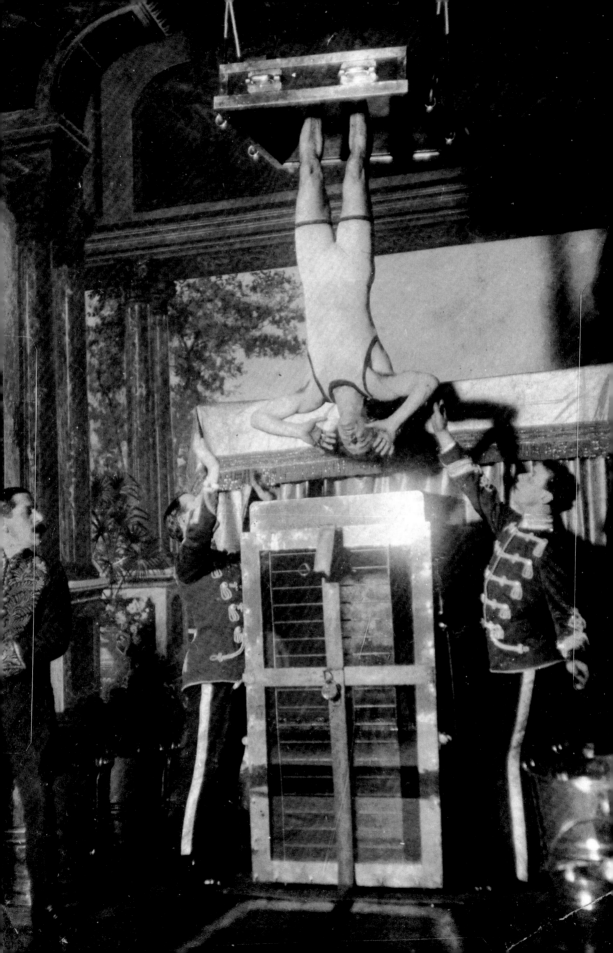

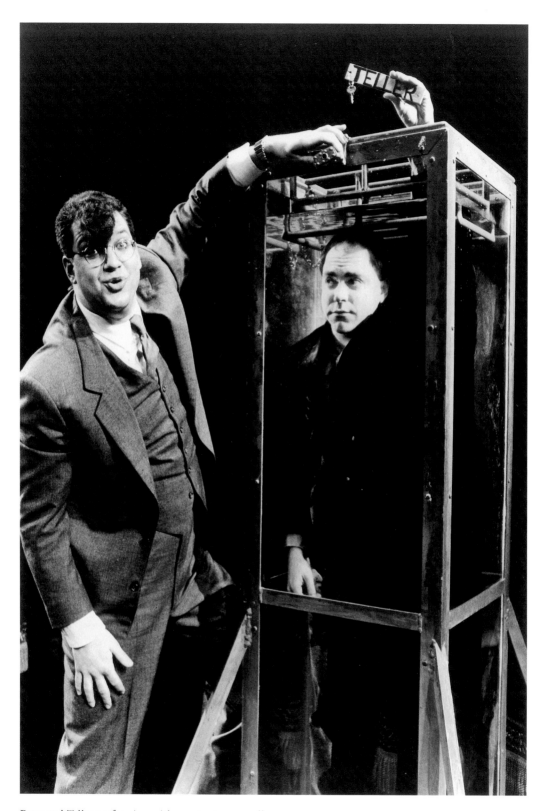

Penn and Teller performing with a water torture cell

pects. He's showing that one small immigrant from the family of a rabbi—he never made a secret of this fact—could be his own man. And that is, in many ways, the greatest form of self-liberation imaginable.

Q: I think that's exactly true. But I would also ask you whether you thought that was part of the immigrant experience in the late 1800s and if that assimilation wasn't what he had to do to secure his ultimate fame.

A: I would say that a little more if he had in some way tried to hide his origins. But he didn't, really. Everyone knew, and it was in its precisely proper perspective. To me the proper perspective is: Here's what I came from, and here's what I am. And those two things are different. I'm a great proponent of individuals. And Houdini is certainly the model of that.

Q: The question of Houdini's Jewishness is significant. There are always the metaphors of escape and transformation in his work that we can relate to his immigrant origins.

A: I think if you asked people, "Was Houdini from a Jewish family?" they would shrug and say, "Sure." But his impact came from embracing his individuality and embracing his Americanness back in the day when Americanness was of high value.

Q: Would you hold up Houdini as unusually influential in the magic field? Or do you see him as a combination of early marketing and supreme skill?

A: As far as the stuff that Houdini was a specialist at, no one was better. If you're asking whether Houdini was the best card magician on earth, no. In his case, it's more important that he was the best possible Houdini than that he was the best possible ordinary magician. Because there is nothing generic about him at all, except his enormous passion for magic. It was huge. His fascination with magic history, with magic literature.

There is one regard in which Houdini's family background probably did influence him: the traditional Jewish respect for learning and books. His formal education was not very extensive, but his passion for literature, for writing, for correct writing, is very great. He had an enormous library, with a personal librarian, and he researched primary sources wherever he went. He employed assistants in the form of editors and ghostwriters to make sure that anything he published was eloquent and grammatical. In that particular, I think we can say we see a rabbi's son.

Artists

A number of artists working today have a profound affinity with Houdini. Some equate magic with the transformative power of creating and viewing works of art. Others have pursued Houdiniana with academic passion, closely studying the extensive documentation and literature on the great magician and escape artist. The far-reaching symbolism in Houdini's magic tricks, the activity surrounding his escapes, his campaign against Spiritualists, and his celebrity stature and theatrical daring are all touchstones for contemporary artists. Below are excerpts from recent interviews with some who have been influenced by Houdini and have intently discerned his significance. All interviews with the artists, with the exception of the first, were conducted in 2009 and 2010 by Brooke Kamin Rapaport.

Matthew Barney

Since the 1990s, Matthew Barney's fascination with Houdini as an alter ego has steered some of his most interesting and complex projects, such as his *Cremaster* series of films. Houdini has been called the artist's "patron saint, role model, and inspiration."[1] Barney (born 1967), who uses such nontraditional materials as prosthetic plastic and petroleum jelly in making his films, sculptures, books, installations, and photographs, has evoked Houdini in all these media. The bodily risk that characterized Houdini's outdoor and stage escapes parallels Barney's courting of raw physicality in his work. Barney came of age artistically during the post–Conceptual Art period of the late 1980s, when work in galleries and contemporary art museums was based largely on gender and identity politics. He turned those movements on their head when his surreal pieces—often featuring himself in a key role—confounded mainstream gender roles and created an absolute world formed in his imagination.

The following is an excerpt from "Matthew Barney: A Conversation with Jeanne Siegel," which appeared in the journal *Tema Celeste*.[2]

Q: I see similarities [in your work] to Joseph Beuys in a large sense, but specifically he also closed off apertures—his eyes with fat and gauze. He used earplugs in order to eliminate outside sound because he was interested in the idea that silence allowed for some inner condition to be revealed for him. Your motivations seem quite different.

A: I definitely share that interest in developing a closed system, but somehow Houdini's work might relate even more [than Beuys's]—the way he relentlessly studied and handled locks, to the extent that when a challenger imposed a foreign lock, Houdini intuitively "absorbed" the lock, really making it an extension

of his own body. In a sense, he harnessed the potential energy of a hermetic practice and used it in an attempt to perform an external disappearing act.

Whitney Bedford

Whitney Bedford's realist paintings have regularly featured disaster imagery such as shipwrecks, battle scenes, exploding volcanoes, and pirate violence. Houdini—with his ability to escape other, potentially fraught circumstances— was a natural subject for the Los Angeles artist (born 1976). Bedford's pictorial language melds the historic with the contemporary as she incorporates vintage scenarios into current settings. The spare backgrounds of her paintings and large works on paper suggest the economy of geometric abstraction, while narrative dominates the foreground.

Q: When did you begin thinking about Houdini? How long after your initial interest did you decide to paint a series on him?

A: We traveled a lot when I was a child, and I loved magic. I always looked up to Houdini. He seems so poignant here [in Los Angeles]. He was one of the first people to be a superstar in Hollywood; he crossed over to the spectrum of superstardom. I feel a lot of kinship with him as an artist. He was practicing an art and had an audience. There's a science to practicing an art, and the bravado that he put into his art made him a spectacular performer. Houdini did tricks that were actually easy and made them look death-defying.

He achieved so much, and his devotion and the way he crafted his performance are like the way I paint and work. I conjure and act an idea, and see it through. He approached his act with his love of magic, and that led to another thing. He was determined to make something out of nothing. His tricks were great. How an artist uses tricks and how a magician uses tricks—there are so many parallels. What he did is akin to what I do today. I feel much more indebted to his kind of pageantry of show performance [than to the work of some great painters].

Joe Coleman

A well-known figure is typically at the center of paintings on wood by Joe Coleman (born 1955). Within these paintings, elements related to that person emanate from various chambers. His exceptionally detailed portraits, characterized by a sophisticated mastery of technique, are done with a single-hair paintbrush and a jeweler's loupe so that he can achieve those intricacies. Coleman, who is

based in Brooklyn, has chosen subjects ranging from the famous, such as Houdini and P. T. Barnum, to the infamous, such as Charles Manson. The artist has at times worked outside the traditional gallery system. Coleman has suggested that in all of his portraits there is the intimation of autobiography.

Q: Did you feel an affinity for Houdini in your work?

A: [All of my paintings are] biographical or autobiographical. Even when I'm not doing a self-portrait. It's almost like method acting, where I become Houdini. I have done performances, too, and in one performance I hung upside down over the audience. The priest robe that I wore for that is mounted between the frame and the actual painting [in *The Man Who Walked Through Walls (Harry Houdini)*]. It's a fetish object that also houses my magic. It's attached to the board the painting is mounted on; you can see it if you get close. If you were to pick up the painting and turn it around, you'd see the entire robe crudely taped to the board.

The performance came many years before the painting. I've always admired Houdini, and I can't remember if there was a specific thing that made me go off on Houdini then. As I was doing the painting, it brought back the memories of performances.

I don't do sketches for my paintings. I paint with jeweler's lenses and complete one square inch at a time, a square inch per day, about eight hours. It's like making miniature worlds. I don't know what the painting will be. There's no sketch of the painting. It's organic. It grows. . . .

I think of Houdini's obsession with life and death. It was not just in the dangers that he faced. There are a lot of magicians, but not many magicians would put their life in peril as he did; the stunts were beyond tricks. There's a fear of death, but being drawn to it at the same time. Then there's the attempt to contact the dead. Houdini was obsessed with the Spiritualists; he would debunk them, but he wanted to find one who was real. I identify with that, the struggle: being drawn to death and not really understanding it. No one understands what it is. That obsession, I can identify with.

Petah Coyne

Petah Coyne's sculptures are abstract objects with figurative references. Her black-wax or white-wax pieces hang from the ceiling and loom over the viewer, an unlikely amalgam of menacing presence and pleasing demeanor. Coyne's imagination and her study of varied subjects energize the sculptural form. In the early 1990s, Coyne (born 1953) read widely about World War II and the Holocaust, and about Harry Houdini. She conflated the subjects in a large black hanging sculpture that dwells on Houdini's emigration from eastern Europe to the

United States and on the fate of concentration camp victims who were denied passage out of their home countries.

Q: You chose to include Houdini's name in the subtitle of a sculpture that you made in 1991: *Untitled #698 (Trying to Fly, Houdini's Chandelier)*. Can you discuss your idea of linking Houdini to a hanging chandelier? Were you thinking of his outdoor performances, such as the Straitjacket Escapes?

A: I should preface this. For years, I have never released the private names of my works to the public. I always numbered [my untitled sculpture]. The reason I did this is that I didn't want to force my ideas on the public. I wanted people to come to the work with their ideas. We were getting to a point in the art world where press releases and websites were dictating. I was against this. I preferred to leave everything untitled and [simply] numbered. People could approach the work with a clean slate.

But in the studio, everyone called this sculpture "Houdini": my studio assistants knew what it was about. They always know what I am diving into in my private reading. I was reading a lot about World War II and at the same time about Houdini. I was fascinated by him and his magic. He was such a colorful figure, so outrageous, a performance artist and a wild character. The two people who really carried him were women, his mother and [his wife,] Bess, who were in the background. He couldn't have had his success without them. He gave them some credit, but you think of the work as *his* magic.

I had a lot of contact with [former] prisoners of war when I was young—Bataan Death March prisoners. We lived in Hawaii, in a Japanese neighborhood, and they would come to our house a lot. They would sit in our garden. When they came, we were allowed to move only slightly, we had to sit still, because they were so disturbed. I liked them very much, because they were different from other people. There was one man I recall in particular: I would hold the cuff of his pant leg, and I felt that I was tethering him to earth.

As I got older, I did research on World War II. Houdini for me was this magical person. I remember thinking about him because of his religion, and when he performed for the Germans, the irony of it amused me. If they [the Jews] could all disappear from the concentration camps, spin around, and leave their clothing the way he left his straitjacket. What an amazing thing.

Jane Hammond

New York painter and printmaker Jane Hammond (born 1950) fuels her subject matter with found photographs and various media sources. Her work has been called surreal in content, yet her methodical, intellectual process of creating a work on paper or a painting veers from Surrealism's dependence on the uncon-

scious. She has compared the artist's ability to conjure imagery on a blank canvas to the magician's capacity for performing a trick out of thin air, both requiring high degrees of concentration and forethought. Hammond has collaged images of Houdini into her work and has used him as a symbol of the power of magic for the artist.

Q: When did your interest in Houdini begin?

A: My interest in Houdini grew out of an interest in magic. I started collecting books on magic. Once you do that, you encounter books on Houdini, Thurston, and others. I wasn't interested in magic growing up. Magic came from art, and I don't understand the connection completely.

There is an interest in my work in science and taxonomies, and you could argue that magic is the opposite. But in a sense, they're both involved in seeing. Houdini comes out of that. In some ways, he is one of the less visually arresting characters. You wouldn't see him on a poster with fourteen white doves in the air. He's more nuts-and-bolts. In all the magic books, everyone has doves, ribbons, and smoke. You associate Houdini with boxes, locks, ropes, the humbler accoutrements. Houdini pried open my consciousness coming through a different door—being tied up, ropes, and bondage. I played games having to do with being tied up as a child. I was obsessed with Indians and pirates.

[In my work] there aren't levitated women being sawed in half or devils looming. Though bondage is a big part of it. I have a lot of books on knots, such as *The Ashley Book of Knots.* I was constantly moving as a child, and always with different people. Houdini has as much to do with bondage as with the escape. Today, bondage has a wildly sexual connotation, but it's really about more than that. To use ropes, tying, slipping out of them, is a metaphor, but once upon a time, it wasn't.

Tim Lee

Tim Lee (born 1975) makes large photographs, videos, and performance pieces of himself based on recognizable figures. He has assumed the guise of Houdini, George and Ira Gershwin, the hockey player Bobby Orr, and the rocker Iggy Pop. Lee, who lives and works in Vancouver, Canada, often critiques popular culture by inserting himself into a known tableau from a famous life.

Q: Was Houdini important to you for his role as a magician or as a historic figure in American culture?

A: I guess my work generally revolves around thinking about when certain historical figures become historical. When did Ehrich Weiss start becoming Harry

Houdini? When did he begin to adopt that persona? I wanted to apply that sort of thinking toward Houdini. I've continually made work about, and have historical interests in, when artists or other figures adopt names to eviscerate their racial heritage. Like the Beastie Boys. Here is an example of a group that adopted names that masked their Jewish ones in order to construct newer personas. So if I was to reenact that scenario, and attempted to articulate my persona through others trying to articulate theirs, the travesty of race becomes more enlarged. It's as if I were an Asian Canadian going through a trio of Jewish Americans in order to get closer to African American culture.

Vik Muniz

Vik Muniz (born 1961) uses unconventional materials from the pantry and the utility closet—syrup, sugar, jelly, chocolate, wire, thread—to render cultural icons. He then photographs the object and considers both object and photo the work of art. He has used Bosco syrup to interpret Hans Namuth's photograph of Jackson Pollock creating a drip painting. The chocolate work survives for a short duration while Muniz photographs it, and the result becomes one in the *Pictures of Chocolate* series of the late 1990s. In his *Pictures of Ink* series, Houdini is featured in a work based on the portrait used on the program cover for the magician's 1926 memorial service. Muniz's passion for magic is deep and began when, as a child, he visited a museum featuring a cabinet of curiosities. More recently, his extensive personal library contains volumes specifically on Houdini, the magic field, science, and art.

Q: You have often made images of cultural icons. Can you discuss your interest in Houdini and how he fits into the canon of those you've featured in your work?

A: I have his books, I collect his films. I love magic.

The Houdini portrait was part of the *Pantheon* that I did for the Corcoran [Gallery of Art] Biennial in 2000. It featured Houdini among other American heroes of mine, such as Buster Keaton and James Brown; Houdini, especially, because magic has a lot to do with what I do.

The role of the contemporary artist isn't to unveil mysteries, but to create new ones. Houdini spent half of his life making illusions and half of his life demystifying the Spiritualists. He inspired contemporary magicians such as Penn and Teller to do the same. James Randi or Ricky Jay, these people are very well versed, they are not just entertainers. There is a whole academic field that has been developed on magic. You are dealing with the interpretation of reality. We rely on a deep understanding of how illusion works and how we are prone to be fooled by things, to have some hint of how reality would look if we could have access to it.

Houdini is also a wonderful character. He makes you think of someone super-human—someone who could do something with his body or mind to challenge what a human being is.

Magic is exactly in the middle point between science and art. It is exactly where one thing becomes another. One depends on the other. You can create models of how black holes collide, but you have to rely on an image to explain this to people. I see magic as this binding agent between science and art. If you think of Houdini as a man of art, you have to think of him as a man of science. Like most artists in the past, he is always working at the edge of technological development. He knew the latest thing that was invented in technology. When you see interesting magic today, you have to think about films, imagination. That is the continuation of Houdini's legacy. It exists at the utmost level, where art meets science.

Ikuo Nakamura

Ikuo Nakamura (born 1960) is a Japanese-born holographer and photographer living in Brooklyn. He is affiliated with the Center for Holographic Art in New York. Holography was developed in the 1960s; the two-dimensional object with the appearance of a three-dimensional setting is familiar to many for its commercial applications on credit cards, record jackets, and children's stickers. Nakamura and his colleagues have advanced the medium by pushing its limits of scale to create life-size works that evoke a room-size environment in a flat space. It is the magic of holography and the convincing transformation of light into illusion that compels viewers.

Q: You are a distinguished holographer. Can you talk about the concept of magic—or illusion—in holography and in your work? Do you regularly consider the performative aspects of magic when creating a three-dimensional space with a two-dimensional one?

A: Originally, I didn't want to make a magic holography. Most holographers started in the medium because it's already magical. We always face people asking, "How did you do this?" It's a double-edged sword. Sometimes I don't like it, because it's too magical. It's a confusion in myself. I feel good because people are puzzled. Magicians never tell how to do [their tricks]. I do, sometimes. But most of the time, people don't get it. I can explain how I did something, but most people don't get it.

Secrecy about magic is very interesting to me. [I compare this to] Japanese Noh theater. My father is a Noh performer, and I was trained in it as a kid. Noh performers hid the secret for more than five hundred years. If it is hidden, it is a

flower. If it is not hidden, it's not a flower anymore. People are curious and excited because something is hidden. If it is revealed, it's not beautiful anymore.

Q: Will you describe your piece based on Houdini, titled *Materialization?*

A: I saw Houdini's magic only from films. [For the Milk Can Escape] people in the audience were holding their breath and guessing [what he was] doing behind the curtain. . . . He never showed. I want to make people's imagination [figure out] what actually he did. This is my own interpretation behind the curtain: he dematerialized his body and passed through the metal [of the milk can] and materialized in air. That's what happened behind the curtain. This is actually how he did it. Nobody knew it. It is the transition from inside the can to outside the can. I freeze how he did it.

Deborah Oropallo

Deborah Oropallo's monumental paintings of Houdini dwell on the power of the Golden Age of magic performance, the late nineteenth and early twentieth century. The scenarios she creates—though painted in the late twentieth century—lull the viewer into reminiscing about a bygone era almost one hundred years earlier. Oropallo (born 1954), who lives in the San Francisco Bay area, first came upon Houdini when, as a youngster, she was drawn to the revealing illustrations in how-to guides, water safety manuals, survival and rescue guides, and a book illustrating magic tricks.[3] She has regularly referred to historic photographs as the source for her figurative paintings.

Q: Your paintings of Houdini are rich and atmospheric. They have a sense of nostalgia about them. Was that intentional—an attempt to evoke the past? Or the mystery about the escape artist?

A: Like painting, magic has certain intangible qualities: illusion, sleight-of-hand, deception. There was not only mystery to Houdini's work, but also poetry. James Dickey once said that "poetry occurs when the utmost reality and the utmost strangeness coincide." The rule that makes art inexhaustible is: We're not supposed to know everything. It is the mystery of things that can be counted on to be self-renewing in art.

When I was painting just magic tricks, and then Houdini, it was when I worked figuratively. I worked from illustrations and how-to books. The magician's manuals could reveal how a trick was done in one simple illustration and remove all mystery in a glance. Once you understood that, it was over.

[In the painting *Houdini* (1990)], rope was about survival and escape. I think people are attracted to the threat, the double-edged aspect. A subtle reminder

that what can save you can also destroy you. You can jump rope, or hang yourself with it. When I saw those images of Houdini where he was wrapped or bound, I thought of that.

Houdini was a theatrical metaphor for the time and had an impact on the human spirit in the early 1900s. More than being an entertainer. The artist's job is basically to make people look. To look at what they know and to question what they know. Houdini operated in the same arena.

Raymond Pettibon

Raymond Pettibon's artistic trajectory has been an unlikely one: he began as an underground graphic artist in California, creating punk band concert flyers and posters, record album covers, and fan zines. More recently, he has become known as a master of combining text and imagery in works on paper that are formally linked to the comic frame, but exist within their own, unique narrative space. Pettibon (born 1957) often makes imagery of well-known but unconnected figures in popular culture, such as Jesus, Elvis Presley, Richard Nixon, cowboys, Superman, and Houdini. In his impartial storyline, each celebrity mandates equal billing.

Q: You don't seem to dwell on Houdini as history—his appearance in your work is up-to-date. He is a timeless figure, and the dilemmas or scenarios you devise for him have continually current meaning.

A: That's not true, actually. Houdini doesn't escape his roots and his historical position. When he died he had this agreement with his wife that he would come back. He was a magician and dealt in sleight-of-hand, as I do, and also he was a debunker of Spiritualism. . . .

Houdini was a physical athlete, for one, he would swallow and then regurgitate the keys that would let him out of these things, and at the same time he was a master showman. He was a brilliant person in many ways. He was a historian of magic. He drew his name from a French magician, and he respected the game and the history of magic. He was also an annotator and a collector of first editions and out-of-print books. He was a Hungarian Jew. It's a classic case of someone pulling himself up by his own bootstraps. In Houdini's case, that involved pulling by the bootstraps and whatever else he could hold on to. He was also a star of films. I saw them when I was a child. He was an athlete and a great mind and showman.

There is a large vaudeville and showmanship part of my work. Houdini is someone who touches upon all of my philosophy or epistemology in art. In art, what is taken for granted is the showmanship, but when you go into it, you have a sense of "Let's put reality aside somewhat." Whether or not you want to know

the sleight-of-hand and the tricks of the trade, perhaps not. Houdini was the debunker, and it's a fine line. I may not believe in the afterlife. But I don't necessarily want to tell the world, and I don't know if I'm right or wrong. Let's leave our options open and have some mystery.

Sara Greenberger Rafferty

Sara Greenberger Rafferty (born 1978) has said that Houdini is with her in her studio at all times. Through his magic performances, he has influenced the form of her work; his diminutive stature (he was approximately five feet, six inches) resonates for Rafferty, who is a small woman; and his background as a Jewish immigrant echoes Rafferty's own family history. The artist, who has created public art pieces, video, performance, sculpture, and drawings, has a studio in Brooklyn.

Q: How did you become interested in Houdini in your work?

A: It's all very circuitous. I started working a lot with things in American history, different moments and Americana: the county fair, the cakewalk. [But also things] that have an underbelly to them. Like Coney Island. Around 1999 or 2000, I read a book about strongmen, Houdini, and Tarzan, and got interested in Houdini. Also, one of my favorite books is *Ragtime:* I like how fiction and history can be woven together in a work of art. What I liked about Houdini were his immigrant situation and the idea of a Napoleon complex. I am a small person and have always tried to incorporate into my work concepts of stature or scale that would indicate the stature of a small person. Of course, the Jewish-immigrant aspect was also interesting. My entire family is eastern European Jewish and immigrated before World War I.

Allen Ruppersberg

Allen Ruppersberg (born 1944), who is based in California and New York, is considered one of the first generation of Conceptual artists—those among whom, in the 1960s and 1970s, the concept surrounding the object took precedence over the "actual" artwork. He frequently combines text and image and often challenges the primacy and preciousness of the art object. Ruppersberg's extensive body of work related to Houdini dates from the early 1970s, when he fused the idea of the magician's ability to transform himself with the notion of the artist's transformative use of multiple disciplines (painting, sculpture, video, performance) in the studio.

Q: What brought you to Houdini as a subject?

A: I know that when I watched the Tony Curtis movie [*Houdini,* 1953] I was intrigued by the person. I went and got a number of Houdini biographies and read those. But I was also interested in magic as a larger subject, because I did other pieces that were faked-out magic works. Like you were looking behind the screen and seeing how it was done.

I got fascinated with the personality of Houdini. And this paralleled the idea of what it means to be an artist. I abstracted that a bit and used the man himself as a surrogate of an artist. [I was] interested in his various performances, and thinking of performance. Performance and video. It's all connected with the emerging art forms at the time and seeing what Houdini did with those ideas as a magician in his time. He got involved in film. I was making connections along those lines.

Christopher Wool

The best-known paintings by Christopher Wool (born 1955) are of large black stenciled letters on white canvas. In these works, reminiscent of the Minimalist aesthetic because of their spare compositions, complete words can become jarring juxtapositions of language that force the viewer to consider the effect of text and its harsh or easygoing content. Wool's 1985 *Untitled (Houdini),* a painting on plywood, was made before the 1990s text pieces. The result is an allover canvas where silver and black enamel paint intermingle to form the illusion of an image behind the scrim of the picture plane. Wool's painting has a whiff of magic.

Q: I realize that you don't favor a close reading of this abstract painting as based specifically on Houdini the escape artist and illusionist. Can you discuss what link, if any, exists between your *Untitled (Houdini)* and the magician himself?

A: It was a metaphorical reference. I titled the painting after it was finished. Houdini was not the subject matter while I was making the painting. I don't always title my paintings, so I must have felt it was an appropriate reference in some way. I remember that I had just read a couple of biographies on Houdini. I was interested in him as anyone might be, not because I was an artist. But I also like this idea that what Houdini did was somehow painterly.

I had this feeling that the painting had to do with the idea that what you think you're seeing you might not be seeing. Houdini, this master of illusion. What you see may not actually be there.

Q: I assume that when you make an abstract work, there isn't a narrative embedded in it.

A: For me, no. The less described the better. Twenty years ago, I may have had a different idea. Tomorrow it may be different again. In an abstract painting, the less the real narrative, the more interesting the work. But I sometimes use titling to bring things like narrative back into the work. In the case of *Untitled (Houdini),* that added something.

The Many Lives of Harry and Bess Houdini

A Chronology

Gabriel de Guzman

1874

Erik Weisz (later Ehrich Weiss) is born on March 24 in Budapest, Hungary, to Rabbi Mayer Samuel Weisz and Cecilia Weisz (née Steiner).

1876

Wilhelmina Beatrice ("Bess") Rahner is born on January 22 in the Greenpoint neighborhood of Brooklyn to German Catholic parents, Gebhardt and Balbina Rahner.

Rabbi Weisz emigrates from Budapest to the United States. He settles two years later in Appleton, Wisconsin, to lead a Reform congregation of approximately fifteen Jewish families.

1878

Cecilia and Mayer Samuel and their four sons—Nátán, Gottfried Vilmos, Erik, and Ferencz Deszö—and the rabbi's son Armin, from his first marriage, join Rabbi Weiss in Appleton. In the United States, the children's names are Americanized: Armin becomes Herman, Nátán becomes Nathan, Gottfried Vilmos

Ehrich Weiss (then Erik Weisz) at age three and a half, with his brother Theodore (then Ferencz Deszö), 1877. Photograph, 7 x 4¾ in. (17.8 x 12.1 cm). Harvard Theatre Collection, Cambridge, Massachusetts, Gift of George B. Beal

becomes William, Erik becomes Ehrich, and Ferencz Deszö becomes Theodore. The family name is now spelled "Weiss."

1879

Ehrich's youngest brother, Leopold, is born in Appleton.

1882

The Weisses' youngest child, Carrie Gladys, their only daughter, is born.

Rabbi Weiss relocates with the family to Milwaukee, hoping for greater opportunities in a city with a larger Jewish population. Without a congregation to lead, however, Rabbi Weiss struggles to find work. The Weisses live in poverty.

1883

Nine-year-old Ehrich starts a small-scale circus with neighborhood friends. Debuting as a contortionist and trapeze artist, he bills himself as "Ehrich, the Prince of the Air."

1885

Ehrich's half brother, Herman, dies of tuberculosis in Brooklyn at age twenty-two.

1886

At about twelve years old, Ehrich runs away from home at least once. He jumps a freight train and makes it as far as Kansas City, Missouri.

Dear Mau
I am going to Galvaston Texas and will be home in about a year. My best regards to all. Did you get my picture if you di dnt write to Mead Bros. Word Stek Okl.
Your truant son
Ehrich Weiss

This postal card mailed by myself when I ran away from home to earn some money. I was on my way to Texas? got into wrong freight car and went to Kansas City Mo.
this card was mailed in a place called Wittersmil
I remember being in Hanibal Mo.
The post mark on car reads Hannibal & St Joseph R.R.
168
1886.

Postcard from Ehrich Weiss to his mother, 1886. Postcard: 5 ¼ x 3 in. (13.3 x 7.6 cm); typed explanation on paper: 2 ¾ x 5 ¾ in. (7 x 14.6 cm). Library of Congress, Rare Book and Special Collections

On this adventure, or perhaps another one, he goes to Delavan, Wisconsin, approximately fifty miles from Milwaukee, where he finds work shining shoes and is taken in by a married couple. He eventually returns home to Milwaukee.

1887

Rabbi Weiss, having failed to start a congregation or find other work in Milwaukee, leaves for New York, taking Ehrich with him. They live in a boardinghouse on East Seventy-Ninth Street in Manhattan. The rest of the family joins them the next year. Ehrich works as a uniformed messenger and a necktie cutter in the garment industry, among other jobs.

EARLY 1890s

Bess Rahner joins two other teenage girls in a song-and-dance troupe, The Floral Sisters, based in Coney Island.

1891

Ehrich Weiss forms The Brothers Houdini, a magic act with Jacob Hayman (or Hyman), a friend from the necktie factory. Ehrich starts calling himself "Harry Houdini." The name Houdini is a reference to the famous French magician Jean Eugène Robert-Houdin (1805–1871).

1892

Rabbi Weiss is hospitalized after developing cancer of the tongue.

Ehrich Weiss at age thirteen, 1887.
Photograph, 7 x 4½ in. (17.8 x 11.4 cm).
Harvard Theatre Collection, Cambridge,
Massachusetts, Gift of George B. Beal

He dies on October 5, at age sixty-three, as a result of complications following surgery.

1893
The Brothers Houdini may have performed on the Midway at the World's Columbian Exposition in Chicago.

1894
Jacob Hayman leaves to pursue his own act as "Houdini, Oriental Conjuror and Mysterious Juggler." Harry's brother Theodore ("Dash") Weiss takes over as the other half of The Brothers Houdini.

Harry meets fellow performer Bess Rahner and three weeks later, on June 22, he and eighteen-year-old Bess are married. The newlyweds spend their honeymoon in Coney Island. Bess's Catholic mother disapproves of her daughter's marriage to a Jewish man. Nevertheless, Bess devotes herself to Harry and replaces Dash in the magic act, now renamed "The Houdinis." Dash will become an accomplished magician in his own right, taking the stage name Hardeen, which he says Harry has given him. Though he enjoys success as Hardeen, Dash will never attain the legendary status of his brother.

Beatrice Houdini, 1894. Photograph, 5¼ x 3¼ in. (13.3 x 8.3 cm). Library of Congress, Rare Book and Special Collections

1895
The Houdinis tour with a number of traveling circuses and perform at dime museums throughout the

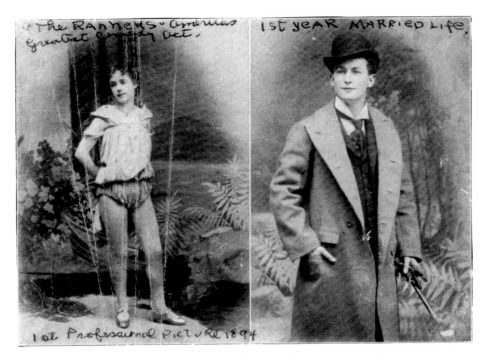

Beatrice and Harry Houdini in their first year of married life, 1894. Library of Congress, Rare Book and Special Collections

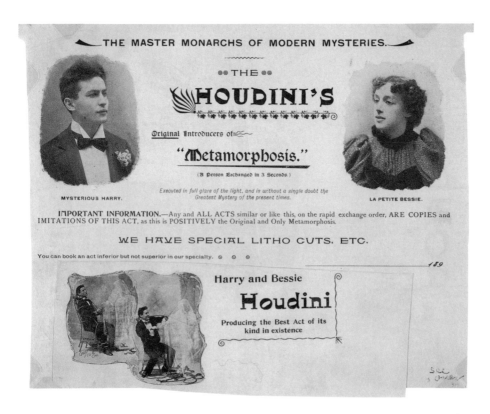

The Houdini's, Original Introducers of "Metamorphosis," c. 1895. Library of Congress, Rare Book and Special Collections

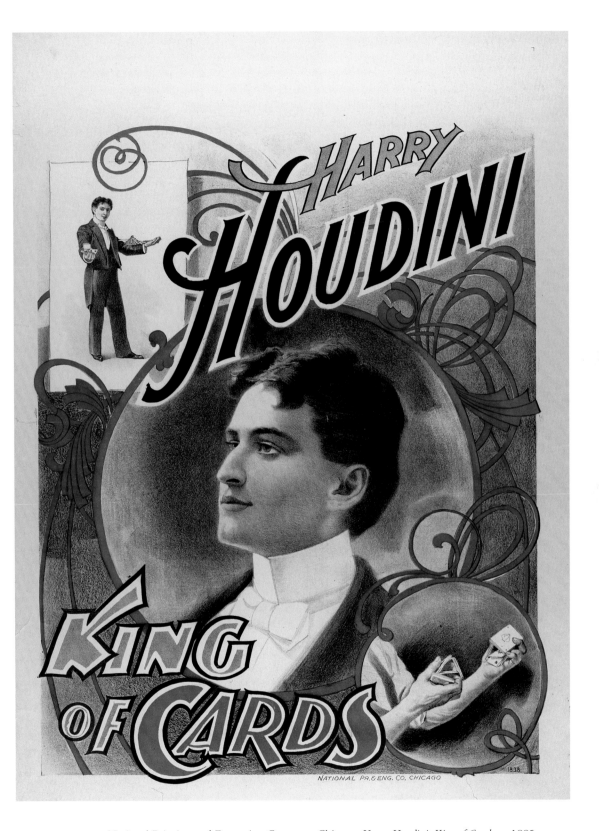

National Printing and Engraving Company, Chicago, *Harry Houdini, King of Cards,* c. 1895. Lithograph, 31¾ x 25 in. (80.7 x 63.5 cm). Museum of the City of New York, Gift of Mr. and Mrs. John A. Hinson

country. They introduce what will be their signature number, "Metamorphosis," in which Bess mysteriously replaces Harry in a locked, rope-tied trunk in a matter of seconds. Harry also performs handcuff escapes in public, showcasing the act for police and reporters.

1898

After years of struggle, Harry and Bess return to New York to regroup; they live with his mother. Frustrated by his lack of prospects, Harry considers leaving show business altogether. He prepares and mails out "Harry Houdini's School of Magic," a sixteen-page catalogue selling magic apparatus and offering to teach the tricks of his trade.

1899

Houdini catches his big break in mid-March, when Martin Beck, manager of the Orpheum circuit of theaters, sees his magic act in St. Paul. A few days later Beck asks Houdini to open a show in Omaha and then offers to book him for the entire next season. Under Beck's management, Houdini is scheduled at top vaudeville theaters around the country.

First public performance of Needle Threading Trick takes place at the Kansas City Orpheum, on April 10. In the act, Houdini places sewing needles in his mouth and begins "chewing" them. He appears to swallow the needles, then puts a

Houdini performs the East Indian Needle Threading Trick, c. 1915. Library of Congress, Rare Book and Special Collections

white linen string into his mouth and appears to ingest it, bit by bit. After all but a tiny piece of string is gone from view, he opens his mouth and draws forth the string—with all of the needles threaded onto it.

In July, Houdini performs a handcuff trick in the nude at a San Francisco police station to show that he can free himself without keys. In the same demonstration, he presents an indoor Straitjacket Escape.

1900

Houdini travels to England as "The King of Handcuffs." Over the next five years, he tours his act overseas; he is soon an international star. Bess travels with Harry but does not always appear on stage with him. To assist with his tours, Harry eventually hires Franz Kukol to handle a variety of tasks onstage and off.

TREMENDOUS SUCCESS
OF
HOUDINI

✦ ✦ ✦

"Absolutely a Miracle,"—

Supt. MELVILLE,

SCOTLAND YARD

Detective Headquarters.

✦ ✦ ✦

✦ ✦ ✦

"Certainly an Astounding
Mystery."—
INSPECTOR ROBERTS,
Bow Street
Police Headquarters.

"A very smart Show,
and certainly requires a
bit of doing."—
SERGT. BUSH,
Chief Gaoler,
Bow Street.

✦ ✦ ✦

The King of Handcuffs.
THE SENSATION OF LONDON.

Tremendous Success of Houdini, the King of Handcuffs, c. 1900. Library of Congress, Rare Book and Special Collections

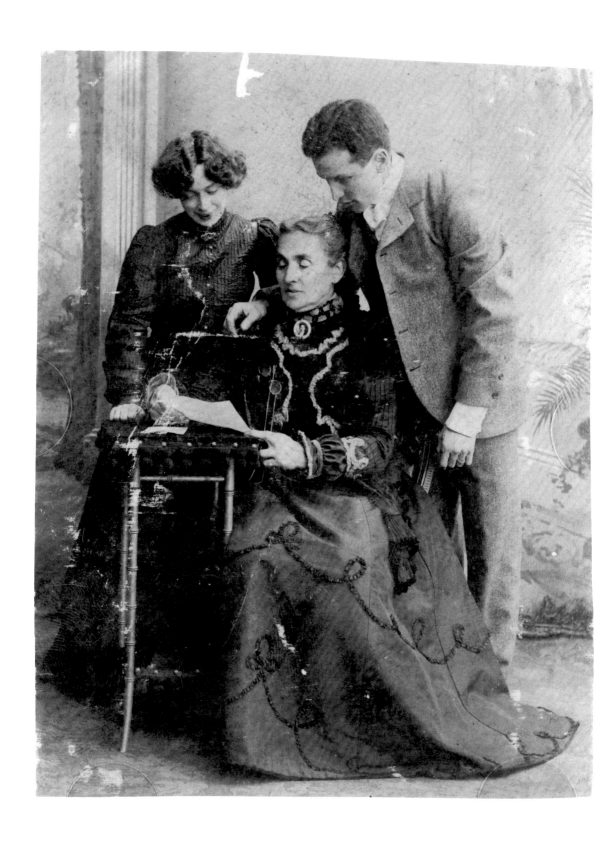

Harry Houdini with his wife, Bess, and his mother, Cecilia Steiner Weiss, c. 1900. Library of
Congress, Rare Book and Special Collections

Three portraits of Harry Houdini and his brother Theodore Hardeen, December 15, 1901. Library of Congress, Rare Book and Special Collections

In September, Houdini performs a stunt for German police in Berlin. Stripped bare, handcuffed, and bound, he frees himself in six minutes. Afterward the police commissioner agrees to endorse the magician's act. Houdini's subsequent advertisements declare that he is the "only artist in the history of Europe to whom the German police have given the Imperial certificates."

1901

After Houdini meets French film-maker Georges Méliès in Paris, Méliès directs Houdini's first short film sometime between 1901 and 1905. *Merveilleux exploits du célèbre Houdini à Paris* includes an appearance by Bess.

1902

An article in the Cologne newspaper *Rheinische Zeitung* accuses Houdini of bribing a policeman to help him with a phony jailbreak and of paying off a civilian police staff member to arrange another fraudulent escape at a public show. Houdini files a libel suit against the newspaper editor and the policeman; Houdini wins, but only after revealing a number of his techniques for escape.

Houdini at the Wintergarten, Berlin, 1903. Lithograph, 13⅞ x 18¾ in. (35.2 x 47.6 cm). Library of Congress, Rare Book and Special Collections

In Blackburn, England, bodybuilder William Hodgson answers Houdini's challenge to cuff him so he cannot escape. Hodgson brings many sets of irons to the event at the Palace Theatre, and although Houdini objects when he sees evidence of lock tampering, he does not back down from the contest. He frees himself from the irons after a grueling hour and forty minutes. Despite the dramatic escape, Hodgson dismisses the stunt and tries to discredit Houdini. Houdini refutes the claims that he has cut his way out; Hodgson, he says, must have sliced the hand-cuff links himself after the event.

1903

In the midst of violent anti-Semitism in Russia, Houdini performs in Moscow for several months. The Jewish magician remains safe in Russia even though his stay there coincides with a pogrom that decimates the Jewish community of Kishinev in April. He later goes to the city to witness the aftermath.

1904

In March, Houdini accepts a challenge by an agent of London's *Daily Illustrated Mirror* to free himself from a custom-made pair of handcuffs. After more than an hour

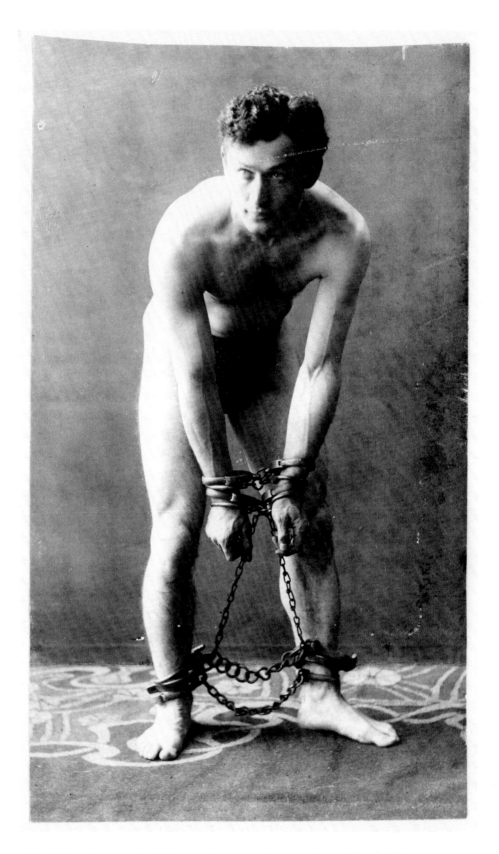

Houdini in chains, c. 1906. Photograph, 5 x 3 in. (12.7 x 7.6 cm). Library of Congress, Rare Book and Special Collections

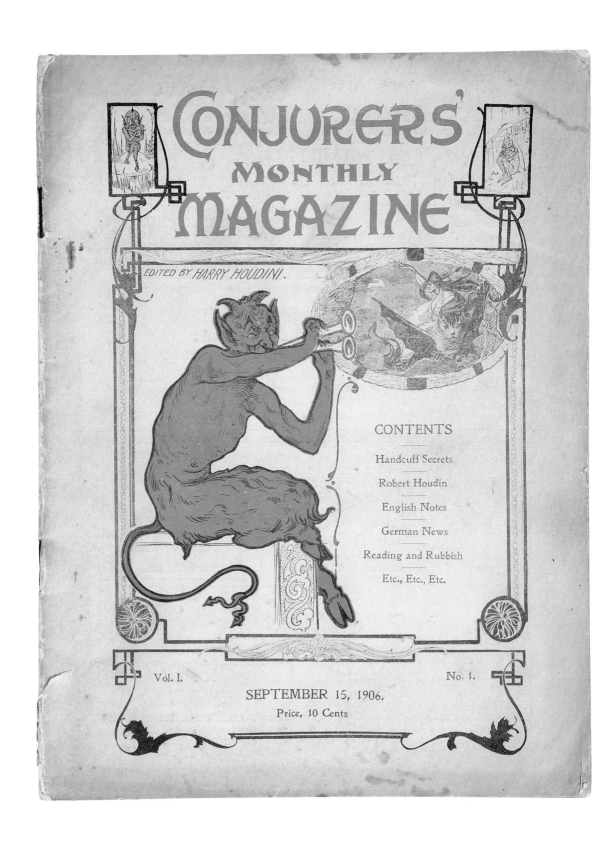

Four covers of *Conjurers' Monthly:* September 15, 1906; May 15, 1907; May 1908; July 1908.
Magazines, each 10 x 8 in. (25.4 x 20.3 cm). Collection of Arthur Moses, Fort Worth, Texas

of struggle, the magician's escape from the "*Mirror* Cuffs" at the London Hippodrome solidifies his renown.

1905

Houdini buys a farm in Stamford, Connecticut, and a Manhattan brownstone at 278 West 113th Street. Because Harry and Bess spend so much time on tour, they let his mother, sister, and two of his brothers move into the Harlem home.

1906

In January, Houdini causes a sensation when he escapes from the Washington, D.C., jail cell that once held Charles Guiteau, who assassinated President James Garfield some twenty-five years earlier. The specially designed brick cell has a bulletproof solid oak door. Houdini releases himself in two minutes, opens the cell doors of the other inmates in twenty minutes, persuades them to exchange cells with one another, relocks the doors, and emerges in the main hall unscathed.

From 1906 to 1908, Houdini serves as editor of the important magic publication *Conjurers' Monthly*.

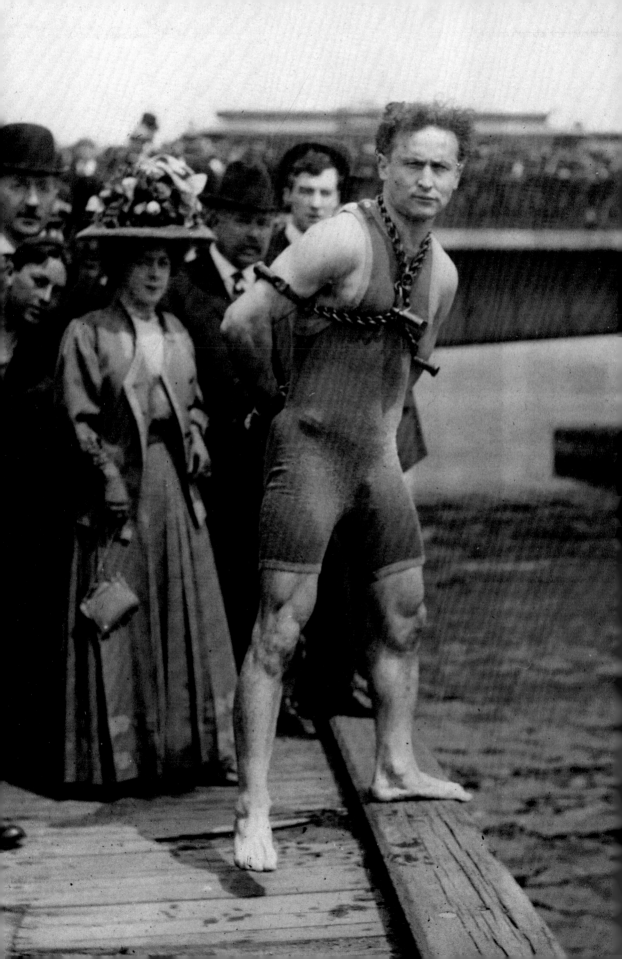

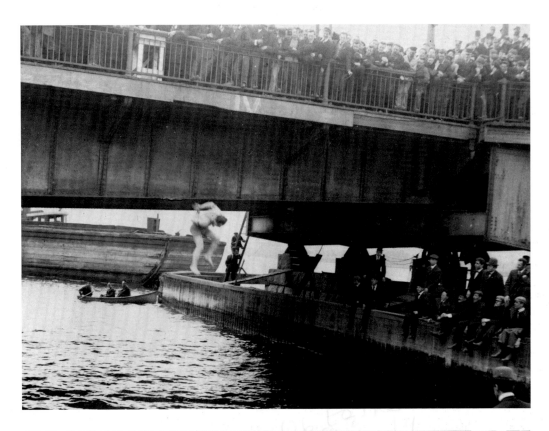

Houdini jumping from Harvard Bridge, Boston, April 30, 1908. Sequence of photographs from lantern slides. Library of Congress, Prints and Photographs Division

1907

In May, a manacled Houdini jumps from the Weighlock Bridge in Rochester, New York. An estimated ten thousand people come to view the spectacle, which is captured on film. Before and after his Rochester feat, Houdini jumps in manacles from bridges in Detroit, New Orleans, Pittsburgh, Boston, and other cities.

1908

In St. Louis, Houdini performs his noted Milk Can Escape, in which he is submerged crouching inside a large galvanized-steel can filled with water; the lid is placed on the can and then padlocked. In the routine, Houdini is able to escape in three minutes.

He publishes his controversial book *The Unmasking of Robert-Houdin*. In it Houdini traces the sources of the French magician's tricks to earlier practitioners, arguing that Robert-Houdin lacked originality.

1910

In March, Houdini makes history by piloting the first flight on the continent of Australia, in his Voisin biplane. He sustains the flight for three and a half minutes; a few days later he flies the plane again for more than seven and a half minutes.

Houdini and *The Unmasking of Robert-Houdin*, 1908. Photograph. Library of Congress, Rare Book and Special Collections

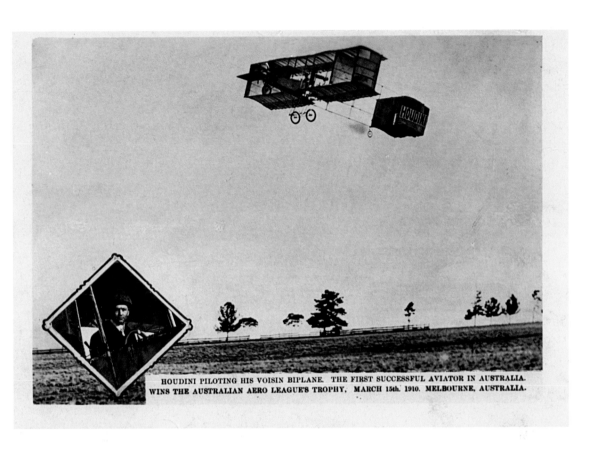

HOUDINI PILOTING HIS VOISIN BIPLANE. THE FIRST SUCCESSFUL AVIATOR IN AUSTRALIA.
WINS THE AUSTRALIAN AERO LEAGUE'S TROPHY, MARCH 15th. 1910. MELBOURNE, AUSTRALIA.

Houdini piloting biplane, Melbourne, Australia, 1910. Photo reproduction with typed text, 3½ x
5 in. (8.9 x 12.7 cm). Harry Ransom Humanities Research Center, The University of Texas at
Austin, Performing Arts Collection, Harry Houdini Collection

The Houdini family at 278 West 113th Street in New York, with Mrs. Rahner seen in the window, c. 1910. Photograph, 4¼ x 6¼ in. (10.8 x 15.9 cm). Kevin A. Connolly Collection

1912

Houdini debuts the underwater box escape in New York's East River on July 7. In the stunt, he is shackled and locked inside a wooden box and then submerged in the river. After about a minute underwater, he reappears, splashing up beside the box.

In September, at Circus Busch in Berlin, Houdini premieres his Water Torture Cell escape, which will become renowned. Hanging upside down, his ankles in stocks, Houdini is locked inside a glass booth filled with water. Over the history of his performance of this trick, he is able to free himself in as little as thirty seconds.

Houdini, in a packing case, being lowered into New York Harbor, 1914. Photograph, 9⁵⁄₁₆ x 7⅜ in. (23.7 x 18.7 cm). Library of Congress, Rare Book and Special Collections

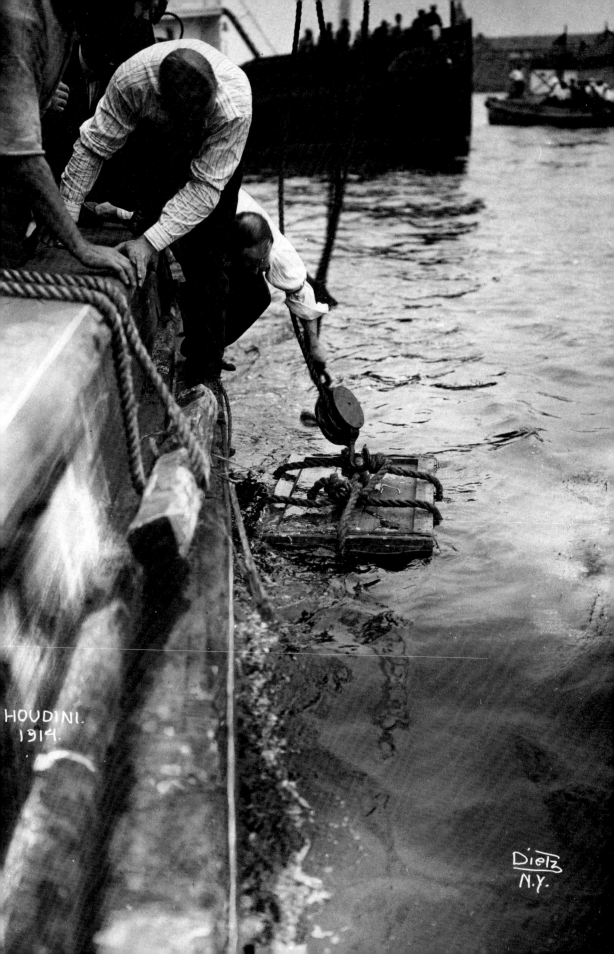

HOUDINI.
1914.

Dietz
N.Y.

1913

Ehrich Weiss legally changes his name to Harry Houdini.

Cecilia Weiss has a stroke and dies on July 17. Houdini, on tour in Copenhagen, reportedly faints upon receiving the news by telegram. Despite Jewish tradition, his mother's burial is postponed until he returns to the United States, so that he can see her one last time.

On the ship back to America, Houdini meets Theodore Roosevelt. He performs a Spiritualist trick, which amazes the former president. Feeling guilty for tricking Roosevelt, Houdini admits to him privately that he did not use "genuine Spiritualism" but rather "hokus pokus."

Harry and Bess Houdini and companion, Munich, 1913. Library of Congress, Rare Book and Special Collections

1915

During a performance at the Los Angeles Orpheum, Houdini gets into an argument with heavyweight boxing champion Jess Willard, who has refused to join the examination committee onstage. Willard insults him, but Houdini wins over the crowd by responding, "I will be Harry Houdini when you are not the heavyweight champion of the world."

In September, Houdini performs an outdoor Straitjacket Escape in front of the headquarters of the *Kansas City Post* and, three weeks later, at the offices of the *Minneapolis Evening Tribune,* hanging forty-five feet above a crowded street. The act becomes a

Houdini with his mother, Cecilia Weiss, c. 1905. Photograph, 6½ x 4 in. (16.5 x 10.2 cm). Collection of Ken Trombly, Bethesda, Maryland

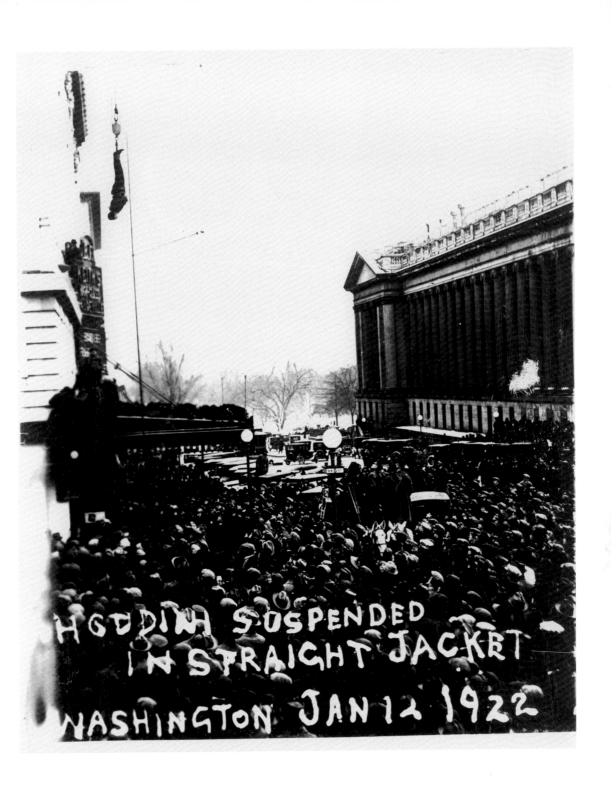

Houdini performing a Straitjacket Escape, Washington, D.C., January 12, 1922. Photograph, 4¼ x 4 in. (10.8 x 10.2 cm). Library of Congress, Rare Book and Special Collections

Houdini, the Justly World-Famous Self-Liberator! Orpheum Winnipeg, c. 1915. Lithograph, 40 x 20 in. (101.6 x 50.8 cm). Collection of Ken Trombly, Bethesda, Maryland

regular escape performance and publicity stunt for the magician, who presents it before opening a show in almost any American city that he visits that has skyscrapers, including Denver, Boston, Omaha, San Antonio, New Orleans, Cleveland, Pittsburgh, New York, and Providence.

1917

After a German submarine sinks the American transport ship *Antilles,* Houdini convinces master magician Harry Kellar to come out of retirement for a benefit at the New York Hippodrome in support of the victims' families. Besides Kellar and Houdini, other members of the Society of American Magicians and a roster of opera and other musical acts are on the bill. The show raises nearly $10,000.

1918

Houdini stars in *Cheer Up,* a patriotic variety show at the New York Hippodrome, performing for nineteen weeks—the longest run of his career. Among the highlights of his act are his underwater box escape and making an elephant disappear.

Houdini with Jennie the elephant performing at the Hippodrome, New York, 1918. Photograph, 14 x 11 in. (35.6 x 27.9 cm). Collection of Ken Trombly, Bethesda, Maryland

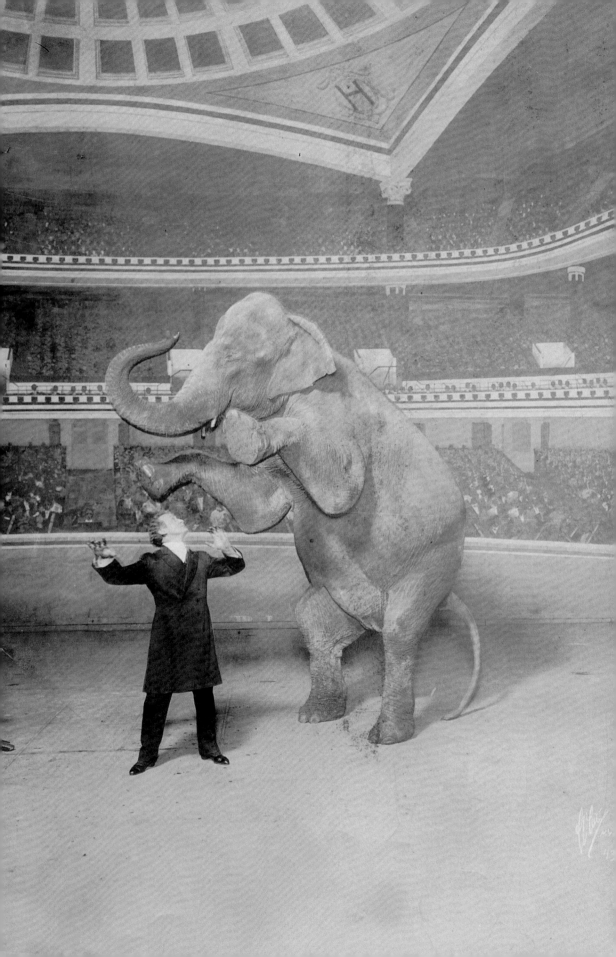

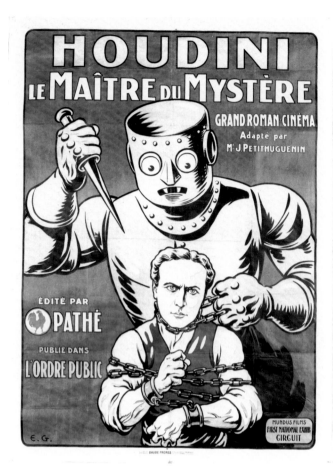

Houdini, *Le Maître du Mystère* (*The Master Mystery*), 1919. Lithograph. Library of Congress, Rare Book and Special Collections

1919

Houdini's first motion picture, *The Master Mystery,* a fifteen-episode serial, is released in January. Despite his minimal acting skills, he wins audiences with his stunts and becomes an even greater international star.

Houdini signs with Famous Players–Lasky Corporation to produce his next film, *The Grim Game,* a murder mystery. The motion picture company's previous productions have starred Mary Pickford, John Barrymore, and Rudolph Valentino.

1920

After a suggestion from Houdini to Mabel Wagnalls, the daughter of a publisher, the new edition of the Funk & Wagnalls dictionary includes the verb *houdinize,* which means "to release or extricate oneself from (confinement, bonds, or the like), as by wriggling out."

Houdini's second film with Famous Players–Lasky, *Terror Island,* is released. The movie is largely panned by critics.

From the motion picture *Back Stage* (1919), Harry Houdini and Roscoe "Fatty" Arbuckle, c. 1919. Gelatin silver vintage print, 8 x 10 in. (20.3 x 25.4 cm). George Eastman House Motion Picture Department Collection

Houdini with Charlie Chaplin, Los Angeles, c. 1919. Photograph, 3 x 2 in. (7.6 x 5.1 cm). Courtesy of Fantasma Magic Shop, New York, www.fantasmamagic.com

Houdini in *"The Man from Beyond,"* 1922. Lithograph, 9⅜ x 13½ in. (23.9 x 34.3 cm). Library of Congress, Rare Book and Special Collections

Houdini establishes his own movie production company, the Houdini Picture Corporation, as a vehicle for making films in which he can star. He begins writing a screenplay for *The Man from Beyond,* which will premiere in 1922. The film combines science fiction and Spiritualist elements.

1921

Miracle Mongers and Their Methods is published by E. P. Dutton. Here Houdini reveals the techniques of fire-eaters, poison-eaters, and venomous-reptile-defiers.

1922

On vacation in Atlantic City with Sir Arthur Conan Doyle, creator of Sherlock Holmes and a leading advocate of Spiritualism, and his family, Houdini attends a séance with Lady Doyle, who claims to channel automatic writing from Houdini's mother. Houdini is not convinced, and the incident sparks the magician's crusade to debunk Spiritualism and leads to the end of his friendship with Doyle.

Haldane of the Secret Service, Houdini's last film, is released. After the detective picture proves a critical and box-office failure, Houdini quits acting and film production altogether.

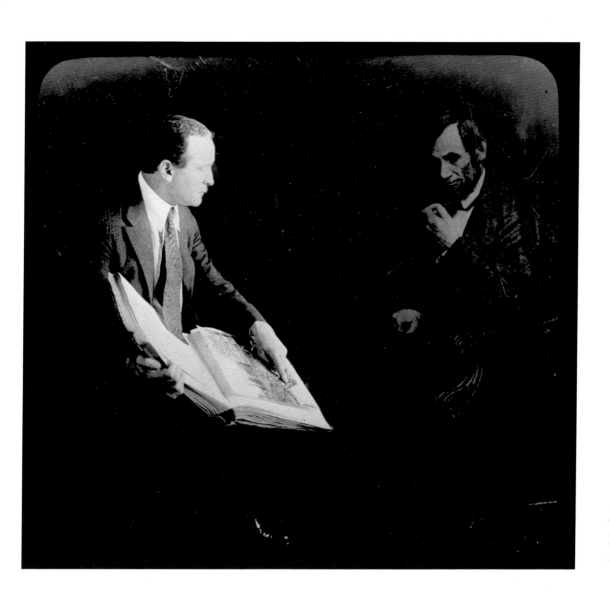

Houdini and the ghost of Abraham Lincoln, 1920s. Lantern slide, 3¼ x 4 in. (8.3 x 10.2 cm).
Library of Congress, Prints and Photographs Division

Houdini sits with famed Boston medium Mina Crandon, a.k.a. "Margery." Convinced that she is a fraud, he disputes her and members of the *Scientific American* panel selected to evaluate her talents. The incident receives extensive press coverage.

In the spring, Houdini publishes *A Magician Among the Spirits,* in which he discloses the practices of fraudulent mediums and Spiritualists.

Early in the year, Houdini invites Margery to appear with him at Symphony Hall in Boston, but she declines. Instead, Houdini stages a séance to expose her methods. In February, members of the *Scientific American* committee deny Margery the prize for producing a "psychic manifestation of a physical character," effectively asserting that they have found no evidence of supernatural gifts. In November, a psychology graduate student at Harvard

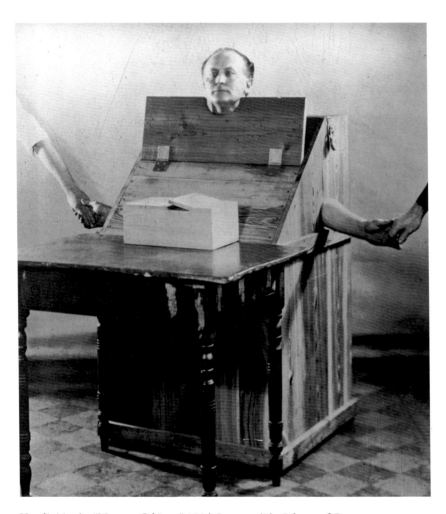

Houdini in the "Margery Cabinet," 1924. Lantern slide. Library of Congress

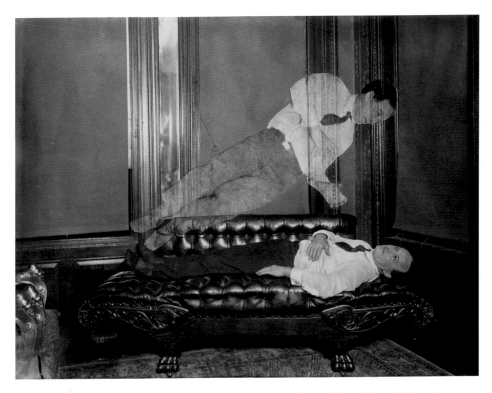

Spiritualist image of Houdini, 1920s. Photo collage, 5½ x 6½ in. (14 x 16.5 cm). Kevin A. Connolly Collection

publishes an article in the *Atlantic Monthly* that shames Margery by revealing her act as an obvious fraud.

At the end of the year, Houdini's eponymously titled Broadway show opens, earning him respect as both theater performer and professional magician. At two and a half hours and three acts, it is the longest show in which he has ever performed; it runs for a few months, including a stop in Chicago. It features a number of his famous escape acts and an exposé of Spiritualism, along with fifteen new magic tricks and illusions.

Harry and Bess Houdini, Married Thirty-One Years, 1925. Photograph, 4 x 3 in. (10.2 x 7.6 cm). Kevin A. Connolly Collection

1926

Houdini speaks before Senate and House subcommittees in February and May for a bill intended to prosecute those "pretending to tell fortunes for reward or compensation." In the highly unorthodox congressional hearing, Bess appears as a character witness.

On August 5, at the Hotel Shelton in New York, Houdini wins a challenge posed by Egyptian fakir Rahman Bey by staying in an airtight coffin submerged underwater for an hour and a half. Houdini denies accusations that the coffin is rigged.

In late October in Montreal, a McGill University student persuades Houdini to allow him to punch the magician in the abdomen in order to test Houdini's strength. Despite intense pain afterward, Houdini refuses to cancel any shows or seek medical attention, until he collapses one week later after a performance at the Garrick Theatre in Detroit and is taken to the hospital. Doctors discover a ruptured appendix, peritonitis, and streptococcal infection. After several days and two operations, Houdini dies, on October 31.

Houdini's funeral is held in New York on November 4 at the Elks clubhouse in Times Square. The event, attended by some two thousand mourners, is reported

Houdini with Senator Arthur Capper, Republican of Kansas, at congressional hearing, February 26, 1926. Glass negative, approx. 5 x 7 in. (12.7 x 17.8 cm). Library of Congress, Prints and Photographs Division

Houdini stepping out of coffin after being sealed up for ninety minutes, Hotel Shelton, New York, August 5, 1926. Library of Congress, Prints and Photographs Division

widely by the press. In accordance with his instructions, Houdini is buried next to his mother in the Jewish Machpelah Cemetery in Queens.

Obituary for Harry Houdini, *Jewish Daily Forward,* November 1, 1926. Newspaper, 24 x 20 in. (61 x 50.8 cm). Collection of Ken Trombly, Bethesda, Maryland

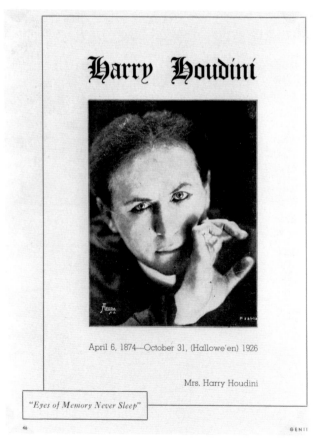

Harry Houdini

April 6, 1874—October 31, (Hallowe'en) 1926

Mrs. Harry Houdini

"Eyes of Memory Never Sleep"

Bess Houdini and Theodore
Hardeen visiting Houdini's
grave, c. 1928. Photograph.
Library of Congress,
Rare Book and Special
Collections

Bess Houdini's memorial
notice for her late husband
in *Genii* magazine, c. 1936.
Photomechanical print.
Library of Congress,
Rare Book and Special
Collections

1927

Fulfilling her husband's dying wish, Bess Houdini holds a séance in an attempt to conjure his spirit on the first anniversary of his death on Halloween. For ten years after his death, she holds a séance every October 31.

In December, Bess performs her own magic act in New York, including a few escapes from her late husband's repertoire.

1928

Bess opens a magic show in March at the Commodore, a vaudeville theater in New York, and develops her magic career. She hires a manager, Edward Saint, and tours the country through the late 1930s.

Harold Kellock enlists Bess in writing his biography of her husband, *Houdini: His Life-Story: From the Recollections and Documents of Beatrice Houdini.*

1931

Bess Houdini launches a campaign to declare October 31 "National Magic Day" in honor of the anniversary of Harry's death.

1936

On the tenth anniversary of the magician's passing, Bess holds her last séance to attempt to communicate with his spirit. After

Bess Houdini, after 1926. Photograph. Library of Congress, Rare Book and Special Collections

the séance is unsuccessful, she abandons all such attempts.

1941

Bess contributes an introduction to Geraldine Conrad Larsen's *Diary of a Magician's Wife,* a fictionalized account of the wife of a famous magician.

1943

Bess Houdini dies on February 11 near Needles, California, en route by train to New York. She is buried in a Catholic cemetery in Hawthorne, New York, as she has arranged beforehand; as a non-Jew, she is forbidden interment next to her husband in the Jewish cemetery.

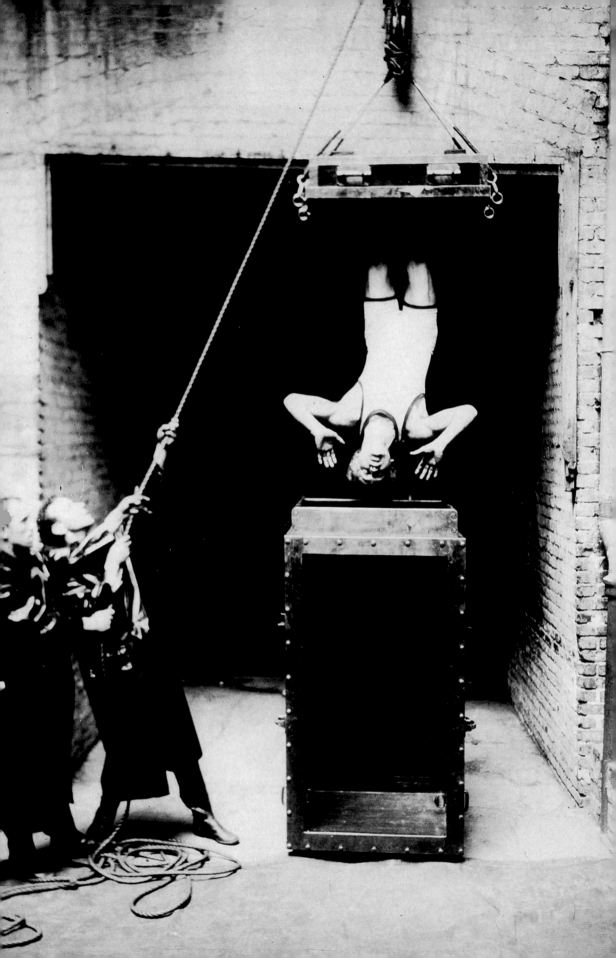

Houdini's Magic Apparatus

Needle Threading

The East Indian Needle Threading Trick is a magic effect that probably developed from the East Indian Bead Trick of the 1800s.[1] Houdini's first view of a needle threading trick may have come in 1893 when he was alleged to have "picked up the secret" of "Ovette's Original Needle Trick" while performing as one of The Brothers Houdini on the Midway at the World's Columbian Exposition in Chicago.[2] However, evidence for Houdini's presence at the Chicago World's Fair is scant. He likely first staged this parlor trick at the Kansas City Orpheum in 1899.[3] Houdini described the effect as follows: "[The] performer . . . invited a committee to step on the stage and examine a pack or several packages of needles, thread and to thoroughly inspect his mouth. Performer taking the needles lays them on his outstretched tongue and swallows them, drinking water to 'wash' them down. Performer unwinds a length of thread and swallows that also. Several grimaces are made after which performer reaches into his mouth and securing hold of the thread withdraws it slowly and it is seen that the needles are threaded on the thread. The mouth once again shown as empty."[4]

Needles and thread, n.d. Metal and string, dimensions variable. From the Collections of American Museum of Magic, Marshall, Michigan

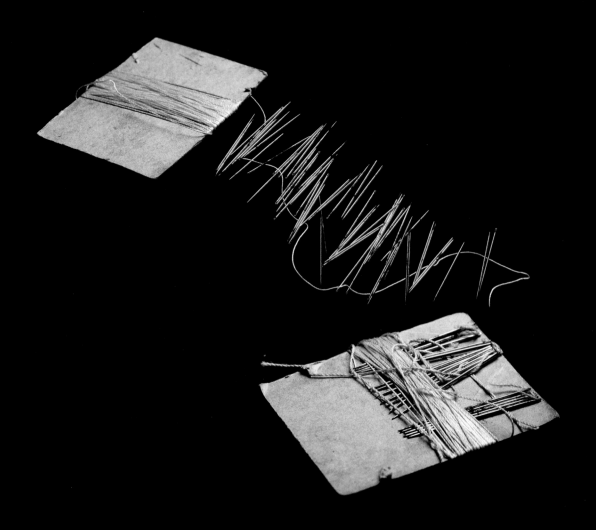

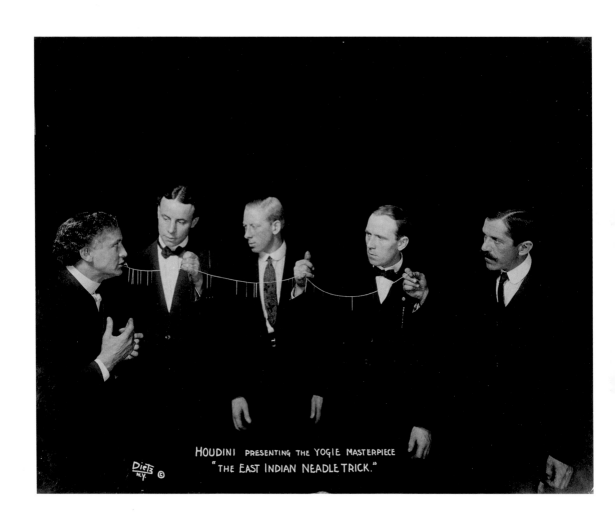

Houdini demonstrating the Needle Threading Trick, c. 1915. Photograph, 11 x 14 in. (27.9 x 35.6 cm). Collection of Ken Trombly, Bethesda, Maryland

The Orpheum Circuit News

Published in the Interest of the Orpheum Circuit of Theatres
NELLIE REVELL, Editor, Palace Theatre Building, New York

| Vol. I. | OAKLAND, CAL., NOVEMBER 14, 1915 | No. 5 |

AN ODE TO HOUDINI

Oh wizard of handcuffs, of bolt, bar,
 and cell,
How he glides from thy clutches no-
 body can tell;
But he flits from thy bonds like a
 bird through the air,
Leaving naught but his fetters and
 wonderment there.

With steel chains you may bind him
 and shackle him fast,
But he's vanished and gone ere a
 moment has passed;
There is nothing can hold him—the
 marvelous elf—
Houdini, the mystery, to all but him-
 self.

Straitjackets in which desperate mani-
 acs pined,
The murderer's cell that held death-
 doomed confined,
The handcuffs and shackles, locking
 fast arm and limb,
Are but mockeries as fetters and use-
 less on him.

From strong box or steel boiler, where
 rivet and nail
Have been driven in vain to make
 for him a jail,
From every contrivance of bondage
 and pain,
He escapes without effort and smiles
 in disdain.
 —J. E. H.

Vaudeville Notes

An American team that has attained great popularity in Australia during the past year is Sidney Jarvis and Virginia Dare. They will get back to America a day or so after Christmas, according to their present schedule and arrangements have been made for them to open a tour of the Orpheum Circuit at San Francisco New Year's week.

 ✗

The stage has been indebted to Henry E. Dixey for many fine characterizations and now he has introduced his son, Henry E. Dixey, Jr., who, reports from New York indicate, is a brilliant young actor and "a worthy son of a worthy sire." He has just made his debut in New York vaudeville in a comedy-dramatic sketch, "The Cheats," which was staged by his famous father.

 ✗

Another romance of the stage has just come to light. The vaudeville team of Natalie & Ferrari, who have been business partners for several seasons, became partners for life during a recent engagement at Atlantic City, N. J. The ceremony revealed the fact that the correct name of the young lady who now likes to be called Mrs. Martin Ferrari never had a Natalie in it. She was Miss Dorothy Damon.

 ✗

Mabel Russell, in real life Mrs. Eddie Leonard, and until this season his vaudeville partner, is now offering a new act with Jimmie Hughes. The "waw waw" singer has an elaborate minstrel act in vaudeville this season. In her new act, Miss Russell is no longer a blonde belle on the stage, but again is seen as the pretty and vivacious blonde she really is.

HOUDINI—MASTER SHOWMAN, KNOWN AS "ELUSIVE AMERICAN," IS THE RAGE

Houdini, the man who is known all over the world as "The Elusive American," is creating so much excitement at the Orpheum in San Francisco that it is lapping over into Oakland and the Oakland Orpheum box office is being besieged with inquiries regarding Houdini's appearance in this city. He comes to Oakland next Sunday.

When the Oakland Orpheum opened in 1907, Houdini was playing in the San Francisco Orpheum and his contract did not permit him to come to

HOUDINI
PRESENTING THE YOGIE MASTERPIECE

Oakland at that time. This was more than eight years ago. Since then Houdini has been abroad most of the time, adding to his already great fame and packing the continental theaters the year round.

Houdini has probably had more newspaper stuff printed about him than any man in the world. He started providing copy for the newspapers fifteen years ago with his famous handcuff tricks. He was the original handcuff king. No pair of handcuffs could hold him nor could any prison doors. Houdini would go to any police station, in company with newspaper men, and allow all the detectives to put their handcuffs on him—handcuffs of which the detectives were proud, and then, step behind a screen and would reappear in a second with every handcuff unfastened. Oregon boots were handled the same way. So were all jails doors. Nothing could hold Houdini.

Naturally the police reporters around the different police stations wrote columns about this genius and so his fame grew. In the theatres he gave a wonderful performance, elaborate and complete.

Then Houdini began performing such cute little stunts as to let himself be put in a straight jacket, manacled and hand-cuffed, and then he would dive from the bridge into a convenient river and in the water would free himself from the straight jacket, hand cuffs and manacles, and swim ashore with ease.

Crowds of twenty and thirty thousand people watched Houdini do these remarkable stunts and of course were drawn to the theatre to see him in his stage illusions.

Houdini's books on magic and illusions have become world known and are said to have netted him a fortune. In the stage profession Houdini is rated as the richest vaudeville performer in the world, being worth easily more than a million. Fifteen years ago he was a dime museum performer in Chicago, doing fourteen shows a day for thirty dollars a week.

Charlotte Parry, the protean actress who was seen over the Orpheum Circuit a few seasons ago in her psychological fantasy, "Into the Light," has just returned to this country from England. She may play a return tour of the Orpheum theatres.

Laura Nelson Hall, who for three years played the title role in the allegory, "Everywoman," and then created the principal part in "The Poor Little Rich Girl," has put aside the drama for vaudeville, and in a sketch by R. H. McLaughlin, called "Demi-Tasse," is journeying over the Orpheum Circuit.

Orpheum Circuit News, November 14, 1915. Pamphlet, 13½ x 7⅞ in. (34.3 x 20 cm). Library of Congress, Rare Book and Special Collections

Jane Hammond (AMERICAN, BORN 1950)

Untitled (193, 184, 141, 109), 1990. Oil on linen, 76 x 70 in. (193 x 177.8 cm). Collection of Madeleine and David Lubar

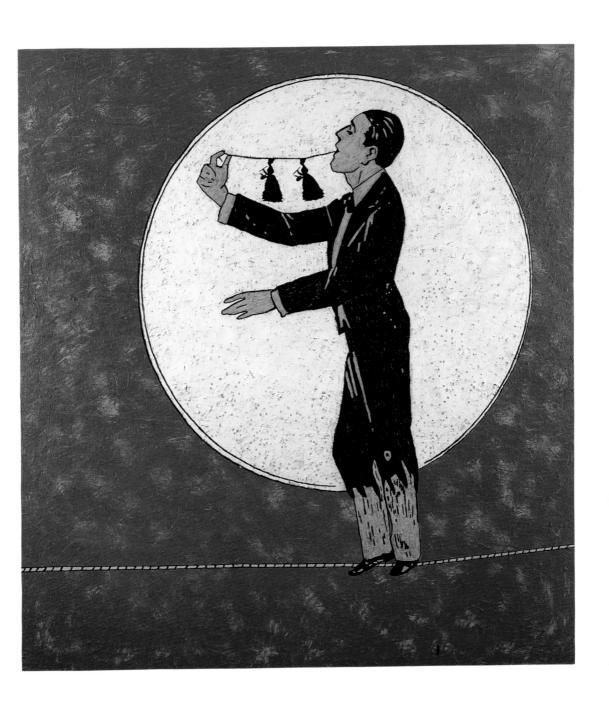

Handcuffs

If it was Houdini's early billing as "The Handcuff King" that helped make him famous, it was those same handcuffs that secured Houdini's discovery by the vaudeville impresario Martin Beck. Their fateful meeting in 1899 changed Houdini's life and has been commemorated in a variety of cinematic-style narratives.[5] But prior to their initial encounter, handcuffs were probably familiar to Houdini. There is extensive lore about Houdini's early run-ins with handcuffs: to secure money for his impoverished family, he apprenticed to locksmiths as a boy in Wisconsin; his mother used to lock aromatic baked goods in cupboards and Houdini's childhood sweet tooth ensured that he would jimmy open any lock; and, for fun, he unlocked stores on Main Street in Appleton long after shopkeepers had gone home. His celebrity was built on the handcuff contest whereby he would challenge audience members to bring him a set of manacles, only to break free from them.[6] Houdini would also visit jails in the towns where he toured and challenge the local authorities to lock him, handcuffed, in a jail cell. Of course, Houdini, often nude when he performed these feats in prisons, escaped.

One of Houdini's most difficult handcuff escapes was in 1904 at the London Hippodrome, where he was finally liberated after seventy minutes from the *Daily Illustrated Mirror* handcuffs, a monstrous set with "six sets of locks and nine tumblers in each cuff."[7] Houdini's leg irons were often paired with handcuffs, and he supplemented his escapes from these fetters with jumps from bridges during which he was further secured with chains, or placed in a locked box and thrown into a river. Other magicians sought to copy these performances, but to no avail—Houdini's mission was to protect his eminence. Of the handcuff challenge, he wrote, "I assert that this act has proved to be the greatest drawing card and longest lived sensation that has ever been offered in the annals of the stage. This has been demonstrated by the record-breaking attendance in every theatre in which I have given the act, either in part or whole, and also by the duration of my term of engagement in the principal theatres among those in which I have been booked."[8]

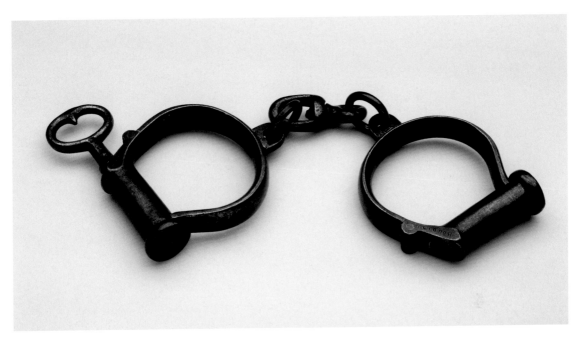

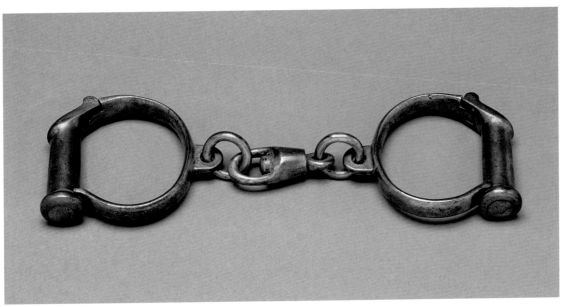

Handcuffs, late nineteenth or early twentieth century. Metal, 4¼ x 10 x ¾ in. (10.8 x 25.4 x 1.9 cm). Kevin A. Connolly Collection

Handcuffs, late nineteenth or early twentieth century. Metal, 4 x 8 x 3 in. (10.2 x 20.3 x 7.6 cm). Harvard Theatre Collection, Houghton Library, Cambridge, Massachusetts

OVERLEAF

Handcuffs, late nineteenth or early twentieth century. Metal, dimensions variable. Sidney H. Radner Collection at The History Museum at the Castle, Appleton, Wisconsin

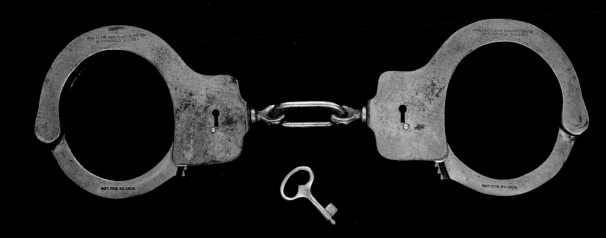

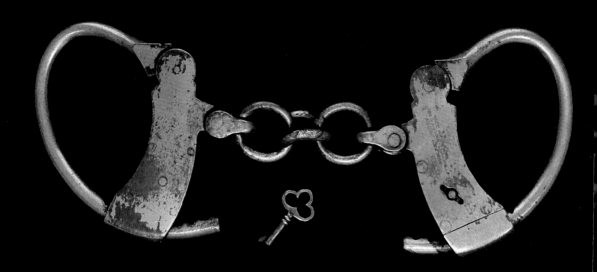

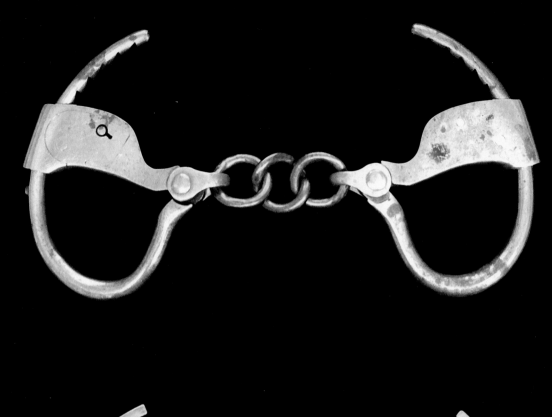

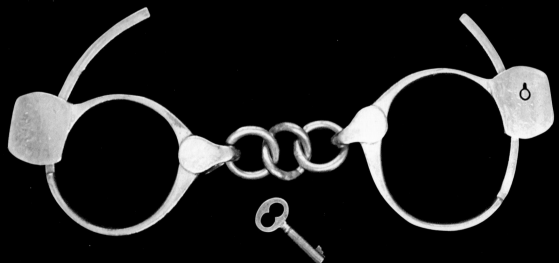

IMPORTANT.

NOTICE.

I OFFER $100.00 to any human being living that can escape from all the cuffs I carry, and from which I release myself.

I escape from the celebrated Bean Giant Cuff with them locked behind my back, a feat no one else has ever accomplished. My hands can be fastened back or front. It makes no difference how many pair of cuffs are locked on me **(at the same time)**, and I will allow the **keyholes to be stamped and sealed,** and as I bring out all the cuffs interlocked, it proves conclusively that **I do not slip my hands.**

I have escaped out of more handcuffs, manacles and leg shackles than any other human being living. As I carry a very rare, curious and costly collection of torture, antique and modern Handcuffs (of every style and make), I give a scientific and historic lecture on them; in fact, I have the ONLY complete act of this description in existence.

Of the Team

Harry and Bessie Houdini

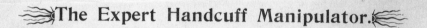

➤The Expert Handcuff Manipulator.◄

NOTE.—There is a **$50.00 REWARD** offered to any one that can escape from the Bean Giant, but that offer is for the cuffs to be fastened behind the back.

Did you ever see any handcuff worker have his hands locked in back to escape from the Bean cuff?

Harry Houdini, the Expert Handcuff Manipulator, c. 1895. Flier, 11 x 8⁵⁄₁₆ in. (27.9 x 21.1 cm). Library of Congress, Rare Book and Special Collections

Manacled Houdini, n.d. Cabinet photograph, 6⅝ x 3⅛ in. (16.8 x 7.9 cm). Collection of Dr. Bruce J. Averbook, Cleveland

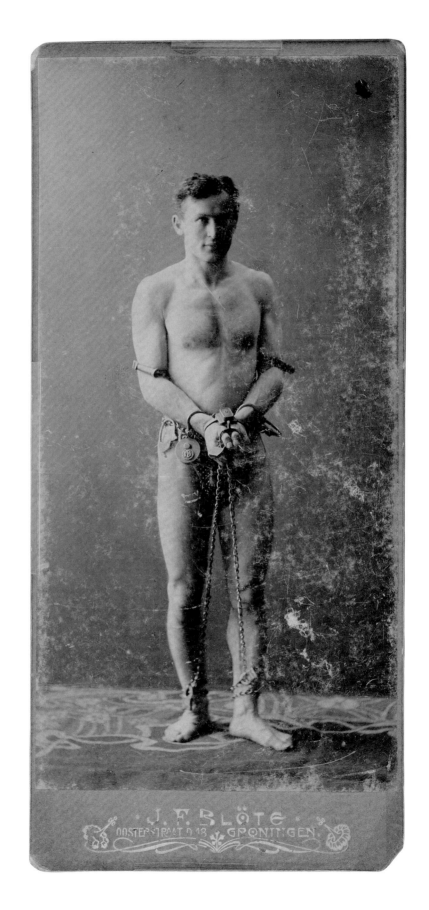

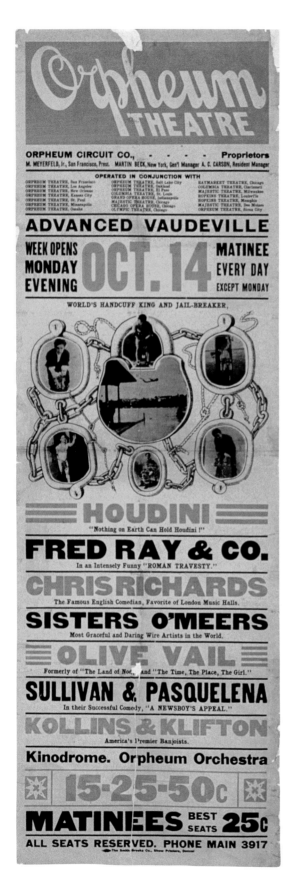

Houdini—"Nothing on Earth Can Hold Houdini!" Orpheum Theatre, c. 1901. Broadside, 40½ x 13⅝ in. (102.9 x 34.6 cm). Library of Congress, Prints and Photographs Division

Houdini in chains, 1903. Photograph, 5½ x 3⁷⁄₁₆ in. (14 x 8.7 cm). Library of Congress, Rare Book and Special Collections

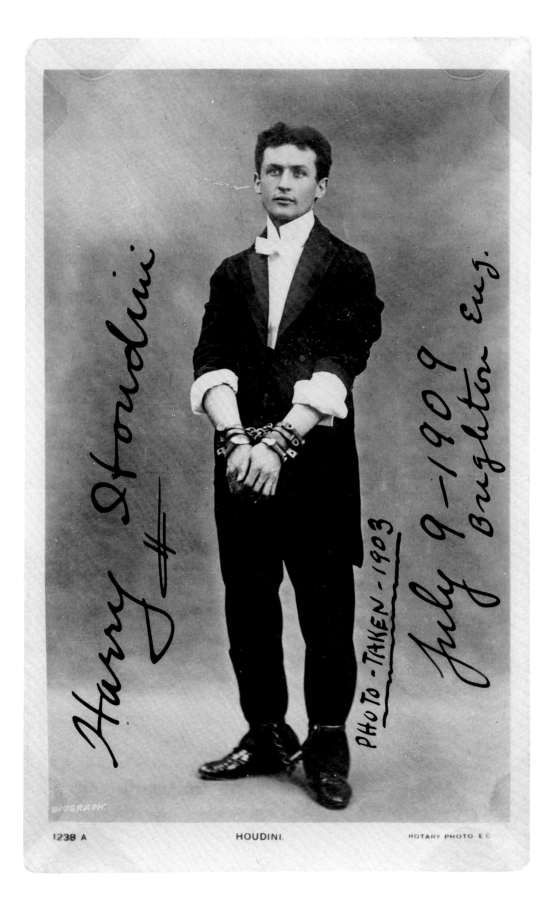

Harry Houdini

PHOTO-TAKEN-1903

July 9—1909
Brighton Eng.

BIOGRAPH

1238 A HOUDINI. ROTARY PHOTO E.C.

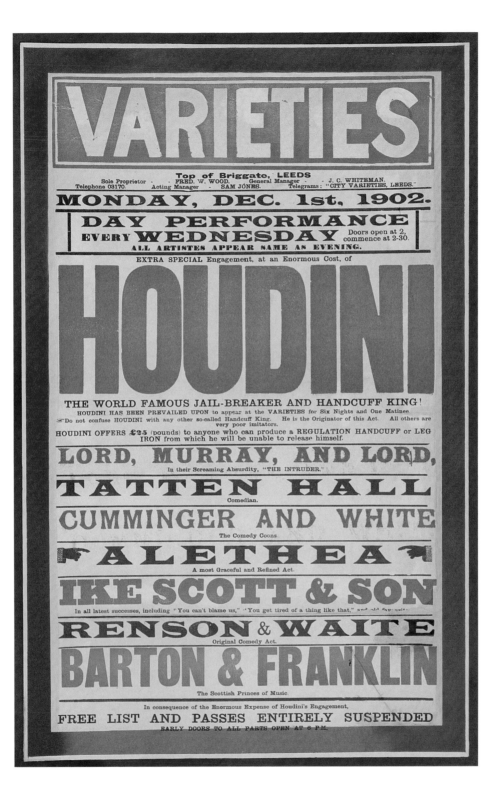

Houdini, the World-Famous Jail-Breaker and Handcuff King! Varieties Theater, Leeds, England, 1902.
Broadside, 19 x 14 in. (48.3 x 35.6 cm). Collection of Ken Trombly, Bethesda, Maryland

Houdini, Victory, Victory, Victory, Still King of Hand-Cuffs, London Hippodrome, March 17, 1904. Broadside, 31 x 22 in. (78.7 x 55.9 cm). Collection of Ken Trombly, Bethesda, Maryland

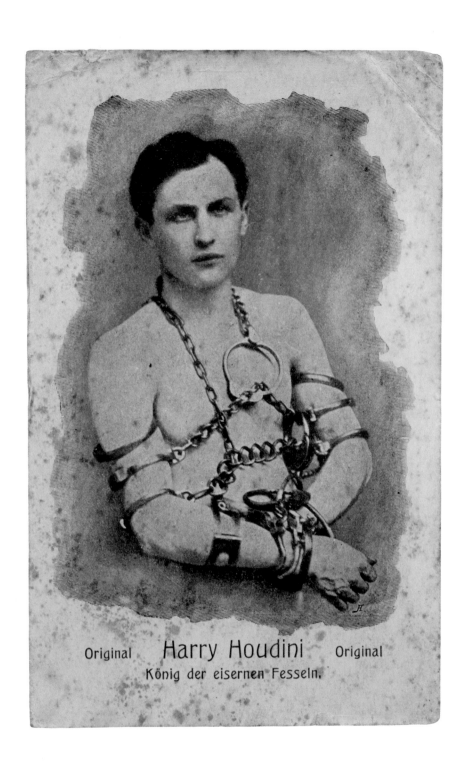

Original **Harry Houdini** Original
König der eisernen Fesseln.

Harry Houdini, King of Handcuffs, c. 1903. German postcard, 5⅞ x 3¾ in. (14.9 x 9.5 cm).
Collection of Dr. Bruce J. Averbook, Cleveland

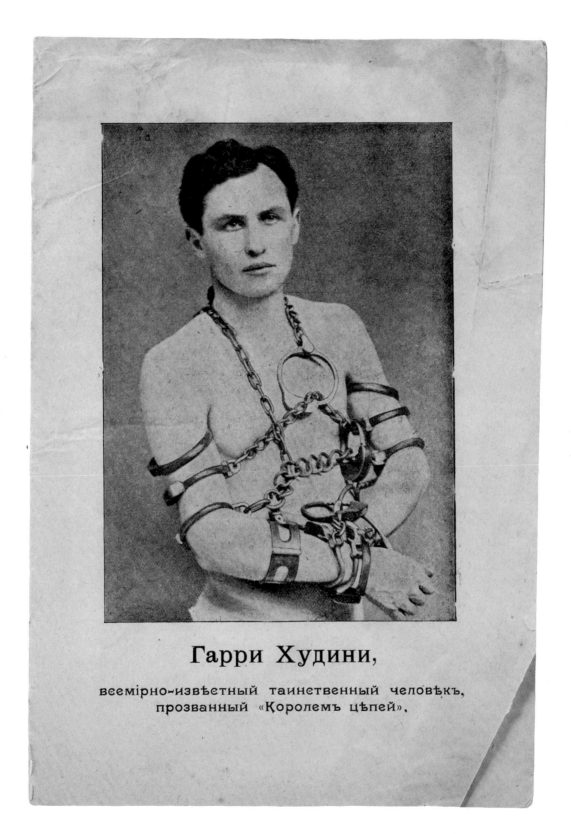

Гарри Худини,

всемірно-извѣстный таинственный человѣкъ,
прозванный «Королемъ цѣпей».

Harry Houdini, King of Handcuffs, c. 1903. Russian pamphlet, 8½ x 5¾ in. (21.6 x 14.6 cm).
Kevin A. Connolly Collection

No Locks Can Hold Houdini at Keith's, n.d. Card, 5 x 10 in. (open) (12.7 x 25.4 cm). Collection of Ken Trombly, Bethesda, Maryland

Bright Bits
from
Keith's
Favorites
*
New
Bookings

KEITH'S THEATRE NEWS.

Doings at
the
Million-
Dollar
Amusement
Palace

VOL. II PHILADELPHIA, WEEK OF JANUARY 22, 1906 NO. 46

LOBBY OF KEITH'S THEATRE DURING THE ENGAGEMENT OF HOUDINI, THE "JAIL BREAKER"

Showing the Handcuff King's wonderful collection of shackles and irons from all parts of the world and of various periods of penal history. This collection was gathered by Mr. Houdini at great expenditure of time, patience and money and stands unique. FROM EVERY ONE OF THESE INSTRUMENTS OF PRISON TORTURE Houdini has escaped with ease—a feat never exceeded by ANY MAN IN THE WORLD.

DO YOU LIKE THIS NUMBER OF "KEITH NEWS?" *You may have a copy sent you FREE on Monday of each week by leaving your Address with an Usher at Box Office, or mailing Post Card to Keith's, Phila., Pa,*

Keith's Theatre News, with image of lobby display, January 1906. Pamphlet, 9¼ x 6¼ in. (23.5 x 15.9 cm). Kevin A. Connolly Collection

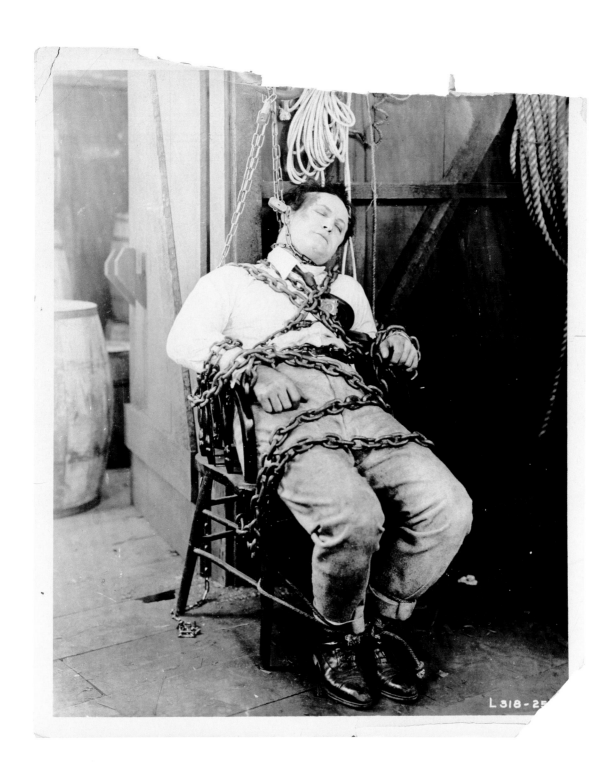

Houdini seated in chains, n.d. Photograph, 9½ x 8 in. (24.1 x 20.3 cm). Courtesy of the Museum of the City of New York, Theater Collection

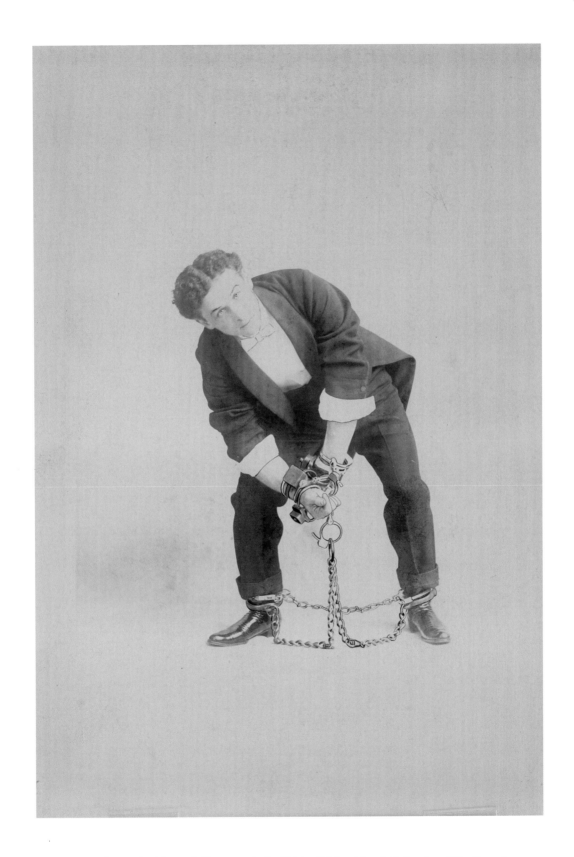

Houdini in shackles, n.d. Photograph, 8 x 5½ in. (20.3 x 14 cm). Collection of Dr. Bruce J. Averbook, Cleveland

Deborah Oropallo (AMERICAN, BORN 1954)

Escape Artist, 1993. Oil on canvas, 86⅟₁₆ x 76 in. (218.6 x 193 cm). Whitney Museum of American Art, New York, Purchase, with funds from Evelyn and Leonard A. Lauder, 95.100

Metamorphosis Trunk

Early on, Houdini performed card tricks and the East Indian Needle Threading Trick, mainstays of the magician's act. However, Houdini's initial fame as an escape artist arose from his earliest effect, the Metamorphosis Trunk, in which a magician is bagged and then sealed into a trunk by an assistant, who seconds later appears bagged and sealed into the trunk while the magician stands free. Magic scholars Milbourne and Maurine Christopher credit two of Houdini's distinguished predecessors, the English magician John Nevil Maskelyne (1839–1917) and the Frenchman Alexander Herrmann (called Herrmann the Great, 1844–1896) as having first performed the Metamorphosis, although Houdini made modifications to enhance the trick's showmanship.[9] Harry debuted the Metamorphosis with his brother Dash in the early 1890s. When Harry and Bess married in 1894, Bess's small frame provided the ideal substitute for Dash, enabling the couple to perform Metamorphosis in the three seconds claimed by the poster advertising their act.

Metamorphosis trunk, late nineteenth or early twentieth century. Wood and metal, 29¾ x 43 x 26½ in. (75.6 x 109.2 x 67.3 cm). Courtesy of Fantasma Magic Shop, New York, www.fantasmamagic.com

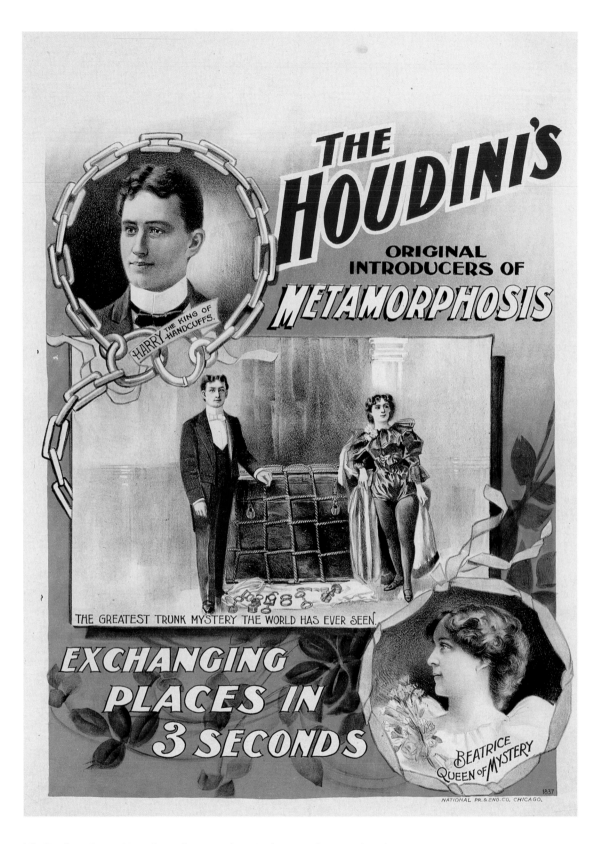

The Houdinis, Original Introducers of Metamorphosis, Exchanging Places in 3 Seconds, c. 1895.
Lithograph, 28 x 20¾ in. (71.1 x 52.7 cm). Collection of Dr. Bruce J. Averbook, Cleveland

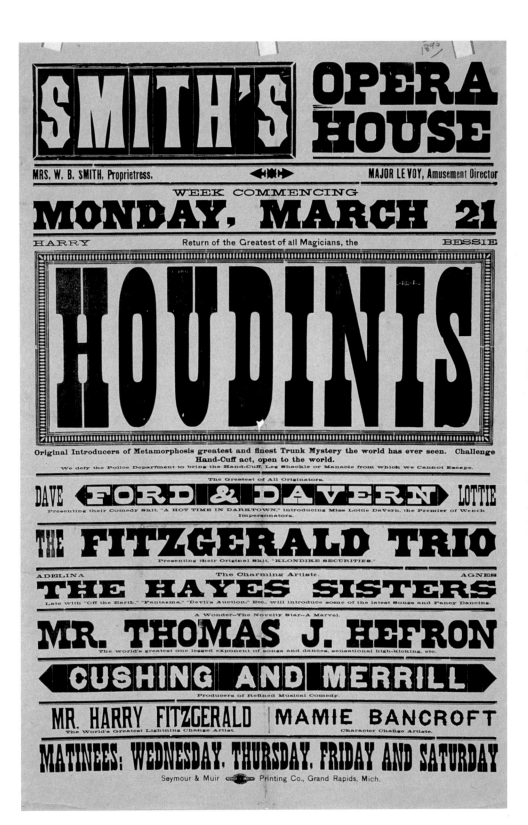

Return of the Greatest of All Magicians, the Houdinis, Smith's Opera House, 1898. Broadside, 36 x 23⅞ in. (91.4 x 60.6 cm). Library of Congress, Prints and Photographs Division

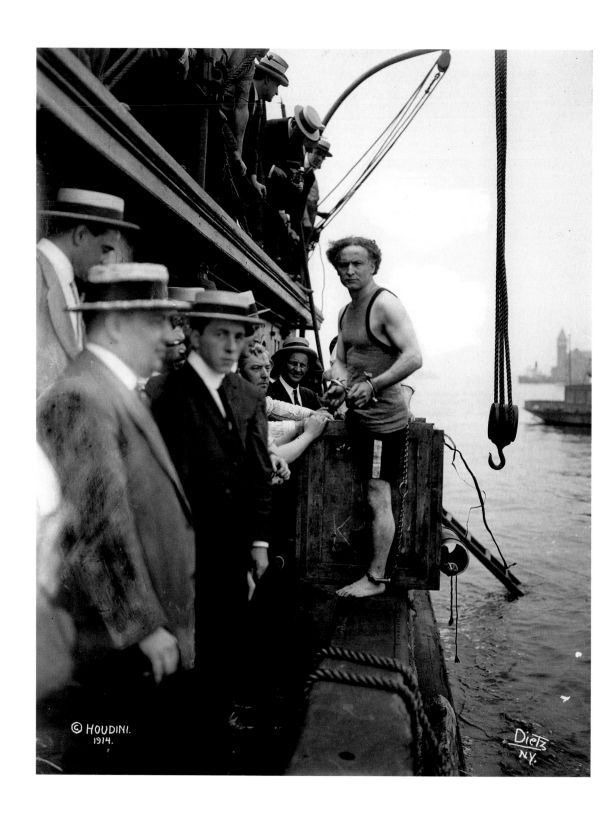

Houdini straddles crate before going into the water, July 20, 1914. Photograph, 9¼ x 7⅜ in. (23.5 x 18.7 cm). Library of Congress, Prints and Photographs Division

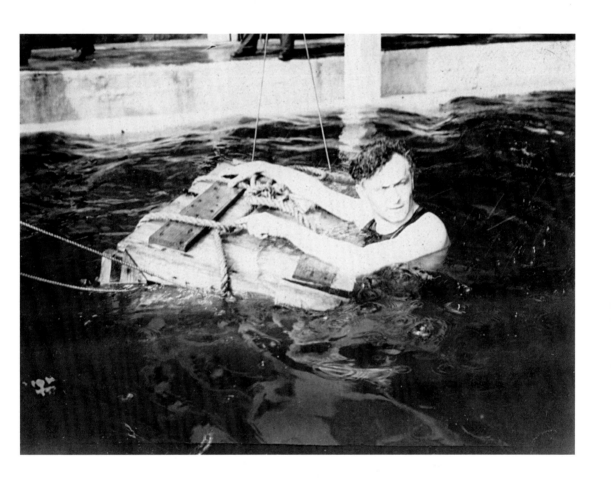

Houdini with trunk in water, n.d. Photograph. The New York Public Library for the Performing Arts, Billy Rose Theatre Collection

Jane Hammond (AMERICAN, BORN 1950)

Untitled (221,181,275,156,227), 1991–92. Oil on canvas, 76 x 70 in. (193 x 177.8 cm).
Private collection

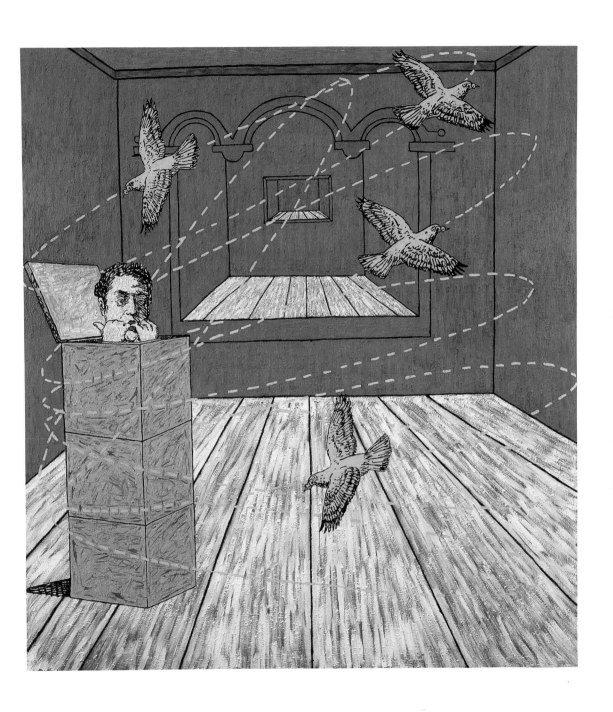

Milk Can

Houdini's Milk Can Escape was a prime example of the magician's constant self-renewal through new and more daring feats. He chose an object common to the lives of the mass public: the milk can, a symbol of rural America. But Houdini's stage milk can was larger than those that went from farm to dairy to home—it could accommodate his folded body and gallons of liquid. Posters boldly warned that should Houdini not escape, "failure means a drowning death." He first performed this escape in 1908 in St. Louis. A summary of this performance suggests how his bravura showmanship equaled his ability to escape:

> His wrists were handcuffed. Again Houdini slid down under the water. More liquid was added until it ran over the edges of the can. Quickly his assistants jammed the top in place and secured it with six padlocks. They drew a cloth cabinet forward around the can and closed the front curtains. Time ticked by. Thirty seconds; one minute; ninety seconds. Franz Kukol, Houdini's chief assistant, came from the wings with an ax in his hand. He put an ear to the side of the cabinet and listened. Two minutes; two minutes and a half; three minutes. Kukol frowned, raised the ax to striking position. The tension was almost unbearable; something must have gone wrong. Surely, any second, the assistant would slash through the curtains and cut into the can. At this moment, Houdini, dripping wet but smiling, burst through the curtains to a rafter-shaking ovation.[10]

Milk can, c. 1908. Metal, 40 x 25 in. (101.6 x 63.5 cm). From the Collections of American Museum of Magic, Marshall, Michigan

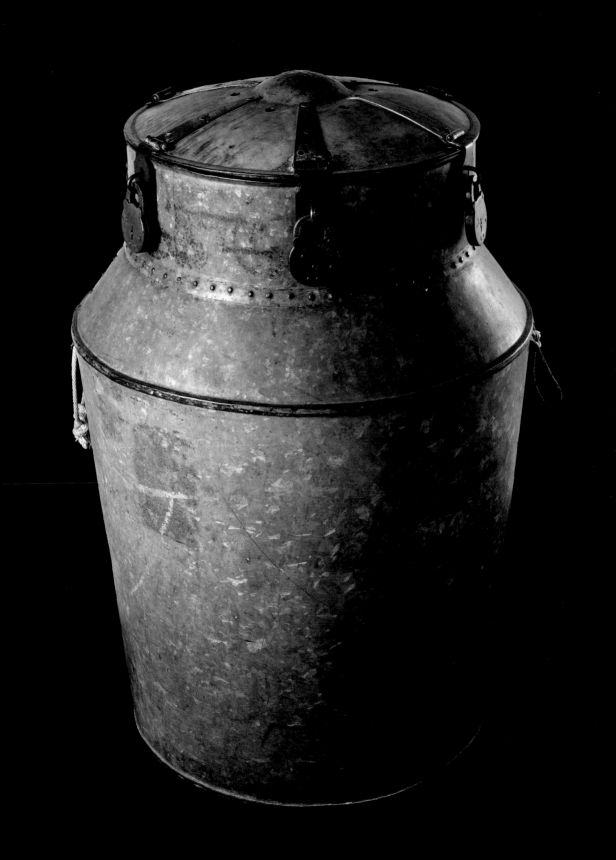

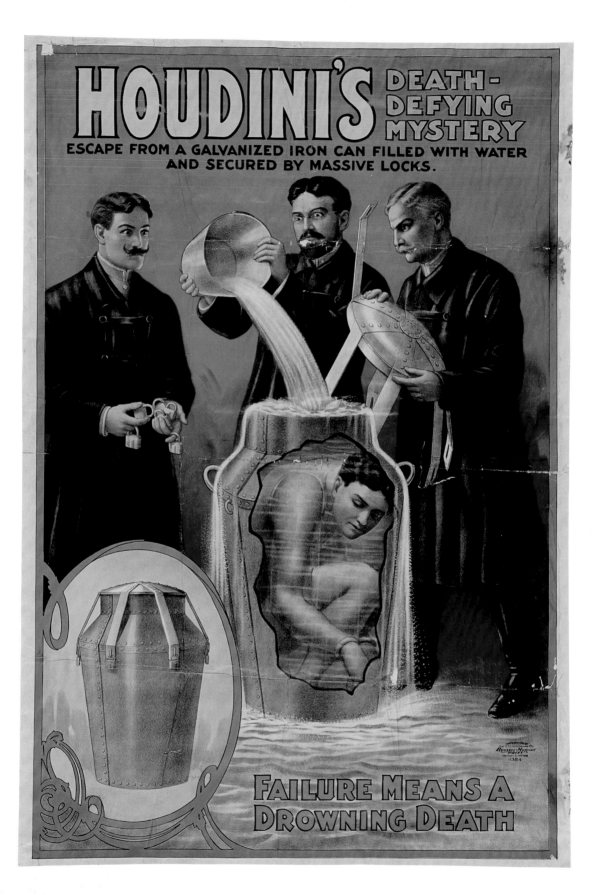

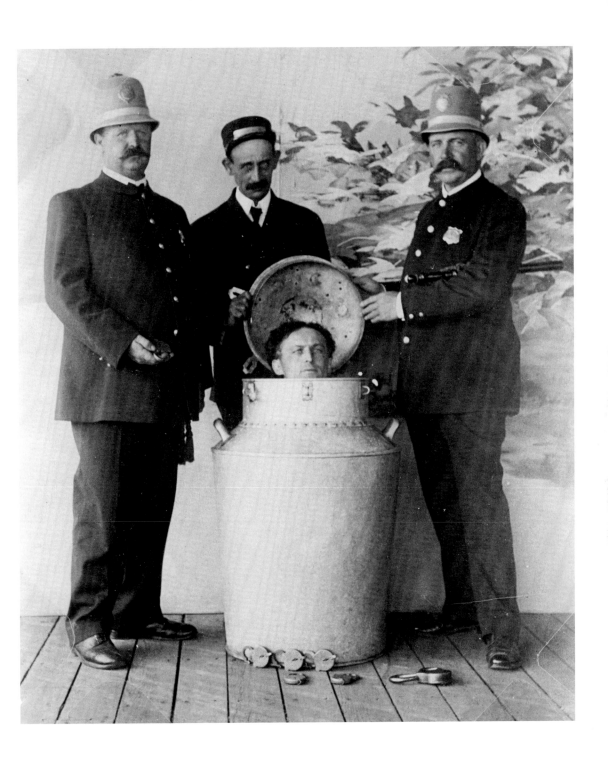

Houdini's Death-Defying Mystery, 1908. Lithograph, approx. 40 x 30 in. (101.6 x 76.2 cm). Harry Ransom Humanities Research Center, The University of Texas at Austin, Performing Arts Collection, Harry Houdini Collection

Houdini performing the Milk Can Escape, c. 1908. Photograph, 3½ x 3 in. (8.9 x 7.6 cm). Library of Congress, Rare Book and Special Collections

Houdini with the milk can,
c. 1908. Photograph, 3½ x
4¼ in. (8.9 x 10.8 cm).
Courtesy of Fantasma
Magic Shop, New York,
www.fantasmamagic.com

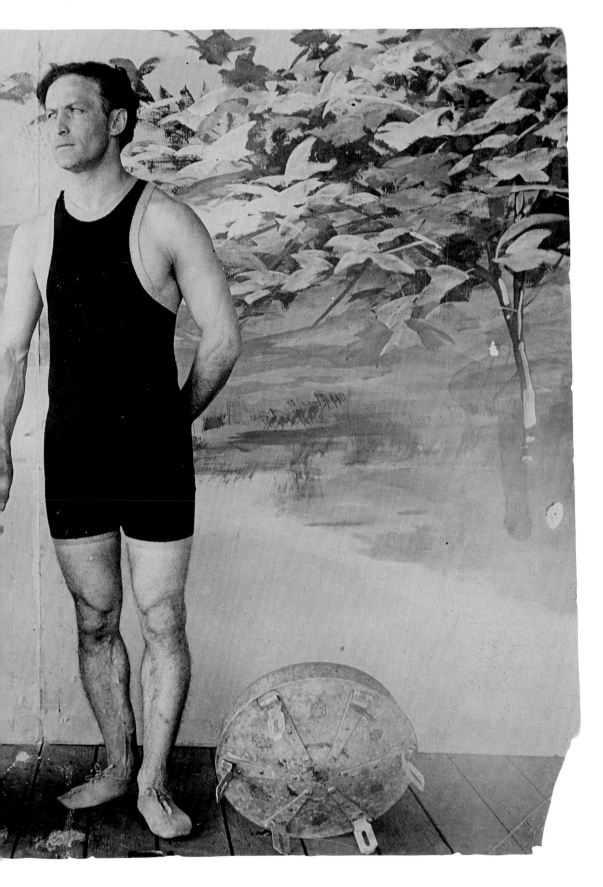

Ikuo Nakamura (JAPANESE, BORN 1960)

Materialization, 2009. Hologram and metal, approx. 64 x 25 in. (162.6 x 63.5 cm). Collection of the artist, Brooklyn; milk can courtesy of Cannon's Great Escapes

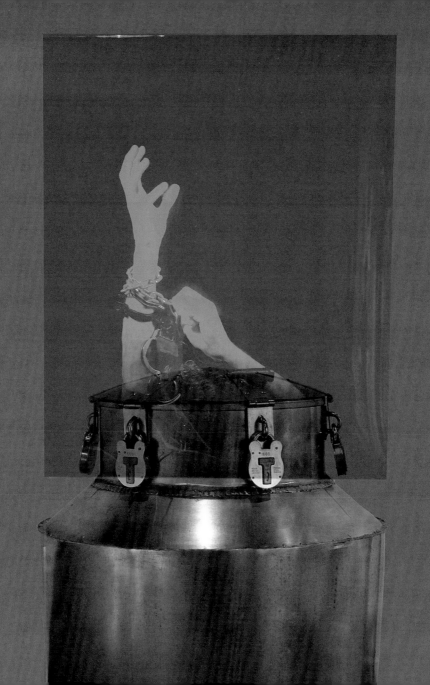

Water Torture Cell

Like his manacled bridge jumps and milk can performance, the use of water in Houdini's escapes added a terrifying dimension for spectators. The sense of confinement was one way to appeal to viewers' deepest fears; breaking out from a watery tomb was another. Houdini's Water Torture Cell capitalized on the audience's sense of terror while posters advertising the exploit proclaimed his ability to escape: "His Own Original Invention, The Greatest Sensational Mystery Ever Attempted in This or Any Other Age." Houdini called the glass-paneled tall box "the Upside Down" or the "U.S.D." Houdini's biographer, Kenneth Silverman, has explained that, after much practice, Houdini debuted the Water Torture Cell escape at the Circus Busch in Berlin in 1912: "In a typical performance, the curtain rose slowly on an eerily handsome setting: three assistants outfitted in gold-laced purple; four brass water buckets; the glass-and-burnished-brass cell on its waterproof sheet, surrounded by a cloth-of-gold cabinet; a felling-ax stuck in a heavy woodblock, gleaming with menace. Entering in evening dress, Houdini began by saying: 'Ladies and gentlemen in introducing my original invention the Water Torture cell, although there is nothing supernatural about it, I am willing to forfeit the sum of $1,000 to anyone who can prove that it is possible to obtain air inside of the Torture Cell when I am locked up in it in the regulation manner

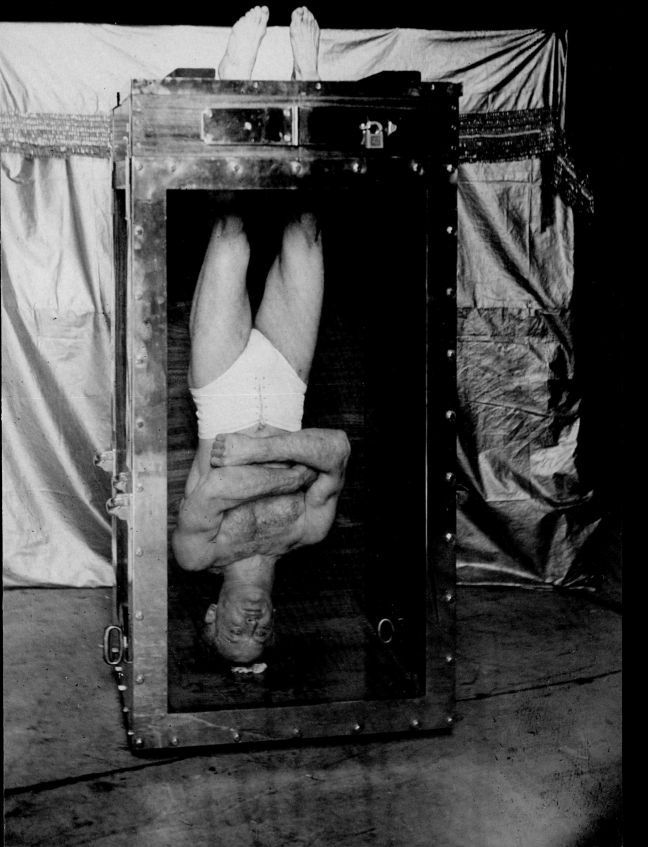

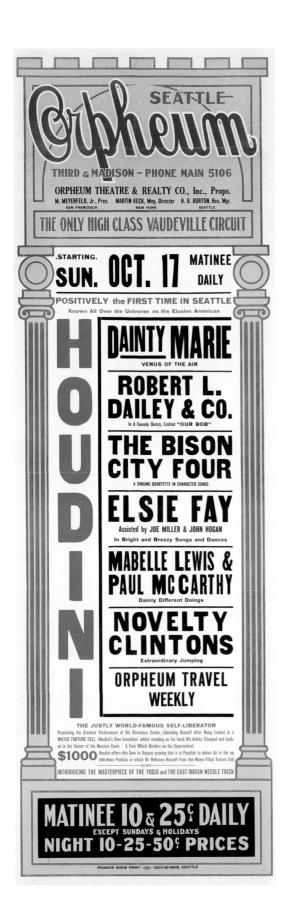

Houdini, Positively the First Time in Seattle, Orpheum Theatre, Seattle, 1915. Broadside, 42 x 13½ in. (106.7 x 34.3 cm). Kevin A. Connolly Collection

Houdini being lowered in the Upside Down, c. 1912. Photograph, 7 x 5 in. (17.8 x 12.7 cm). Collection of Dr. Bruce J. Averbook, Cleveland

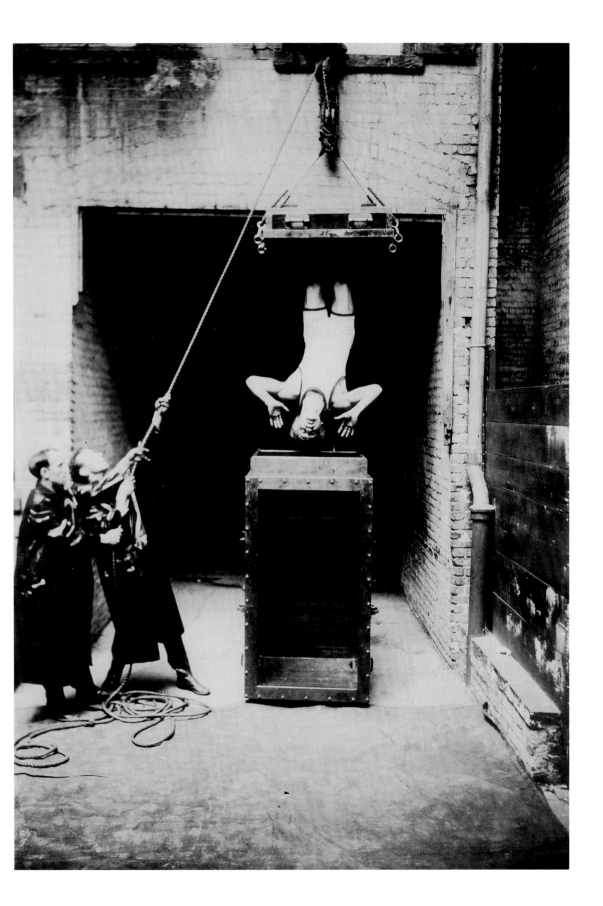

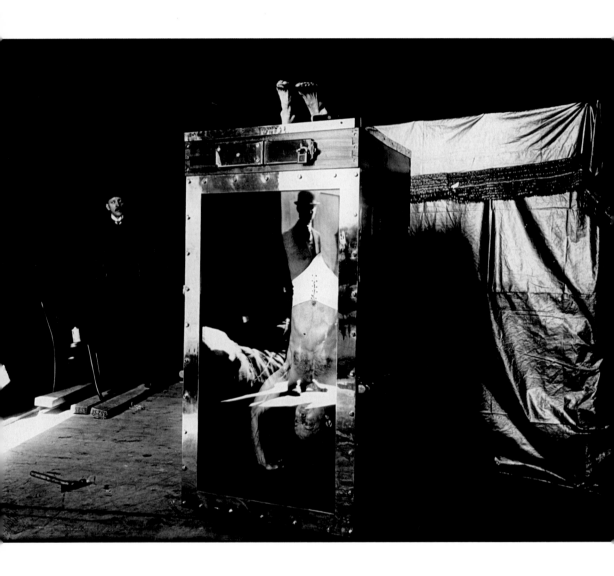

Houdini in the Water Torture Cell, c. 1912. Photograph, 8⅛ x 10 in. (20.6 x 25.4 cm). Harry Ransom Humanities Research Center, The University of Texas at Austin, Performing Arts Collection, Harry Houdini Collection

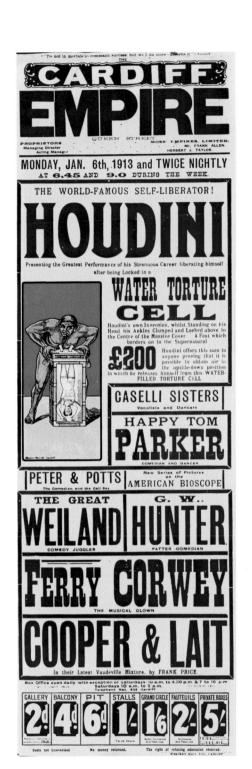

The World-Famous Self-Liberator! Houdini, Presenting the Greatest Performance of His Strenuous Career, 1913. Lithograph, 30 x 10 in. (76.2 x 25.4 cm). Library of Congress, Rare Book and Special Collections

World-Famous Self-Liberator, Houdini, the Supreme Ruler of Mystery, 1914. Broadside, 10¾ x 4¼ in. (27.3 x 10.8 cm). Kevin A. Connolly Collection

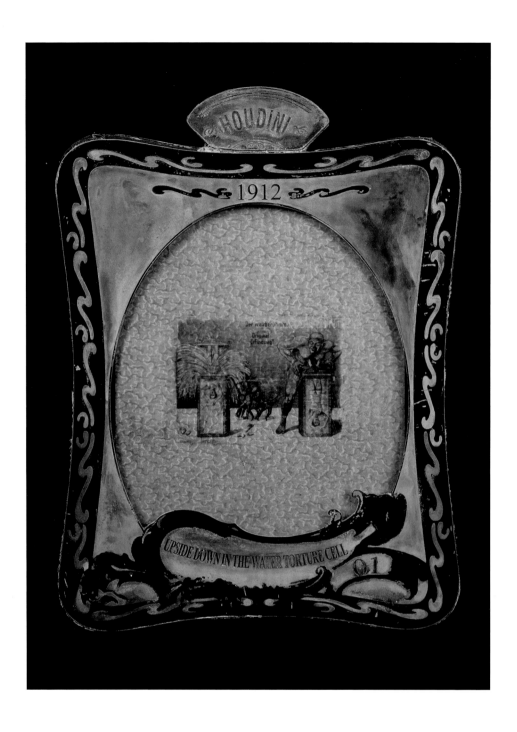

Water Torture Cell Presentation Piece given to Houdini commemorating his performance at the Circus Busch, 1912. Brass, glass, paint, cardboard, silver, and cloth, 14½ x 11¼ x 1 in. (36.8 x 28.6 x 2.5 cm). Collection of Dr. Bruce J. Averbook, Cleveland

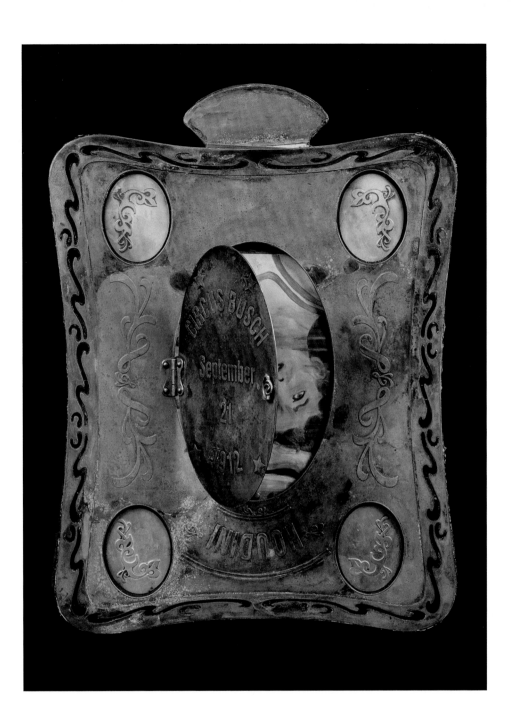

Tim Lee (KOREAN, BORN 1975)

Upside-Down Water Torture Chamber, Harry Houdini, 1913, 2004. Photograph, 45¼ x 49¼ in. (115 x 125 cm). Lent by the American Fund for the Tate Gallery, Courtesy of the American Acquisitions Committee, 2006

\mathfrak{S}traitjacket

When in the late 1890s Houdini accompanied a doctor into a Canadian psychiatric hospital, the magician watched a patient struggling desperately to free himself from a straitjacket. It was a transforming moment for Houdini, who knew that he was witnessing a true obstacle to escape. He would practice performing the Straitjacket Escape until its outdoor public debut, probably in 1915 in front of the *Kansas City Post* newspaper offices and then at the *Minneapolis Evening Tribune* building.[12] The Straitjacket Escapes are easily Houdini's most documented achievement. Not only would reporters and photographers exploit the opportunity just outside of their windows for newspaper sales and front-page byline credit, but Houdini often arranged for films of these performances to be shot from multiple angles.[13] Throngs of spectators witnessed these free outdoor shows, and his later indoor theater performances would regularly sell out as a result of the excitement generated by the daytime event.

Straitjacket, c. 1915. Canvas, leather and copper, 33 x 25 x 12 in. (83.8 x 63.5 x 30.5 cm). Collection of Arthur Moses, Fort Worth, Texas

OVERLEAF

Part of 80,000 Spectators Watching Houdini Challenge, Providence, Rhode Island, March 7, 1917. Photograph, 10¼ x 13⅜ in. (26 x 34 cm). Museum of the City of New York, Gift of Mr. and Mrs. John A. Hinson. Houdini is suspended from the *Evening News* building on the right.

Houdini at the London Palladium, c. 1920. Photograph, 8 x 10⅛ in. (20.3 x 25.7 cm). Courtesy of the Museum of the City of New York, Theater Collection

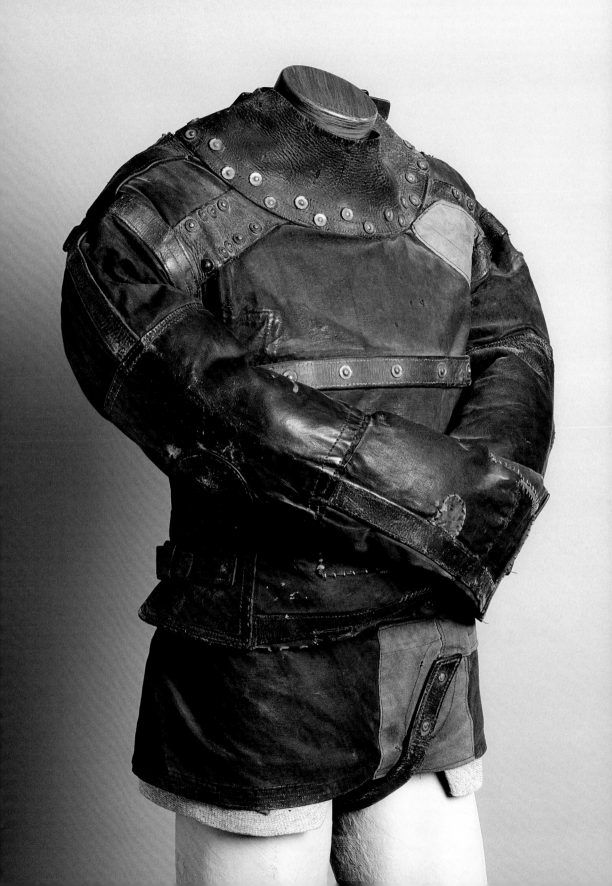

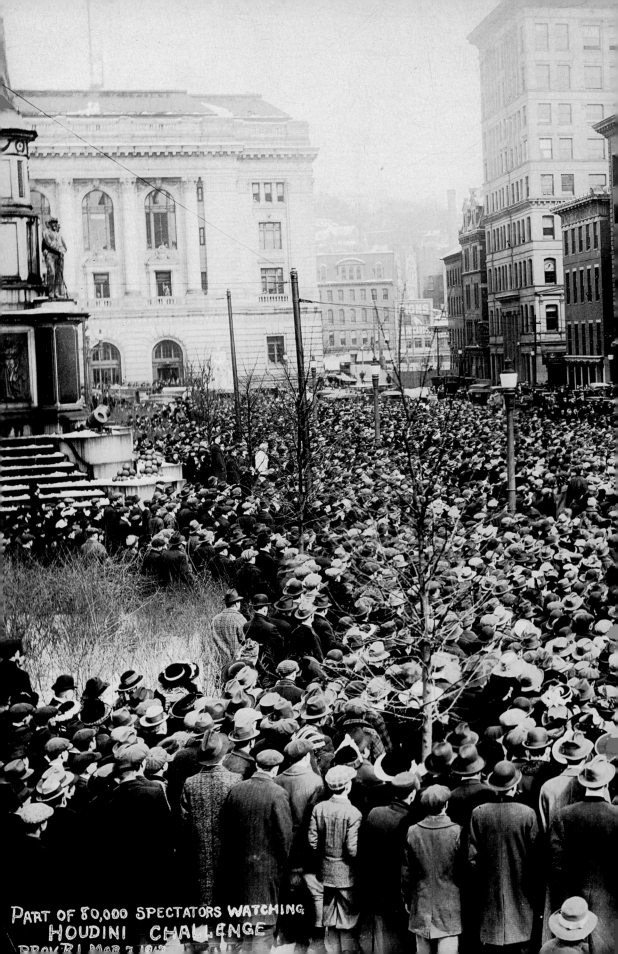

PART OF 80,000 SPECTATORS WATCHING
HOUDINI CHALLENGE
PROV. R.I. MAR 7 1915

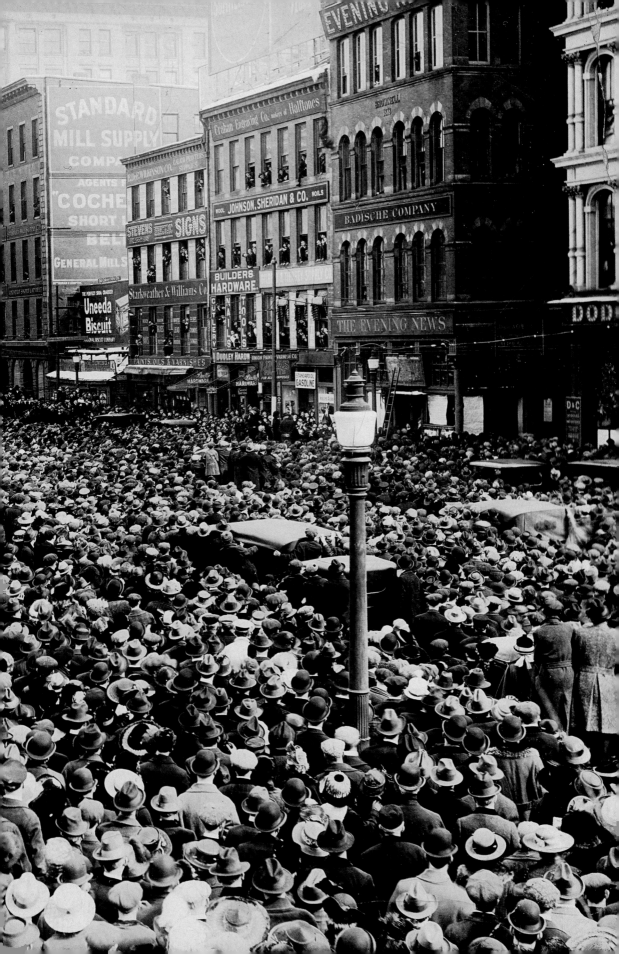

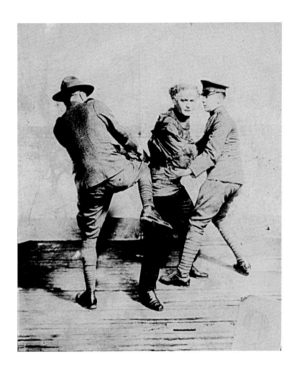
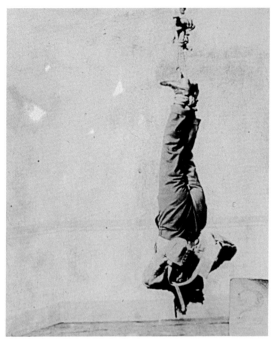
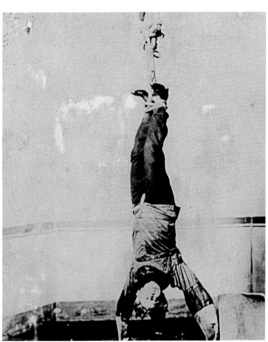
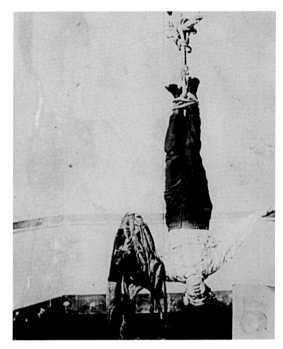

White Studio, New York, photographs of Houdini Straitjacket Escapes, c. 1915. The New York Public Library for the Performing Arts, Billy Rose Theatre Collection

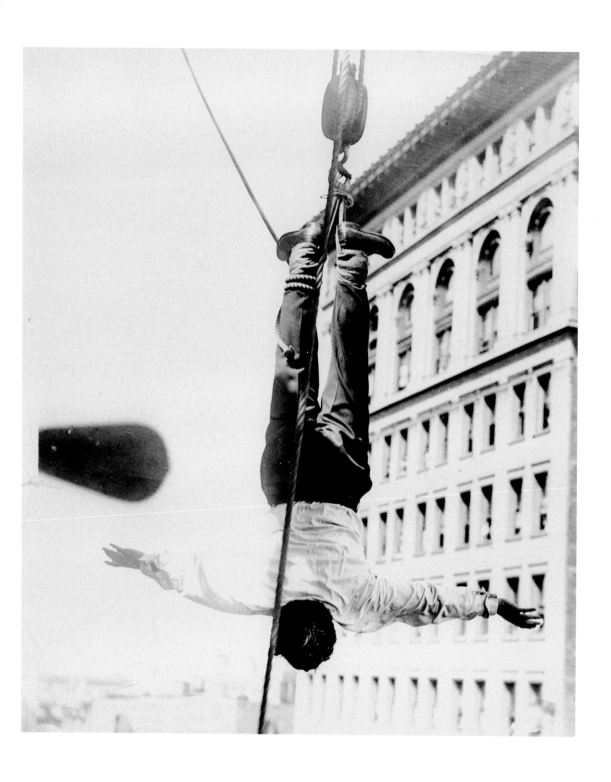

Back view of Houdini with arms open, n.d. Photograph, 9⅞ x 7⅞ in. (25.1 x 20 cm). Courtesy of the Museum of the City of New York, Theater Collection

Whitney Bedford (AMERICAN, BORN 1976)

Houdini (Upside Down), 2007. Ink and oil on unprimed paper, 72 x 44 in. (182.9 x 111.8 cm).
Hammer Museum, Los Angeles, Purchased with funds provided by Susan and Larry Marx

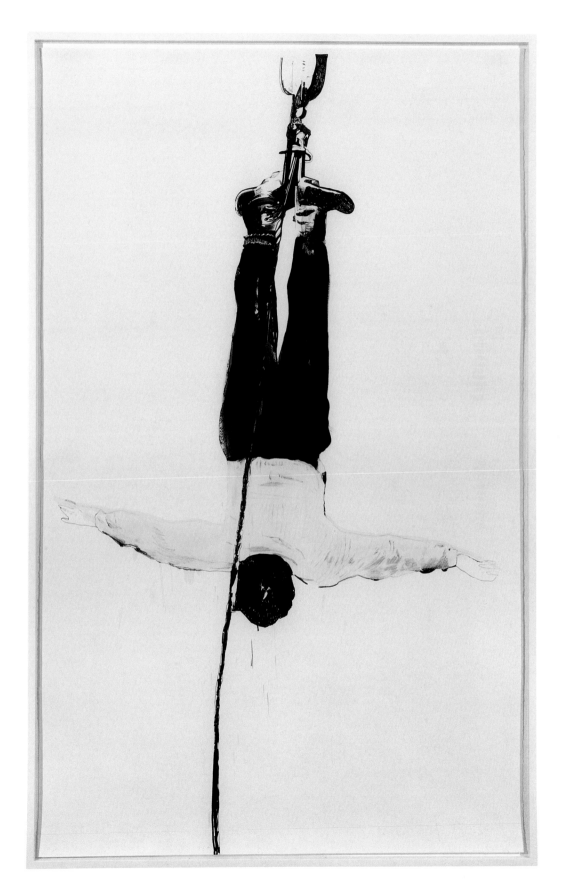

Deborah Oropallo (AMERICAN, BORN 1954)

Houdini, 1989. Oil on canvas, 80 x 80 in. (203.2 x 203.2 cm). Collection of Nat and Georgia Kramer

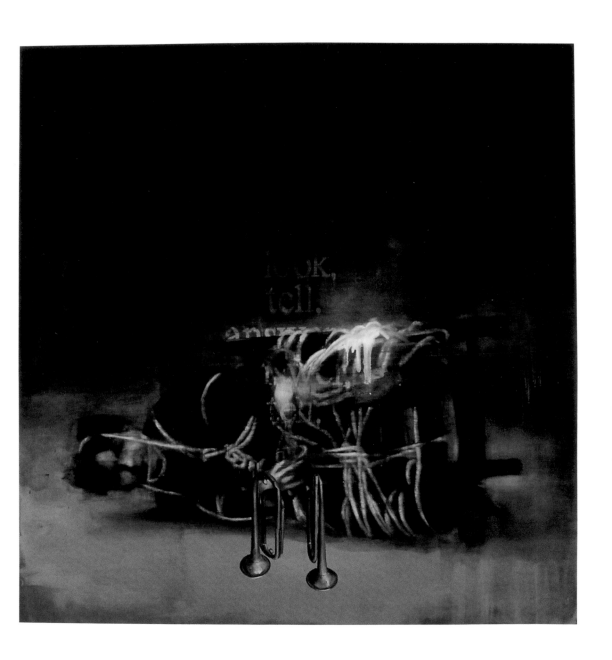

Notes

Introduction

1. Harry Houdini, *Houdini on Magic,* ed. Walter B. Gibson and Morris N. Young (Mineola, N.Y.: Dover, 1953), 3.

2. I am grateful to Professor Kellie Jones of the department of art history and archaeology at Columbia University for suggesting a review of the life of Henry Box Brown in Daphne A. Brooks, "The Escape Artist: Henry Box Brown, Black Abolitionist Performance, and Moving Panoramas of Slavery," *Bodies in Dissent: Spectacular Performances of Race and Freedom, 1850–1910* (Durham, N.C.: Duke University Press, 2006), 66–130. On page 121, Brooks writes, "Brown's reenactments of boxing would seemingly anticipate Victorian magic's increasing use of cabinets, crates and trunks as critical stage devices. Although box escapes which featured a performer's self-liberation from sealed receptacles and nailed packing cases did not gain popularity until the early twentieth century and in the wake of Harry Houdini's dominating success as a magician, confinement imagery nonetheless played a central role in the burgeoning magic culture of the mid-Victorian era." Brown's account of his ordeal (and the size of his crate) can be found in *Narrative of the Life of Henry Box Brown, Written by Himself* (Manchester, Eng., 1851), at the Documenting the American South Web site, http://docsouth.unc.edu/neh/brownbox/brownbox.html.

Rapaport: "Houdini's Transformation in Visual Culture"

1. "Houdini Feat for Antilles Benefit," *New York Times,* November 6, 1917.

2. See the bibliography for a list of Houdini biographies. Like the visual art based on Houdini, these biographies can sometimes reveal as much about the author (or the time period in which the book was written) as the subject. The first posthumous biography, published just two years after Houdini's death, was written in consultation with Bess Houdini: Harold Kellock, *Houdini: His Life-Story: From the Recollections and Documents of Beatrice Houdini* (New York: Harcourt Brace, 1928). Bernard C. Meyer, *Houdini: A Mind in Chains, a Psychoanalytic Portrait* (New York: Dutton, 1976), mines the metaphor of escape as significant to Houdini's psyche. Scholarly pay dirt is found in Kenneth Silverman, *Houdini!!! The Career of Ehrich Weiss* (New York: HarperCollins, 1996). Silverman charts in learned and cinematic detail the rise of Houdini's

phenomenal success and how his personal transformation (from immigrant to superstar) secured his status as a cultural icon. Houdini is compared to Tarzan as the embodiment of the physical ideal and a breakout figure of masculine zeal in John F. Kasson's *Houdini, Tarzan, and the Perfect Man: The White Male Body and the Challenge of Modernity in America* (New York: Hill and Wang, 2001). In a book published in the same year, Adam Phillips, a British psychotherapist, puts Houdini on the couch in *Houdini's Box: The Art of Escape* (New York: Pantheon, 2001). Houdini has consistently become fodder for assumptions of all kinds, as in William Kalush and Larry Sloman, *The Secret Life of Houdini: The Making of America's First Superhero* (New York: Atria, 2006), a controversial volume that implicates Houdini as a spy and brings conspiracy theory to his death.

3. Harry Houdini, *Houdini on Magic,* ed. Walter B. Gibson and Morris N. Young (Mineola, N.Y.: Dover, 1953), 5.

4. Recent exhibitions have drawn comparisons between the work of an established artist and the contemporary inheritors. See my *The Sculpture of Louise Nevelson: Constructing a Legend* (New York: The Jewish Museum; New Haven: Yale University Press, 2007). Jeffrey Weiss's exhibition catalogue *Mark Rothko* (Washington, D.C.: National Gallery of Art, 1998) includes interviews with Ellsworth Kelly, Brice Marden, Gerhard Richter, Robert Ryman, and George Segal. In K. Michael Hays and Dana Miller, *Buckminster Fuller: Starting with the Universe* (New York: Whitney Museum of American Art, 2008), Elizabeth A. T. Smith's essay is entitled, "The Comprehensivist: Buckminster Fuller and Contemporary Artists." The Museum of Contemporary Art in Chicago presented the exhibition *Alexander Calder and Contemporary Art: Form, Balance, Joy* in the summer of 2010.

5. Houdini's tricks have sometimes been chronicled by size rather than chronology. "He took pride in proclaiming that he performed the smallest and largest stage magic ever shown. The smallest was 'The East Indian Needle Mystery,' in which he swallowed seventy needles and twenty yards of thread, then brought up the needles threaded. The largest was a vanishing elephant illusion in which he caused a 10,000-pound pachyderm to disappear from a box on the stage of the New York Hippodrome." See Milbourne Christopher, *Magic: A Picture History* (New York: Dover, 1962), 185.

6. Christopher, *Magic: A Picture History,* 181. Christopher writes that the magician Pinetti performed a rope escape in the eighteenth century and that Samri Baldwin (a.k.a. The White Mahatma), who

was Houdini's senior by a quarter-century, "slipped out of handcuffs during his séances."

7. "Lithography was invented by Aloys Senefelder in 1796, but it was not until the latter part of the nineteenth century that the art of the poster can be said to have begun. . . . Although posters influenced the avant-garde, they were not at the forefront of formal innovation in the arts. Their significance lay in the fact that they conveyed the vitality of the popular culture. . . . They were also accessible to the populace, had an impact on the urban streetscape, promoted products and were easily affordable or free." Stuart Wrede, *The Modern Poster* (New York: Museum of Modern Art, 1988), 13–14.

8. David W. Kiehl, *American Art Posters of the 1890s in the Metropolitan Museum of Art Including the Leonard A. Lauder Collection* (New York: Metropolitan Museum of Art, 1987), 12.

9. Wrede, *Modern Poster,* 14. Wrede suggests that as the creative faculties of a graphic artist could exceed the physical ability of a stage performer, entertainment posters regularly promised more than the performer could deliver. If Houdini's posters hyped his ability, audiences seemed not to notice, as the magician pushed his own work constantly.

10. Kiehl, *American Art Posters of the 1890s,* 12. Kiehl writes, "To meet the growing demand, many of the larger lithographic firms in New York, Boston, Chicago, Philadelphia, San Francisco, Buffalo and Cincinnati employed skilled artists to produce a continual flow of images suitable for the advertising needs of their clients. Few records survive for these large firms, and even less information is known about the artists they employed."

11. Houdini wrote: "The following challenges have been performed by myself, some of which are very interesting. Release in full view of the audience from straitjackets used on murderous insane; the nailed up in packing case escape; the packing case built on the stage; the paper bag; the willow hamper; the hamper swung in the air; the steel unprepared cage or basket; riveted into a steel water boiler; hung to a ladder in mid-air; nailed to a door; escape from unprepared glass box; out of a large football; release from a large mail pouch; escape from a roll top desk; escape from a zinc-lined piano box, etc. etc." Houdini, *Houdini on Magic,* 5.

12. Houdini had performed Metamorphosis before with his brother, Dash, when they appeared as The Brothers Houdini. Bess replaced Dash on stage and the act was renamed The Houdinis.

13. Silverman, *Houdini!!! The Career of Ehrich Weiss,* 22.

14. Bernard Sobel, *A Pictorial History of Vaudeville* (New York: Citadel, 1961), 77.

15. Ibid.

16. Joe Laurie, Jr., *Vaudeville: From the Honky-Tonks to the Palace* (New York: Henry Holt, 1953), 363.

17. "Thereafter, no stars of the legitimate drama, opera or ballet could claim that vaudeville was beneath them. When vaudeville began to flag, [Beck] branched out into the legitimate theatre, no great stretch for a man who had booked Sarah Bernhardt and Ethel Barrymore in vaudeville." Frank Cullen, Florence Hackman, and Donald McNeilly, *Vaudeville: Old and New* (New York: Routledge, 2007), 86.

18. For *Europe's Eclipsing Sensation: A Look at One Houdini Poster,* see http://www.handcuffs.org/poster. This poster depicts largely accurate representations of those handcuffs that Houdini used in his performances. They include the Russian manacle, English Darby handcuffs, Bean Cobb handcuffs, Romer handcuffs, and a Berliner handcuff. Other handcuffs in the poster are not identifiable, perhaps due to artistic license. With various examples appearing on this poster, contemporary Houdiniphiles have gone so far as to deconstruct the accuracy of each set.

19. Houdini, *Houdini on Magic,* 4.

20. Silverman, *Houdini!!! The Career of Ehrich Weiss,* 110.

21. The Amazing Randi and Bert Randolph Sugar, *Houdini: His Life and Art* (New York: Grosset and Dunlap, 1976), 88. According to the authors, "By 1912 the milk can escape had become old hat. Not only was it advertised in the Mysto Magic Company's catalogue for $35, but escapologists everywhere were even imitating Houdini's dress and his speech." Houdini worked to vary the Milk Can Escape, filling the can with beer and next placing the milk can upside down in an iron-bound wooden chest. "His Own Original Invention" was the tag line on several of the posters advertising the Water Torture Cell, Houdini's other triumphant water feat.

22. Ibid., 89.

23. Ibid.

24. *Los Angeles Times,* October 28, 1924.

25. Kellock, *Houdini: His Life-Story,* 306.

26. Ibid., 308.

27. Harry Houdini, *A Magician Among the Spirits* (1924; Amsterdam: Fredonia, 2002), 154.

28. Houdini, *Houdini on Magic,* 124.

29. Ibid., 126.

30. In a May 2009 interview with Teller, he stated: "Houdini seems to have been, as far as the public is concerned, the only magician who ever mattered." In 1978, Doug Henning wrote *Houdini: His Legend and His Magic.* See Randi and Sugar, *Houdini: His Life and Art,* 12. As a magician, Randi has continually felt Houdini's outsize presence: "The shadow of Harry Houdini hangs over me constantly, like a strange, burdensome cloud. Every time I perform a feat of escape, I have 'done a Houdini' to the press. . . . For it is more obvious now than ever before that Harry Houdini is the Master Magician of all time. No one has ever so captured the imagination and love of the public as he did." In a PBS *American Experience* documentary, David Copperfield said: "It was a great era for his kind of entertainment. I mean, it really can't be duplicated today. You know, this man that could escape from anything, be free of all boundaries. It was a time of boundaries. It was a time of constraints. So he was kind of a walking metaphor, which is probably why he's lasted so long in our consciousness."

31. While art photographers who lived in Houdini's time did not concentrate on him, his legend lived on in the photography world. See Patricia Bosworth, *Diane Arbus: A Biography* (New York: W. W. Norton, 2006), 81, which quotes Arbus's goddaughter, May Eliot, recalling Arbus family group activities based on Houdini: "We would tie each other up with ropes in all kinds of knots and then you had to work yourself free. Allan [Arbus, Diane's husband] was reading about Houdini."

32. I am grateful to Joyce Schiller at the Delaware Art Museum for sharing this with me. In an excerpt from John Sloan's unpublished 1907 diary, he wrote: "May 13, 1907: This morning (12 o'clock or thereabout) Dolly and I took a walk together down Broadway, over 14th St. and then sat for some time sunning ourselves in Stuyvesant Square. . . . [Robert] Henri came in at 5:30 or so and said he had been here earlier. Meanwhile he went to Proctor's and saw a 'bad show' bought varnish to varnish the 'French Girl' (portrait, low tone) which I have of his." A footnote after "bad show" reads, "The vaudeville at Keith and Proctor's 23rd St. starred Joe Welsh and Co. in 'Ellis Island.' Harry Houdini and others were also on the bill." John Sloan Manuscript Collection, Helen Farr Sloan Library and Archives, Delaware Art Museum.

33. See Patricia McDonnell, *On the Edge of Your Seat: Popular Theater and Film in Early Twentieth-Century American Art* (New Haven: Yale University Press, 2002), 6. McDonnell writes of the impetus that vaudeville and silent movies provided for artists in the early twentieth century: "American visual artists did not ignore this stimulating environment.

Many turned to it for their own amusement, as did countless Americans." See chapter 1.

34. I am grateful to Jessica Holmes, deputy director of the Calder Foundation in New York, for bringing this work to my attention.

35. John Finlay, "'De la magie blanche a la magie noire': 'Primitivism,' Magic, Mysticism and the Occult in Picasso," *Apollo,* October 2003, 21.

36. Deborah Solomon, *Utopia Parkway: The Life and Work of Joseph Cornell* (New York: Farrar, Straus and Giroux, 1997), 4.

37. The Jewish Museum in New York and the Contemporary Jewish Museum in San Francisco exhibited Warhol's *Ten Portraits of Jews of the Twentieth Century* in 2008. The ten Jewish subjects depicted by Warhol are Sarah Bernhardt, Louis Brandeis, Martin Buber, Albert Einstein, Sigmund Freud, George Gershwin, Franz Kafka, the Marx Brothers, Golda Meir, and Gertrude Stein. See Richard Meyer, *Warhol's Jews: Ten Portraits Reconsidered* (New York: The Jewish Museum; San Francisco: Contemporary Jewish Museum, 2008).

38. Interview with Allen Ruppersberg, April 17, 2009.

39. E-mail exchange with Jane Hammond, November 17, 2008.

40. Interview with Deborah Oropallo, February 10, 2009.

41. In a July 28, 2009, letter to The Jewish Museum, Petah Coyne wrote: "The sculpture . . . titled *Trying to Fly, Houdini's Chandelier,* conveys my personal wish that all the allied prisoners of WWII, both in the German camps as well as those held by the Japanese (and in particular those soldiers in the Bataan Death March), had been able to do as Houdini had done: to magically spin around and then to—'poof'—disappear into the atmosphere. To disappear both mentally and physically, from those horrible environments and the savage guards who kept them there. My dream was to magically transport these people back into their safe and loving homes and into the lives they once lived, so their prisoner experience and all that had happened to them was somehow just a very bad dream. Houdini's idea of magic could perform these heroic feats for me, and I so wanted it to spill over into every soul held in captivity."

42. See Nancy Spector, *Matthew Barney: The Cremaster Cycle* (New York: Solomon R. Guggenheim Museum, 2002). Spector discusses the selection of Budapest as the location for *Cremaster 5:* "For Barney, then, it is a place of origin, a procreative vessel, a site of gestation where the resident spirit

of the *Cremaster* cycle was born. Patron saint, role model, and inspiration, Houdini presides over the entire project, which in a sense begins and ends with him."

43. Jeanne Siegel, "Matthew Barney," *Tema Celeste,* Spring 1993, 66.

44. Interview with Raymond Pettibon, August 4, 2009.

45. Ann Douglas, *Terrible Honesty: Mongrel Manhattan in the 1920s* (New York: Farrar, Straus and Giroux, 1995), 444.

46. Kasson, *Houdini, Tarzan, and the Perfect Man,* 136; and Silverman, *Houdini!!! The Career of Ehrich Weiss,* 194. In Kellock's book, Bess Houdini describes an early Straitjacket Escape in September 1918 in front of the offices of the *Kansas City Post.* She recalled that seven thousand people "pressed about the building." See Kellock, *Houdini: His Life-Story,* 254.

47. Edmund Wilson, "Houdini," in *The Shores of Light: A Literary Chronicle of the Twenties and Thirties* (New York: Farrar, Straus and Young, 1952), 175. Wilson's essay was first published in June 1925.

48. Matthew Paul Solomon, "Stage Magic and the Silent Cinema: Méliès, Houdini, Browning" (Ph.D. diss., University of California at Los Angeles, 2001), 106, 107. Solomon writes that the "staging of the suspended straitjacket escape also seems to have been designed for the benefit of photographers and cinematographers. . . . The stunt was frequently filmed and extant documentary footage indicates not only the immense crowds which gathered to witness the suspended straitjacket escape, but also the frequent presence of more than one motion picture camera recording . . . from different vantage points."

49. Kellock, *Houdini: His Life-Story,* 255. My description of this feat is based on my viewing of the historic Straitjacket Escapes in the DVD collection *Houdini: The Movie Star,* produced by Kino International. Much of the archival footage of these escapes is from films in the collection of the George Eastman House in Rochester, New York.

50. In some photographs, Houdini hangs like a cruciform, suspended for seconds—his dark trousers and white shirt set off against the backdrop of a skyscraper. The barbarism of having ankles and arms tightly bound in constraints is oddly (for a Jewish entertainer) Christlike.

51. In this way, Houdini became curator of his public performances and anticipated the legacy of these films. After Houdini died in 1926, Bess similarly guarded his image. When Americans clamored for entertainment as diversion, Bess appeared at magic clubs across the country and presided over annual séances on Halloween, the anniversary of his death, attempting to reach Harry in the spirit realm. See Solomon, *Stage Magic and the Silent Cinema,* 99.

52. Sally Struthers played Bess in the 1976 ABC Friday Night Movie *The Great Houdinis.*

53. Houdini and Curtis shared more than a love of entertaining. Both were Jewish men who changed their names (Houdini: Ehrich Weiss; Curtis: Bernard Schwartz) to appeal to their audiences.

54. Review of *Houdini, New York Times,* July 3, 1953.

55. Mae Tinee, "Houdini Film Retells Story of Magician," *Chicago Daily Tribune,* September 11, 1953.

56. For further discussion on the 1953 Paramount Pictures movie, see John F. Kasson, "Houdini," in Kasson, *Past Imperfect: History According to the Movies* (New York: Henry Holt, 1995), 212–15.

57. E. L. Doctorow, *Ragtime* (1975; New York: Penguin, 1996), 8.

58. Ibid., 26, 81, 82, 87, 168.

59. Ibid., 265.

60. Ibid., 266–67.

61. Frederic Paul and Allan McCollum, *Allen Ruppersberg: Books, Inc.* (Paris: F.R.A.C. Limousin, 2001), 32.

62. E-mail from Allen Ruppersberg, December 12, 2009.

63. Interview with Sara Greenberger Rafferty, April 13, 2009.

64. Interview with Tim Lee, January 22, 2009.

65. Ibid.

66. Interview with Whitney Bedford, February 19, 2009.

67. Ibid.

68. Interview with Joe Coleman, July 29, 2009.

69. Ibid.

Brinkley: "The Immigrant World of Harry Houdini"

1. Sources not included elsewhere in the notes but important for an understanding of immigration and the experience of immigrants include John Bodnar, *The Transplanted: A History of Immigrants in America* (Bloomington: University of Indiana Press, 1985); Oscar Handlin, *The Uprooted: The Epic Story*

of the Great Migrations That Made the American People (Boston: Little, Brown, 1951); and John Higham, *Send These to Me: Jews and Other Immigrants in Urban America* (New York: Atheneum, 1975).

Biographical information about Houdini included in this essay is drawn from the following: John F. Kasson, *Houdini, Tarzan, and the Perfect Man: The White Male Body and the Challenge of Modernity in America* (New York: Hill and Wang, 2001); Joshua Ranger, "Houdini: A Magician Among the Spirits," *Journal of American History* 87 (December 2000): 967–69; and Kenneth Silverman, *Houdini!!! The Career of Ehrich Weiss* (New York: HarperCollins, 1996).

2. John Higham, *Strangers in the Land: Patterns of American Nativism* (1955; New York: Atheneum, 1969), 110–19.

3. Josiah Strong, *Our Country and Its Present Crisis* (New York: Baker and Taylor, 1891), 56–58.

4. Edward A. Ross, "Racial Consequences of Immigration," *Century* 65 (February 1914): 87.

5. Higham, *Strangers in the Land,* 81–87.

6. *Takao Ozawa v. United States,* 260 U.S. 178 (1922).

7. *United States v. Bhagat Singh Thind,* 261 U.S. 204 (1923).

8. Leonard Dinnerstein, *Anti-Semitism in America* (New York: Oxford University Press, 1994), 40; and *New York Tribune,* June 13, 1882.

9. Jacob Riis, *How the Other Half Lives: Studies Among the Tenements* (1901; reprint, New York: Dover, 1971), 19–25.

10. Michael R. Weisser, *A Brotherhood of Memory: Jewish Landsmanshaftn in the New World* (New York: Basic, 1985).

11. Abraham Cahan, *The Rise of David Levinsky* (New York: Harper and Brothers, 1917), and "Tzinchadzi of the Catskills," *Atlantic Monthly,* August 1901, reprinted in Moses Rischin, ed., *Grandma Never Lived in America: The New Journalism of Abraham Cahan* (Bloomington: Indiana University Press, 1988), 238.

12. William Leach, *Land of Desire: Merchants, Power, and the Rise of American Culture* (New York: Pantheon, 1993).

13. *New York Times,* January 13, 1918, May 7, 1922, and May 9, 1924; and William Kalush and Larry Sloman, *The Secret Life of Houdini: The Making of America's First Superhero* (New York: Atria, 2006).

14. Kimberly Louagie, "The Bonds He Did Not Break: Houdini and Wisconsin," *Wisconsin Maga-zine of History* 85 (Spring 2002): 16.

Silverman: "Houdini, the Rabbi's Son"

The quotations and information in this essay have been culled from the extensive archive of writings by and about Houdini that I deposited at the YIVO archives in New York, catalogued there as Record Group 1915. See my books *Houdini!!! The Career of Ehrich Weiss* (New York: HarperCollins, 1996) and *Notes to Houdini!!!* (Washington, D.C.: Kaufman and Greenberg, 1996).

Diner: "Bess: The Magician's Assistant, the Magician's Wife"

1. Geraldine Conrad Larsen, *The Diary of a Magician's Wife* (Portsmouth, Ohio: Midwest Magic Service, 1941), 5–7.

2. On her 1943 death certificate, her maiden last name is listed as "Rohner." See the online database California Death Index, 1940–97, at http://www.ancestry.com/.

3. Bess provided abundant material to Harold Kellock for his *Houdini: His Life-Story: From the Recollections and Documents of Beatrice Houdini* (New York: Harcourt, Brace, 1928), but she offered no information about her life before meeting Houdini. Accordingly, details on her early life are very sketchy.

4. On the centrality of religion to German Catholics in the United States, see Jay P. Dolan, *The American Catholic Experience: A History from Colonial Times to the Present* (Notre Dame, Ind.: Notre Dame University Press, 1992), 168. The neighborhood in the 1870s and 1880s was served by St. Cecilia's Parish on North Henry and Herbert streets.

5. William Lindsay Gresham, *Houdini: The Man Who Walked Through Walls* (New York: Henry Holt, 1959), 131.

6. Kellock, *Houdini: His Life-Story,* 211.

7. Houdini Scrapbooks, vol. 4, Houdini Collection, Rare Book Room, Library of Congress, Washington, D.C. See Kenneth Silverman, *Houdini!!! The Career of Ehrich Weiss* (New York: HarperCollins, 1996), 190.

8. Nearly every chronicler of Bess's life with Harry has remarked on her superstitions and Harry's insistence that she shed them. See, for example, William Kalush and Larry Sloman, *The Secret Life of Houdini: The Making of America's First Superhero* (New York: Atria, 2006), 59.

9. Ruth Brandon, *The Life and Many Deaths of Harry Houdini* (New York: Random House, 1993), 53.

10. Kellock, *Houdini: His Life-Story,* 67; and Kathy Lee Peiss, *Hope in a Jar: The Making of America's Beauty Culture* (New York: Metropolitan, 1998).

11. Her work in the tailor shop is related in Kalush and Sloman, *Secret Life of Houdini,* 30.

12. Susan Glenn, *Female Spectacle: The Theatrical Roots of Modern Feminism* (Cambridge, Mass.: Harvard University Press, 2000); and Janet M. Davis, *The Circus Age: Culture and Society Under the American Big Top* (Chapel Hill: University of North Carolina Press, 2002).

13. Raymund Fitzsimons, *Death and the Magician: The Mystery of Houdini* (New York: Atheneum, 1985), 17. William Kalush and Larry Sloman claim that Wilhelmina met the other two Floral Sisters while working as a seamstress in a traveling circus; see Kalush and Sloman, *Secret Life of Houdini,* 30.

14. Manny Weltman, *Houdini: Escape into Legend, the Early Years, 1862–1900* (Van Nuys, Calif.: Finders/Seekers, 1993), 29.

15. For Coney Island in the days of Bess's brief career as a performer with the girl song-and-dance group, see Oliver Pilat and Jo Ranson, *Sodom by the Sea: An Affectionate History of Coney Island* (Garden City, N.Y.: Doubleday, Doran, 1941), 55, 93, 123; Michael Immerso, *Coney Island: The People's Playground* (New Brunswick, N.J.: Rutgers University Press, 2002), 35, 109; Stephen Frederick Weinstein, "The Nickel Empire: Coney Island and the Creation of Urban Seaside Resorts in the United States" (Ph.D. diss., Columbia University, 1984); Edo McCullough, *Good Old Coney Island: A Sentimental Journey into the Past* (New York: Fordham University Press, 1957), 253; and John F. Kasson, *Amusing the Million: Coney Island at the Turn of the Century* (New York: Hill and Wang, 1978), 42–43, 47.

16. Multiple stories have floated around as to how Bess and Harry met, and even about the details of their wedding. In some versions Harry was performing at the school—unnamed—that Bess attended, entertaining the students with a magic trick. In the course of his act he ruined the dress of a girl (Bess) sitting in the front. Gallantly, Harry asked his mother, Cecilia, to sew a new dress just like the one the girl had been wearing. He brought the dress to her house—and it was love at first sight. Another rendition has him seeing her on a bus and falling instantly in love. Yet other accounts say that it was Harry's brother Dash who first met Wilhelmina among the sea of Coney Island performers and that he arranged to go out with her while Harry would go out with one of the other Floral Sisters. On that double date Harry fell for

Bess. See Harold Kellock, *Houdini: His Life-Story,* 42–45; Brandon, *The Life and Many Deaths of Harry Houdini,* 40; Christopher Milbourne, *Houdini: The Untold Story* (New York: Crowell, 1969), 21; and Kalush and Sloman, *Secret Life of Houdini,* 30.

17. Bess claimed that the wedding was performed by John Y. McKane, the Democratic Party boss of Coney Island, but William Lindsay Gresham, in *Houdini: The Man Who Walked Through Walls,* 25, noted that on the very day that Bess and Harry claimed as their anniversary, McKane happened to be incarcerated in Sing Sing Prison. Manny Weltman has written that McKane was in prison at the time; that the priest G. S. Loui, whom Harry identified as the Catholic officiant, did not exist; and that Harry's statement that "Rabbi Tintner of Mt. Zion Temple married me" could not be true. In addition, Weltman found that no marriage license exists to prove that Harry and Bess were actually married. See Weltman, *Houdini: Escape into Legend,* 31–34.

18. Gresham, *Houdini: The Man Who Walked Through Walls,* 26. Once again, a number of contradictory stories make the details of Bess's replacing Theodore a bit murky. Gresham claims that in an interview given years later Bess said that she joined the show because she had seen Harry with "a redhead who worked on the same bill with him in the *musée*" (a dime museum). Bess said that she started to fight the woman and "Harry had to pull me off. . . . From then on in I determined to work with him." Gresham, *Houdini: The Man Who Walked Through Walls,* 27.

19. Davis, *Circus Age,* 96.

20. Ronald F. Walters, "Cowboys and Magicians: Buffalo Bill, Houdini and Real Magic," in Amy Wygant, ed., *The Meaning of Magic from the Bible to Buffalo Bill* (New York: Berghahn, 2006), 206.

21. An image of Ehrich Weiss's passport application, dated August 9, 1900, can be found at http://content.ancestrylibrary.com/iexec. Houdini may have lied here. Some biographers put him closer to five feet, four inches. He also lied about his birthplace on various forms, claiming to have been born in Wisconsin, when in fact he had been born in Hungary.

22. John F. Kasson, *Houdini, Tarzan, and the Perfect Man: The White Male Body and the Challenge of Modernity in America* (New York: Hill and Wang, 2001), 89. See also Michael S. Kimmel, *Manhood in America: A Cultural History* (New York: Oxford University Press, 2006), 82–83.

23. Gresham, *Houdini: The Man Who Walked Through Walls,* 38, 59.

24. Jim Steinmeyer, *Hiding the Elephant: How Magicians Invented the Impossible and Learned to Disappear* (New York: Carroll and Graf, 2003), 148; and John Springhall, *The Genesis of Mass Culture: Show Business Live in America, 1840–1940* (New York: Palgrave Macmillan, 2008), 190–91.

25. *Los Angeles Times,* June 25, 1899, 28.

26. Christopher, *Houdini: The Untold Story,* 135.

27. Kalush and Sloman, *Secret Life of Houdini,* 59–62.

28. Christopher, *Houdini: The Untold Story,* 31.

29. Silverman, *Houdini!!! The Career of Ehrich Weiss,* 187.

30. Kalush and Sloman, *Secret Life of Houdini,* 90.

31. See Houdini Scrapbooks, vols. 2 and 3, for newspaper clippings of Houdini's performances with no mention of assistants and no obvious evidence of them in the photographs. On the fact that he did use assistants, see Walter B. Gibson, *The Original Houdini Scrapbook* (New York: Corwin Sterling, 1976), 13.

32. James W. Cook, *The Arts of Deception: Playing with Fraud in the Age of Barnum* (Cambridge, Mass.: Harvard University Press, 2001), 257.

33. Brandon, *The Life and Many Deaths of Harry Houdini,* 54.

34. On the fact that he gave the house to her, see "Real Estate Field," *New York Times,* July 24, 1918, 18.

35. Gresham, *Houdini: The Man Who Walked Through Walls,* 75.

36. Ibid., 49–50.

37. As the keeper of the family's finances, she did object, but to no avail, when he became an avid collector of art and artifacts in the 1910s. See Kellock, *Houdini: His Life-Story,* 210.

38. House of Representatives, Hearings Before the Subcommittee on the Judiciary of the District of Columbia, Sixty-Ninth Congress, first session on H.R. 8989 (fortune-telling), February 26, May 18, May 20, and May 21, 1926; see Kellock, *Houdini: His Life-Story,* 368–70.

39. Among the sources that have related this anecdote is Kalush and Sloman, *Secret Life of Houdini,* 37.

40. Kellock, *Houdini: His Life-Story,* 299.

41. Ibid.

42. See, for example, Houdini Scrapbooks, vol. 4.

43. Ron Cartlidge, *Houdini's Texas Tours, 1916 and 1923: A Complete and Up-to-Date Account of Houdini's Two Texas Tours in 1916 and 1923* (Austin, Tex.: Ron Cartlidge, 2002), 96–97.

44. Walter B. Gibson, *Houdini's Escapes and Magic: Prepared From Houdini's Private Notebooks and Memoranda with the Assistance of Beatrice Houdini, Widow of Houdini, and Bernard M. L. Ernst, President of the Parent Assembly of the Society of American Magicians* (New York: Funk and Wagnalls, 1930).

45. Christopher, *Houdini: The Untold Story,* 252–53.

46. Houdini Scrapbooks, vols. 4 and 5.

47. *New York Times,* December 30, 1927.

48. Ibid., March 25, 1928, 124.

49. Houdini Scrapbooks, vol. 5.

50. Ibid., vol. 7.

51. Ibid., vol. 4. As early as 1931, Bess tried to have October 31 designated Houdini Day.

Considering Houdini

1. Nancy Spector, *Matthew Barney: The Cremaster Cycle* (New York: Solomon R. Guggenheim Museum, 2002), 66.

2. "Matthew Barney: A Conversation with Jeanne Siegel," *Tema Celeste,* Spring 1993, 65.

3. Marrill Falkenberg and Jeff Kelley, *How To: The Art of Deborah Oropallo* (San Jose, Calif.: San Jose Museum of Art, 2002), 24.

Houdini's Magic Apparatus

1. See "Needle Trick" entry at http://geniimagazine.com/wiki/index.php/Needle_Trick.

2. The Amazing Randi and Bert R. Sugar, *Houdini: His Life and Art* (New York: Grosset and Dunlap, 1977), 28, 52.

3. Kenneth Silverman, *Houdini!!! The Career of Ehrich Weiss* (New York: HarperCollins, 1996), 24.

4. Randi and Sugar, *Houdini: His Life and Art,* 52.

5. Silverman, *Houdini!!! The Career of Ehrich Weiss,* 22, notes that Houdini and Beck's meeting was unexpected, taking place "at a St. Paul, Minnesota, beer hall, the Palmgarden. . . . A party of sightseeing theater managers dropped in. One of them, Martin Beck, challenged him to escape some handcuffs—'perhaps more in a joke than sincerity,' Harry thought." In Milbourne and Maurine Christopher, *The Illustrated History of Magic* (New York: Carroll and Graf, 2006), 346, the authors write: "A short, plump man with a German accent ques-

tioned Houdini after his performance in a small hall in St. Paul, Minnesota, early in 1899. Could he free himself from other manacles? Or just those used in the show? Harry boasted that the restraint had yet to be made that would hold him. The next evening the man returned with his own fetters, locked them on Houdini's wrists, and pocketed the key. When the brash young escapologist justified his boast, the stranger introduced himself. He was Martin Beck, booker for the Orpheum vaudeville circuit." Magician Doug Henning charted Houdini's rise in *Houdini: His Legend and His Magic* (New York: Warner, 1977), 42. Henning emphasized that the meeting with Beck was a fitting close to the nineteenth century, "but the sudden upturn his career took in 1899 was not just a stroke of good fortune. It was, of course, fortunate that Houdini's act was seen by vaudeville impresario Martin Beck, but when that break came, Houdini was ready for it. All of the tough years in beer halls, dime museums, and circuses had paid off."

6. As Houdini's celebrity escalated, so did the market for his magic apparatus. While the use of common, recognizable objects in performance—such as handcuffs—distinguished Houdini from most of his peers in magic, it also made his tools susceptible to imitation and dissemination. Despite his efforts, replicas of his apparatus proliferated, especially handcuffs because they were affordable, mass-produced items and as easily available to the public as to the master magician. Today scholars, auctioneers, dealers, and collectors are typically reticent to ascribe provenance directly to Houdini— even those fetters made from the late nineteenth century to the mid-1920s, and even those stamped *Houdini*. The handcuffs reproduced here represent the range of styles available to Houdini in his day.

7. Christopher and Christopher, *Illustrated History of Magic,* 349, 350.

8. Harry Houdini, *Houdini on Magic,* ed. Walter B. Gibson and Morris N. Young (New York: Dover, 1953), 4.

9. Christopher and Christopher, *Illustrated History of Magic,* 342.

10. Ibid., 351.

11. Silverman, *Houdini!!! The Career of Ehrich Weiss,* 165.

12. Experts differ as to the debut of this performance. The Amazing Randi suggests 1914; John F. Kasson believes that it took place in 1915; and Kenneth Silverman writes that Houdini "seems first to have attempted" the Straitjacket Escape outdoors in 1915. See Randi and Sugar, *Houdini: His Life and Art,* 100; Kasson, *Houdini, Tarzan,* *and the Perfect Man: The White Male Body and the Challenge of Modernity in America* (New York: Hill and Wang, 2001), 136, 237 n. 110; and Silverman, *Houdini!!! The Career of Ehrich Weiss,* 194.

13. Matthew Paul Solomon, "Stage Magic and the Silent Cinema: Méliès, Houdini, Browning" (Ph.D. diss., University of California at Los Angeles, 2001), 106.

Selected Bibliography and Filmography

Books by Houdini

Houdini Exposes the Tricks Used by the Boston Medium "Margery" to Win the $2500 Prize Offered by the Scientific American. Also a Complete Exposure of Argamasilla, the Famous Spaniard Who Baffled Noted Scientists of Europe and America, with His Claim to X-Ray Vision. New York: Adams, 1924.

Magic and Mystery: The Incredible Psychic Investigations of Houdini and Dunninger. New York: Weathervane, 1967.

A Magician Among the Spirits. New York: Harper, 1924. Reprint, Amsterdam: Fredonia, 2002.

Miracle Mongers and Their Methods: A Complete Exposé. New York: E. P. Dutton, 1920. Reprint, New York: Cosimo, 2007.

On Magic. Ed. Walter Gibson and Morris Young. New York: Dover, 1953.

The Right Way to Do Wrong: An Exposé of Successful Criminals. Boston: Harry Houdini, 1906. Reprint, Mattituck, N.Y.: Ameron House, 1980.

The Unmasking of Robert-Houdin. New York: Publishers Print Company, 1908.

Biographies and Related Works

Brandon, Ruth. *The Life and Many Deaths of Harry Houdini.* New York: Random House, 1993.

Cannell, J. C. *The Secrets of Houdini.* New York: Dover, 1973.

Christopher, Milbourne. *Houdini: The Untold Story.* New York: Crowell, 1969.

———. *Houdini: A Pictorial Life.* New York: Crowell, 1976.

Doyle, Arthur Conan. "Houdini: The Enigma." *Strand Magazine* 75, nos. 440–41 (August–September 1927): 134–43.

Ernst, Bernard M. L., and Hereward Carrington. *Houdini and Conan Doyle: The Story of a Strange Friendship.* Whitefish, Mont.: Kessinger, 2003.

Fitzsimons, Raymond. *Death and the Magician: The Mystery of Houdini.* London: Hamish Hamilton, 1980.

Gibson, Walter. *Houdini's Escapes, and Magic.* New York: Blue Ribbon, 1930.

———. *Houdini's Fabulous Magic.* Philadelphia: Chilton, 1961.

Gresham, William. *Houdini: The Man Who Walked Through Walls.* New York: Henry Holt, 1959.

Henning, Doug, and Charles Reynolds. *Houdini: His Legend and His Magic.* New York: Times Books, 1977.

Hilgert, Ronald. *Houdini Comes to America.* Appleton, Wisc.: Houdini Historical Center, 1996.

Kalush, William, and Larry Sloman. *The Secret Life of Houdini: The Making of America's First Superhero.* New York: Atria, 2006.

Kellock, Harold. *Houdini: His Life-Story: From the Recollections and Documents of Beatrice Houdini.* New York: Harcourt, Brace, 1928.

Koval, Frank. *The Illustrated Houdini Research Diary.* Chadderton, Eng.: Frank Koval, 1992.

Meyer, Bernard C. *Houdini: A Mind in Chains, a Psychoanalytic Portrait.* New York: Dutton, 1976.

Moses, Arthur. *Houdini Speaks Out: "I Am Houdini! and You Are a Fraud!"* Philadelphia: Xlibris, 2007.

Phillips, Adam. *Houdini's Box: The Art of Escape.* New York: Pantheon, 2001.

Randi, James (The Amazing Randi), and Bert Randolph Sugar. *Houdini: His Life and Art.* New York: Grosset and Dunlap, 1976.

Saposnik, Irving S. "Yasha Mazur and Harry Houdini: The Old Magic and the New." *Studies in American Jewish Literature* 1 (1981): 52–60.

Shavelson, Melville. *The Great Houdinis: A Vaudeville.* London: W. H. Allen, 1977.

Silverman, Kenneth. *Houdini!!! The Career of Ehrich Weiss.* New York: HarperCollins, 1996.

———. *Notes to Houdini!!!* Washington, D.C.: Kaufman and Greenberg, 1996.

———. Review of John F. Kasson, *Houdini, Tarzan, And the Perfect Man: The White Male Body and the Challenge of Modernity in America,* and Adam Phillips, *Houdini's Box: The Art of Escape. New York Times,* August 12, 2001.

Solomon, Matthew. "Houdini's Actuality Films: Mediated Magic on the Variety Stage." *Nineteenth Century Theatre and Stage* 33, no. 2 (December 2006): 45–61.

Stashower, Daniel. "The Medium and the Magician." *American History* (August 1999): 38–46.

Weltman, Manny. *Houdini: A Definitive Bibliography, a Description of the Literary Works*

of Harry Houdini. Van Nuys, Calif.: Finders/Seekers, 1991.

———. *Houdini: Escape into Legend, the Early Years, 1862–1900.* Van Nuys, Calif.: Finders/Seekers Enterprises, 1993.

Williams, Beryl, and Sam Epstein. *The Great Houdini: Magician Extraordinary.* Folkestone, Eng.: Bailey Bros. and Swinfen, 1971.

Wilson, Edmund. "Houdini" and "A Great Magician." In *The Shores of Light: A Literary Chronicle of the Twenties and Thirties,* 174–78, 286–92. New York: Farrar, Straus and Young, 1952.

Magic, Vaudeville, and Popular Entertainment

Appelbaum, Stanley. *The Chicago World's Fair of 1893: A Photographic Record.* New York: Dover, 1980.

Christopher, Milbourne. *Panorama of Magic.* New York: Dover, 1962.

———, and Maurine Brooks Christopher. *The Illustrated History of Magic.* New York: Crowell, 1976. Reprint, New York: Carroll and Graf, 2006.

Clark, Hyla M. *The World's Greatest Magic.* New York: Crown, 1976.

Cullen, Frank, Florence Hackman, and Donald McNeilly. *Vaudeville: Old and New.* New York: Routledge, 2007.

Dawes, Edwin. *The Great Illusionists.* London: David and Charles, 1979.

Evans, A. J. *Escape: True Tales of Adventure and Intrigue.* New York: Toby, 1953.

Fortman, Janis L. *Houdini and Other Masters of Magic.* New York: Contemporary Perspectives, 1977.

Jay, Ricky. *Jay's Journals of Anomalies.* New York: Farrar, Straus and Giroux, 2001.

———. *Learned Pigs and Fireproof Women.* New York: Villard, 1987.

Kasson, John F. *Amusing the Million: Coney Island at the Turn of the Century.* New York: Hill and Wang, 1978.

Laurie, Joe Jr. *Vaudeville: From the Honky-Tonks to the Palace.* New York: Henry Holt, 1953.

Lévi, Éliphas. *The History of Magic.* 1913. Reprint, Boston: Weiser, 2001. Original French edition: *Dogme et ritual de la haute magie.* Paris: G. Baillière, 1856.

McDonnell, Patricia. *On the Edge of Your Seat: Popular Theater and Film in Early Twentieth-Century American Art.* New Haven: Yale University Press, 2002.

McNamara, Brooks. *Step Right Up.* Garden City, N.Y.: Doubleday, 1976.

Nasaw, David. *Going Out: The Rise and Fall of Public Amusements.* New York: Basic, 1993.

Robsjohn-Gibbings, T. H. *Mona Lisa's Mustache: A Dissection of Modern Art.* New York: Knopf, 1947.

Sobel, Bernard. *A Pictorial History of Vaudeville.* New York: Citadel, 1961.

Solomon, Matthew Paul. "Stage Magic and the Silent Cinema: Méliès, Houdini, Browning." Ph.D. diss., University of California, Los Angeles, 2001.

Springhall, John. *The Genesis of Mass Culture: Show Business Live in America, 1840–1940.* New York: Palgrave Macmillan, 2008.

Steinmeyer, Jim. *Art and Artifice and Other Essays on Illusion.* New York: Carroll and Graf, 2006.

———. *Hiding the Elephant: How Magicians Invented the Impossible and Learned to Disappear.* New York: Carroll and Graf, 2003.

Waters, T. A. *The Encyclopedia of Magic and Magicians.* New York: Facts on File, 1987.

Literary Works

Brownstein, Gabriel. *The Man from Beyond: A Novel.* New York: W. W. Norton, 2005.

Chabon, Michael. *The Amazing Adventures of Kavalier and Clay.* New York: Random House, 2000.

Doctorow, E. L. *Ragtime.* New York: Random House, 1975.

Hjortsberg, William. *Nevermore.* New York: Atlantic Monthly Press, 1994.

Rukeyser, Muriel. *Houdini: A Musical.* Ashfield, Mass.: Paris, 2002.

Satterthwait, Walter. *Escapade.* New York: St. Martin's, 1995.

Smith, Patti. *Ha! Ha! Houdini.* New York: Gotham Book Mart, 1977. Reprinted in *Early Work 1970–1979.* New York: W. W. Norton, 1994.

Stashower, Daniel. *The Dime Museum Murders: A Harry Houdini Mystery.* New York: Avon, 1999.

————. *The Floating Lady Murder: A Harry Houdini Mystery.* New York: Avon, 2000.

Selected Filmography

Films Starring Houdini

Merveilleux exploits du célèbre Houdini à Paris, 1901/5. Directed by Georges Méliès. Pathé Frères.

The Master Mystery, 1919 (fifteen-part serial). Directed by Burton L. King. Octagon Films.

The Grim Game, 1919. Directed by Irving Willat. Famous Players–Lasky Corporation.

Terror Island, 1920. Directed by James Cruze. Famous Players–Lasky Corporation.

The Man from Beyond, 1922. Directed by Burton L. King. Houdini Picture Corporation.

Haldane of the Secret Service, 1923. Directed by Harry Houdini. Houdini Picture Corporation.

Houdini: The Movie Star. 3 DVDs. Kino International, 2008. Includes *The Master Mystery, The Grim Game, Terror Island, The Soul of Bronze, The Man from Beyond, Haldane of the Secret Service,* handcuff and straitjacket escapes, and 1914 audio of Houdini speaking.

Documentary Films

Houdini Never Died. Directed by Pen Densham. Insight Productions/Wombat Productions, 1978.

Houdini. Directed by Elizabeth Koerner. Distributed by Congress Video Group, 1986.

Houdini: The Life of the World's Greatest Escapologist. Directed by Anna Benson Gyles. BBC/White Star, 1993.

Houdini: The Great Escape. Arts & Entertainment Networks, 1994.

The Truth About Houdini. Directed by David C. Rea. William H. McIlhany, 1998.

The American Experience: Houdini. Produced by Nancy Porter and Beth Tierny. PBS, 2000.

Houdini: Unlocking the Mystery. A&E Television Networks (History Channel), 2005.

Fictional Films and Biopics

Houdini. Directed by George Marshall. Paramount Pictures, 1953. Starring Tony Curtis as Houdini.

The Great Houdini. Directed by Melville Shavelson. ABC Circle, 1976. Starring Paul Michael Glaser as Houdini.

Fairy Tale: A True Story. Directed by Charles Sturridge. Icon Entertainment International, 1997. Starring Harvey Keitel as Houdini.

Believe: The Houdini Story. Directed by Pen Densham. Trilogy Entertainment Group, 1998. Starring Johnathan Schaech as Houdini.

Death Defying Acts. Directed by Gillian Armstrong. Weinstein Company, 2008. Starring Guy Pearce as Houdini.

Contributors

Brooke Kamin Rapaport is an independent curator and a writer. Her most recent exhibition, organized for The Jewish Museum, was *The Sculpture of Louise Nevelson: Constructing a Legend* (2007). From 1989 to 2002 she was assistant curator and then associate curator of contemporary art at the Brooklyn Museum, where she organized many exhibitions and wrote a number of catalogues, including *Vital Forms: American Art and Design in the Atomic Age, 1940–1960* (2001, with Kevin L. Stayton). She is a contributing editor and frequent writer for *Sculpture* magazine.

Alan Brinkley is the Allan Nevins Professor of American History at Columbia University, where he served as provost from 2003 to 2009. His books include *The Publisher: Henry Luce and His American Century* (2010), *The End of Reform: New Deal Liberalism in Recession and War* (1995), and *Voices of Protest: Huey Long, Father Coughlin, and the Great Depression* (1982), which won the National Book Award.

Gabriel de Guzman, Neubauer Family Foundation Curatorial Assistant at The Jewish Museum, was coordinator at the museum for career-spanning surveys of the work of Louise Nevelson (2007) and Joan Snyder (2005), and the exhibitions *They Called Me Mayer July: Painted Memories of a Jewish Childhood in Poland Before the Holocaust* (2009), *Susan Hiller: The J. Street Project* (2008), *Warhol's Jews: Ten Portraits Reconsidered* (2008), and *Schoenberg, Kandinsky, and the Blue Rider* (2003).

Hasia R. Diner teaches at New York University, where she is Paul S. and Sylvia Steinberg Professor of American Jewish History, Professor of Hebrew and Judaic Studies and History, and director of the Goldstein-Goren Center for American Jewish History. Her books include *The Jews of the United States, 1654 to 2000* (2004), *Hungering for America: Italian, Irish and Jewish Foodways in the Age of Migration* (2002), and *The Lower East Side Memories: The Jewish Place in America* (2000).

Kenneth Silverman, professor emeritus of English at New York University, has published biographies of Cotton Mather, Edgar Allan Poe, Samuel F. B. Morse, and Harry Houdini. A fellow of the American Academy of Arts and Sciences, he has received the Bancroft Prize in American History, the Pulitzer Prize for Biography, the Edgar Award of the Mystery Writers of America, and the Christopher Literary Award of the Society of American Magicians—of which he is a lifetime member.

Lenders to the Exhibition

American Museum of Magic, Marshall,
 Michigan
Appleton Public Library, Appleton,
 Wisconsin
Dr. Bruce J. Averbook, Cleveland
Matthew Barney, courtesy of Gladstone
 Gallery, New York
Brooklyn Museum, New York
Cannon's Great Escapes
Kevin A. Connolly
David and Rhonda Denholtz
Mr. and Mrs. E. L. Doctorow
George Eastman House Motion Picture
 Department Collection
Fantasma Magic Shop, New York,
 www.fantasmamagic.com
Hammer Museum, Los Angeles
Harvard Theatre Collection, Houghton
 Library, Cambridge, Massachusetts
Samuel and Ronnie Heyman
The History Museum at the Castle,
 Appleton, Wisconsin
International Poster Center, New York
Eleanor Jacobs
The Jewish Museum, New York,
 National Jewish Archive of
 Broadcasting
Kino International
Nat and Georgia Kramer
Library of Congress, Washington, D.C.
Madeleine and David Lubar

Arthur Moses, Fort Worth, Texas
Vik Muniz, courtesy of Sikkema Jenkins
 & Co.
Museum of the City of New York
The Museum of Modern Art, New York
Ikuo Nakamura
The National Portrait Gallery,
 Smithsonian Institution,
 Washington, D.C.
The New York Public Library for the
 Performing Arts, Billy Rose Theatre
 Collection
Paramount Pictures
Raymond Pettibon, courtesy of Regen
 Projects, Los Angeles
Private collections
Sara Greenberger Rafferty, courtesy of
 Rachel Uffner Gallery, New York
Harry Ransom Humanities Research
 Center, The University of Texas at
 Austin
Allen Ruppersberg, courtesy of Christine
 Burgin, New York, and Margo Leavin
 Gallery, Los Angeles
Sender Collection
Kenneth Silverman
Tate, London
Ken Trombly, Bethesda, Maryland
The Weinstein Company
Whitney Museum of American Art,
 New York

Index

Page numbers referring to illustrations appear in *italics*.

Illustration Credits

Numerals refer to page numbers.

Abbreviations

AMM: American Museum of Magic, Marshall,
Michigan, photography by Thomas R. DuBrock

BJA: Dr. Bruce J. Averbook, Cleveland

FMS: Fantasma Magic Shop, New York,
www.fantasmamagic.com, photography by Bill
Orcutt

HRHRC: Harry Ransom Humanities Research Center,
The University of Texas at Austin

HTC: Harvard Theatre Collection, Houghton Library,
Cambridge, Massachusetts

KAC: Kevin A. Connolly, photography by
Richard Goodbody

KS: Kenneth Silverman, photography by
Richard Goodbody

KT: Ken Trombly, Bethesda, Maryland, photography
by Dean A. Beasom

LOC: Library of Congress, Washington, D.C.

MCNY: Museum of the City of New York

MoMA: Digital Image © The Museum of Modern Art/
Licensed by SCALA/Art Resource, New York

NYPL: The New York Public Library for the
Performing Arts, Billy Rose Theatre Division, Astor,
Lenox, and Tilden Foundations

RG: Photography by Richard Goodbody

WMAA: Whitney Museum of American Art,
New York

Cover: The National Portrait Gallery, Smithsonian
Institution, Washington, D.C.

Frontmatter: i–v BJA. vi HRHRC.

Foreword: © The Bruce Cratsley Archive, courtesy of
Jane Cratsley and Sarah Morthland Gallery LLC,
New York/Brooklyn Museum

Introduction: xiii The National Portrait Gallery,
Smithsonian Institution, Washington, D.C.
xviii–1 LOC.

Rapaport Essay: 3 KT. 4 LOC (left), FMS (right). The
Jewish Museum, New York/RG. 8 LOC. 9 HRHRC.
10 KAC. 11 LOC. 12 FMS. 14 NYPL. 15 HTC (left),
LOC (right). 16–17 FMS. 18 KT. 19 Courtesy of
Jay Disbrow and International Poster Center, New York
(left), Courtesy of Seymour Chwast and International
Poster Center, New York (right). 20 WMAA/
Photography by Geoffrey Clements. 21 MoMA (top),
© 2010 Calder Foundation, New York/Artists Rights
Society (ARS), New York (bottom). 22 Art © The
Joseph and Robert Cornell Memorial Foundation/
Licensed by VAGA, New York. 24–25 LOC. 26 ©
2010 The Andy Warhol Foundation for the Visual Arts,
Inc./Artists Rights Society (ARS), New York/Ronald
Feldman Fine Arts, New York. 27 Art © Vik Muniz/
Licensed by VAGA, New York. 28 Courtesy of Allen
Ruppersberg and Margo Leavin Gallery, Los Angeles. 29
Courtesy of Stephen Wirtz Gallery, San Francisco. 30
Courtesy of Luhring Augustine, New York. 31 © Petah
Coyne, courtesy of Galerie Lelong, New York/Brooklyn
Museum. 33 © 1999 Matthew Barney/Courtesy of
Gladstone Gallery, New York/Photography by Michael
James O'Brien. 34 © 1997 Matthew Barney/Courtesy
of Gladstone Gallery, New York/Photography by
Michael James O'Brien. 36–37 Courtesy of Matthew

Barney and Gladstone Gallery, New York. 40–41
NYPL. 42 KAC/© Paramount Pictures Corporation,
all rights reserved. 43 Courtesy of Eleanor Jacobs. 45
Courtesy of Allen Ruppersberg and Christine Burgin.
46 Courtesy of Sara Greenberger Rafferty and Rachel
Uffner Gallery, New York. 49 MCNY. 51 Courtesy of
Joe Coleman and Tilton Gallery.

Brinkley Essay: 53 LOC. 54 Appleton Public Library,
Wisconsin. 55 HTC. 56–57 MCNY. 61 NYPL.
62 MCNY. 64 BJA/RG. 65 The New York Public
Library, General Research Division, Astor, Lenox,
and Tilden Foundations.

Silverman Essay: 66 RG. 67 The New York Public
Library, Photography Collection, Miriam and Ira D.
Wallach Division of Art, Prints, and Photographs,
Astor, Lenox, and Tilden Foundations (top), FMS
(bottom). 68 BJA/RG. 70 HTC. 74–76 KAC. 78–79
RG. 80–83 HRHRC. 84 LOC. 86 RG. 87 KS.
88 BJA/RG. 89 KS (top), RG (bottom). 91 LOC.

Diner Essay: 93 LOC. 94 KT. 96 LOC. 99 KT.
100, 103, 105–107 LOC.

Pettibon Drawings: 109 © Raymond Pettibon/MoMA.
110–115 © Raymond Pettibon, courtesy of Regen
Projects, Los Angeles.

Considering Houdini: 117 KT. 118–119 Mr. and Mrs.
E. L. Doctorow/Courtesy of Max Yeh/RG. 124 KS.
129 LOC. 130 Courtesy of Penn and Teller.

Chronology: 144 HTC. 145 LOC. 146 HTC.
147–148 LOC. 149 MCNY. 150–155 LOC.
156–157 Arthur Moses, Forth Worth, Texas/
Photography by Robert LaPrelle. 158–160 LOC.
161 HRHRC. 162 KAC. 163 LOC. 164 LOC (top),
KT (bottom). 165 LOC. 166–167 KT. 168 LOC.
169 George Eastman House Motion Picture
Department Collection (top), FMS (bottom).
170–172 LOC. 173 KAC. 174 LOC. 175 KT.
176–177 LOC.

Houdini's Magic Apparatus: 178 BJA/RG. 181 AMM.
182 KT. 183 LOC. 185 Courtesy of Jane Hammond.
187 KAC (top), HTC (bottom). 188–189 Sidney H.
Radner Collection at The History Museum at the
Castle, Appleton, Wisconsin. 190 LOC. 191 BJA/RG.
192–193 LOC. 194–195 KT. 196 BJA/RG. 197 KAC.
198 KT. 199 KAC. 200 MCNY. 201 BJA/RG.
203 WMAA/Photography by Bill Orcutt/Courtesy of
Stephen Wirtz Gallery, San Francisco. 205 FMS.
206 BJA/RG. 207–208 LOC. 209 NYPL. 211 Courtesy
of Jane Hammond. 213 AMM. 214 HRHRC.
215 LOC. 216–217 FMS. 219 Courtesy of Ikuo
Nakamura. 221–222 KAC. 223 BJA/RG. 224 HRHRC.
225 LOC (left), KAC (right). 226–227 BJA/RG.
229 © 2008 Tate, London. 231 Arthur Moses, Forth
Worth, Texas/Photography by Robert LaPrelle.
232–235 MCNY. 236 NYPL. 237 MCNY. 239 Cherry
and Martin, Los Angeles/Courtesy of Susanne Vielmetter
Los Angeles Projects, LLC. 241 Courtesy of Stephen
Wirtz Gallery, San Francisco.

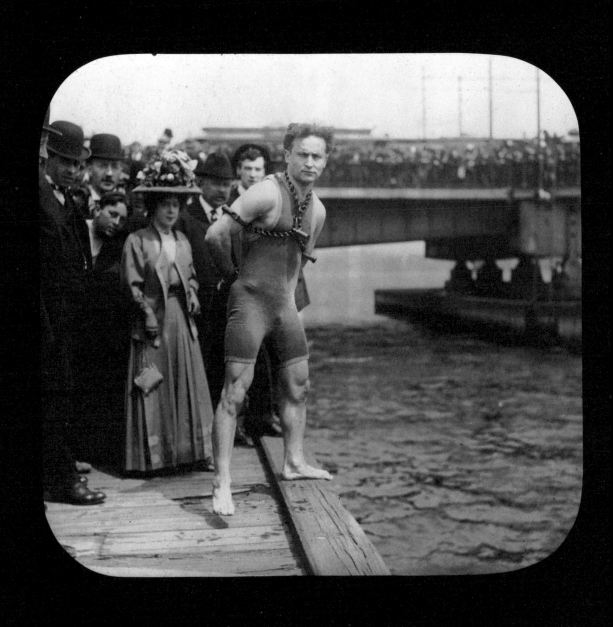